ART AND SURVIVAL IN FIRST WORLD WAR BRITAIN

Art and Survival in First World War Britain

Stuart Sillars

St. Martin's Press New York

First published in the United States of America in 1987

Printed in Hong Kong

ISBN 0–312–00544–X

Library of Congress Cataloging-in-Publication Data
Sillars, Stuart, 1951–
Art and survival in First World War Britain.
Bibliography: p.
Includes index.
1. Arts, British 2. Arts, Modern—20th
century—Great Britain. 3. World War, 1914–1918—
Art and the war. I. Title.
NX543.S5 1987 700′.941 86–31308
ISBN 0–312–00544–X

For my parents, and for J.D.B.
with love; and for Laurence,
in hope

Contents

List of Illustrations

*My mind is a corridor. The minds about me are
 corridors.
Nothing suggests itself. There is nothing to do but
 keep on.*

T. E. Hulme, 'Trenches: St Eloi'

Acknowledgements

This book has profited greatly from the sympathetic advice and practical help of many people. I am grateful to the following for their help in answering specific questions: Group Capt. W. G. Abel, RAF (retired), College Secretary, RAF Staff College, Bracknell; Comdr. P. J. Everett, OBE, RN, General Secretary, The Sea Cadets; Lt.-Comdr. D. J. Knight, RN, HMS Raleigh, Torpoint, Lt. Comdr. J. R. Leatherby, RN, Britannia Royal Naval College, Dartmouth; Mrs C. Penman, Royal Naval College, Greenwich; Mrs J. S. Tierney, Curator, Welholme Galleries, Great Grimsby.

The staffs of the National Library of Wales and Cambridge University Library answered innumerable questions with their customary efficiency, precision and kindness, and the staff of the photographic department of the latter institution were most helpful in giving advice on the preparation of material for reproduction. Stephen Perry and Stephen Badsey of the Department of Film, and Jenny Wood of the Department of Art, Imperial War Museum, provided much invaluable material and gave generously of their time and expertise.

Duncan Isles, Lecturer in English at the University College of Wales, Aberystwyth, read parts of the text in an early draft and made many helpful suggestions. Professor John Chadwick-Jones, of Saint Mary's University, Halifax, Canada, and Dr Araceli Chadwick-Jones, of Mount Saint Vincent University, Halifax, gave detailed guidance on the theory of social psychology involved in chapters 4 and 5. Part of chapter 8 originally appeared in *Critical Quarterly*, and I am grateful to J. R. Banks and the editorial board for permission to include it here. Siegfried Sassoon's poem 'Blighters' is reproduced by permission of G. T. Sassoon and Viking Penguin, Inc.

It should not be necessary to add that those omissions and inaccuracies which remain are the sole result of my own determined perversity.

Cambridge, 1986 Stuart Sillars

1
Functions and Circumstances

Of the horror and degradation, surely, there may no longer be any doubt. During the four years, three months and seven days of the Great War, the soldier had been interred in trenches which, when they were not flooded with glutinous mud, were infested with rats and lice, and under fearfully arbitrary bombardment. He had been assaulted by many kinds of poison gas, liquid fire and high explosive, bombed and strafed from the air, and made to advance through darkness against impenetrable barbed wire. He had contracted trench foot and trench fever and, if fit in body, had lived with shell-shock and the constant death and maiming of his companions. This was in France. Other fronts had other perils: dysentery at Gallipoli, cholera at Salonika, malaria in the African desert. At sea there was the menace of submarines; in the air the fear of spinning to earth in flames. At home, Zeppelin raids foreshadowed the larger terror of bombing aeroplanes, and food shortages and a thousand minor legal irritations sapped the energy of those left behind from the fighting.

In its daily reality the war offered a range and complexity of experience which, for those who faced it, presented great difficulties of comprehension and assimilation. The landscape of battle was an unprecedented wasteland:

> Behold then a stretch of country – a sea of mud as far as the eye can reach, a grim desolate expanse, its surface ploughed and churned by thousands of high-explosive shells into ugly holes and tortured heaps like muddy waves struck motionless upon this muddy sea.[1]

The final bombardment before the Somme offensive, with one gun for every 17 yards of the front line, was an appalling spectacle:

> The entire German position appeared as a seething wall of smoke, rent and splashed by volcanoes of black clouds and darting flame. Mingled with these, and exploding continuously, were sparkling gleams of

shrapnel, while above this scintillating mass, billowing aloft to a great height, there ascended a heavy mantle of smoke and dust.[2]

Gas attacks added a peculiarly intense horror to war, increased by each man's isolation within his helmet:

> The two sat there with grey flannel bags over their heads obscenely pierced by goggle eyes of glass, as though they were some primitive form of fish, and the air seemed also aqueous, as though the gas were a grey tide of fog rising about us.[3]

The natural landscape which remains after battle has a similar quality of terrible unreality, both in itself and in the way it altered men's lives. Forests are destroyed, and only the dead remain above ground, while the living shelter beneath:

> But oh the poor woods . . . Not a leaf – not one single leaf; and, instead of undergrowth, just tossed earth, fuses, a boot, a coat, some wire, and above-ground dead men. Below ground (or as far below as they can get in the time) live men.[4]

Circumstances at home are similarly strained towards the borders of credibility. Although not so pervasive, the apparent unreality is still strong. An eyewitness of a Zeppelin raid voices his incredulity:

> In daylight it seemed impossible at first to believe that the events before midnight had been a reality. The countryside was at its fairest and leafiest. The hedges were a mass of flowers and crimson berries. Wild honeysuckle was blooming freely . . . What had countryside such as this to do with war and death in the air?[5]

Strange sights and experiences became commonplace. Women munition workers grew accustomed to smearing their faces with protective grease when working with tetryl, or wearing respirators when handling mercury compounds: the risk of explosion was great, as was that of toxic jaundice turning their faces yellow. When the Silvertown munition-factory blew up, flames burst right across the river and endangered Woolwich Arsenal: the sky 'eddied and swirled from a chaotic mass into a settled and beautiful colour design'.[6] Less spectacular manifestations were more frequent. 'The staircases and platforms of the Tube Stations were like a huge bedroom and "night-nursery" . . . the poor sleepy little

children were wrapped up in the blankets off their beds, and were sleeping peacefully.'[7] In the country, the railway stations received shoals of wounded:

> men on pickaback with bandaged feet; men with only a nose and one eye showing, with stumbling legs, bound arms. The station, for five minutes, is full of jokes and witticisms; then they pass out and into the waiting chars-a-banc.[8]

It is almost a grotesque hallucination: yet the sense of an ending is everywhere. 'London is only skin deep. Beneath it lies the body of the world'.[9]

This range of experience provides an immediate answer to the question which underlies any consideration of art in war – what exactly is its relevance or purpose in the face of such devastation? Here its function is revealed at one level as simply to convey the nature and experience of war in a form that is accurate and convincing. 'Art' is an inadequate term, nor is there a valid alternative, since this function is shared by artists working in a great range of forms usually held apart by the division between 'popular' and 'fine' art. Here, though, the artists may be writers of press reports or editorials, popular illustrators, photographers, poets, cartoonists, novelists and authors of memoirs, as well as official war artists and those who respond to war within the definable confines of 'fine art'. The task of simply recording events devolved most often to the popular writers and illustrators. How they performed their work was clearly of crucial importance to the mental welfare of the nation: their precision of utterance in clarifying the exact nature of events was simply essential to the many thousands who could do no more than read and try to understand about happenings in the distant fronts, or events at home which were just as confusing. To their work must be added the intuitive power of the poet or painter, whose individual perception adds another kind of reality and insight, though, as will emerge, the two are not often as easily separable as might be supposed in either subject matter or approach.

At the most basic level, then, a major function of art of all kinds is simply to inform and record. But as a task this is far from simple. Many writers, of all kinds, felt 'the supreme difficulty of communicating the actual sights and sounds and sensations through which we have lived as through a vivid dream, imperfectly understood, imperfectly memorised'.[10] Some felt the task was impossible:

> It is easy to talk . . . But words cannot convey even a suggestion of the

sounds heard and the emotions felt, when every faculty is heightened, when every nerve is tense.[11]

To this difficulty must be added those created by the context of the writing and the intention, conscious or unconscious, of the writer – or of the photographer or illustrator – who shared the aim of recording events. In some cases both context and aim seem straightforward enough: the letter-writer in the trenches, the war correspondent, the official photographer, the artist working for an illustrated weekly – all shared the clear intention of letting people know the current state of things. But they were all limited by external constraints of some kind – the officer-censor, the Press Officer, and the various bodies dealing with propaganda and the dissemination of information respectively. And even those accounts most avowedly impartial, which aim to do no more – or no less – than simply record, cannot avoid a personal, interpretative stance of some kind. The writer conceals the truth about his conditions to avoid upsetting those at home; the correspondent's desire for a 'story' leads him towards the unusual rather than the quotidian; and the photographer and artist both subconsciously use their professional skill to select a striking composition which may distort the inner reality while clarifying the external form. Underlying assumptions and attitudes of which the artist is himself unaware add another layer of interpretation, and for the beholder may reveal much about psychological stances of both artist and intended audience.

Other reports are more obvious in the interpretation, comment or attempted persuasion they contain, being perhaps led by patriotic zeal to falsification, or by moral outrage to desperate protest. The reports of the official 'Eye-Witness'[12] circulated by the Press Bureau to all the daily papers early in the war exemplify the first category: Sassoon's bitter poems such as 'The General'[13] and Owen's pathetic preface 'All a poet can do today is warn'[14], the latter. Sir Douglas Haig expressed one view of the role of the official war artist in a way which again stresses simple reportage: the artist's aim was 'recording for all time the spirit of the age in which he has lived', his paintings 'a permanent record of the duties which our soldiers have been called upon to perform, and the quality and manner of its [sic] performance'.[15] But few would accept such a straitened definition, or accept that no subjective element is present: Nevinson, Orpen, Roberts and others display mounting cynicism in their canvases, and even the apparently uncomplicated Muirhead Bone reveals a critical stance of some kind in his lithographs.

It is in these implicit attitudes, once they have been decoded, that we

can discover much about the temper of the time and the place of the artist within it: thus what Arthur Marwick has called the 'unwitting testimony'[16] of the artist is of invaluable importance to us in realising something of a past moral and intellectual climate. More significant in ultimate terms is the role such assumptions and attitudes performed for the original audiences, where their statement or reinforcement is often revealed as a means of psychological survival during a time of immense upheaval and distress.

The balance between the simply informative and the psychologically or ideologically supportive is tilted more discernibly towards the latter in war art which fulfils another function: that of providing some immediate guidance and reassurance in the first shock of tumultuous news. It is a function most commonly performed by newspaper editorials. Upon their writers fell the task of drawing together fragmentary and limited official dispatches into some kind of over-all coherence, and then suggesting – normally by implication rather than overt statement – how the news was to be accepted, whether as triumph or tragedy. Thus the retreat from Mons must be made sense of, and survived; the stand at Le Cateau seen as a glorious fight to the death in which the British bulldog turned to face the aggressor with all his traditional pluck; and the reversal at Neuve Chapelle turned deftly into a campaign against a weak and ineffectual administration which had little idea of how to equip a modern army. These three examples demonstrate recurring kinds of role performed by the leader writers: to reassure in reversal; to see in a larger context actions which in themselves are complex and confusing; and to change dismay into anger, and direct it at an appropriate target – government inadequacy – in the hope that something positive might come of it. Such kinds of guidance and reassurance represent a function of the popular writer which is of great importance in the day-to-day survival of the war.

Perhaps the converse of this function is in the provision of some kind of cathartic release for the artist. Hervey Allen's prefatory statement to his war diary shows well how the act of writing about the war's events, or recording them in some other way, can offer such release:

> After returning in 1919, I found myself much troubled by memories of the war and often unable to sleep. It occurred to me then that I might rid myself of my subjective war by trying to make it objective in writing . . . The medicine worked, although perhaps the style of the utterance suffered.[17]

That expression of this kind is of value to the creator is self-evident:

but its value to the beholder is less clear. Yet the cathartic act may often be shared by both writer and reader since, in the effort to rid himself of the war's troublesome memories, the writer may well produce material of great compression, approaching the intensity of an artistic symbol or image in which a range of related experiences are distilled into a key episode of much power. Because of its intensity and concentration, such a symbol often has the effect of allowing the beholder imaginatively to share the experience being described; and it may also give a sense of order to a series of events otherwise too complex to be easily comprehended, thus making intelligible to the beholder the strange reality that is being re-created.

This kind of intensity, which is at once cathartic for the writer and creative of order and understanding for the reader, is apparent in many accounts which on the surface seek to do no more than record events. It may be seen, for example, in a recollection of Gallipoli:

> We all sat there – on the Hellespont! – waiting for it to get light. The first thing we saw were big wrecked Turkish guns, the second a big marquee. It didn't make me think of the military but of the village fêtes. Other people must have thought like this because I remember how we all rushed up to it, like boys getting into a circus, and then found it all laced up. We unlaced it and rushed in. It was full of corpses. Dead Englishmen, lines and lines of them, with their eyes wide open. We all stopped talking. I'd never seen a dead man before and here I was looking at two or three hundred of them. It was our first fear.[18]

It is a terrible confrontation, this emptying of expectation in experience: it has about it the timeless shame of the devastation of innocence. Yet in its effectiveness it relies on what would in another context be literary techniques. Had an imaginative writer striven to encapsulate the confrontation between the idle hill of Edwardian high summer and the city of dreadful night of twentieth-century atrocity he could have found no better emblem. The style is suited to the images, the general, vague association of village fête and circus being replaced by the incisive, significant detail of the open eyes of the dead and the short, powerful sentence which follows. This is ostensibly a recollection, in which no artistic expression has been aimed at; but the intensity of the experience has given it a power which works on the reader exactly as does a literary symbol of much sophistication. Here the effort to record experience and

release the writer from its emotional effect has caused a concentration which omits many related details of the actual landings. To add to this passage the scythe of machine-gun bullets meeting the troops as they left the *River Clyde*, the bombardment from the Turkish guns, and the dysentery and sense of betrayal would be to make the sequence too large and bewildering to be comprehended in its full horror by the reader. The single, pivotal fact is selected, horrific but comprehensible, giving cathartic release to the writer and offering a moment of striking insight to the reader.

The single image taken from a complex reality as a means of imposing order can, then, be created as a cathartic release in the mind of the writer: but it may also be created for other reasons, most often through a conscious or subconscious act of selection to allow a pattern to be created, and thus make sense of reality for the beholder. In the most consciously 'artistic' treatments of events and aspects of the war this selectivity is shown in the use of a single episode of symbolic force, such as Rosenberg's 'Break of Day in the Trenches',[19] or the terrible vignette of Owen's 'Disabled',[20] or in visual terms the symbolic devastation of Nash's *We are Making a New World*.[21] In popular treatments, the single image often becomes a mythic incident, reported in many related forms all of which share certain basic iconographic elements. 'Mythic' in this sense does not denote untruth: rather, it signifies the kind of epic stature accorded to a single act – usually one of heroic bravery – which has become legendary, drawing to itself all the various significances of the larger situation of which it is part. In both kinds, a single incident or image stands for the whole: order is given to chaos, and a manageable myth or symbolic image created, through which the beholder may derive some sense of understanding – or, in some cases, of sharing in – the larger movement of the war. Often the particular incident selected is revealing about the attitude of the artists to the war: instead of a single icon of horror, like the marquee on the Hellespont, such treatments often present an icon of heroism in which the beholder's response is guided in an optimistic, but often misleading, manner, as will appear in later chapters of this study. When, as is often the case, such incidents are depicted by many writers or artists and a conventional iconography emerges, much is revealed about the psychological assumptions of the time, and the role of the particular branch of war art within them. Another striking feature of this selection of single events for such treatment is that the distinction between 'fine' and 'popular' art is blurred: on many occasions a similar event is selected in both kinds of art, and a similar iconography may even develop. Thus

tanks are depicted attacking in a heroic manner, flanked by advancing infantry, in both popular illustrations and paintings by war artists; and the confusion of Jutland is rendered plain by both academic easel paintings and commercial illustrations of the heroism of John Travers Cornwell.

This need to concentrate experience into a single, comprehensible action is matched by the need to provide a context, most often by placing contemporary events in the setting of a heroic past. Although this may appear more a convention than a function of war art, it is in fact performing an important psychological role. In placing the strange new events in the context of familiar, glorious occurrences of the past, it provides considerable reassurance for the uncertain and bewildered onlooker. Thus naval actions are seen in the context of Drake and Nelson, and Royal Flying Corps (RFC) pilots are presented as latter-day knights-errant. An ideal England, a pre-industrial paradise, is evoked as the homeland for which battle is being joined, ignoring the pre-war realities of social and industrial distress. In the search for order and context, traditional forms, compositions and techniques also become important as an assertion of the continuity of earlier values as a way of making sense of things. Portraits of naval and military leaders thus resemble Gainsborough's treatments of eighteenth-century landowners;[22] watercolours of wrecked buildings recall studies of classical ruins;[23] and aerial combats extend the convention of cloud studies by Constable and Turner.[24] The need to contextualise in both subject and idiom is widespread in both popular and fine art, with the result of providing a reassuring sense of continuity: psychological need recognises none of the habitual cultural frontiers.

The need to record, to order and contextualise these experiences of dreadful novelty and anguish, is thus basic to the war. In the widest sense, 'art' in some form, be it poster, editorial, poem or easel painting, has a range of functions which are essential to the war as a means of comprehension and survival, whether concordant or dissentient with official attitudes and policies. The arts in wartime are consequently of great importance in social and historical, as well as psychological and spiritual, terms. As the interchange of idiom, stance and role is so complete and so widespread, it is not enough to study only the painting, or the poetry, or the popular press: solely by examining a much wider range of response will both individual significance and over-all function emerge. The results of such study offer disturbing and often pathetic insights into the assumptions and insecurities of the artist and the age he is both recording and addressing.

II

Recording complex reality; offering guidance and a way of coming to terms with apparent defeat; providing a cathartic release for emotion; generating manageable myths; relating all to a familiar or historic context. These are some of the more important functions of the arts in ensuring psychological survival in wartime. Clearly, though, to chronicle the workings of them all, and the subtle interplay between them and other roles, throughout the whole of the First World War is beyond the scope of any single volume. Rather than attempt such a task and inevitably provide only a superficial account, the chapters that follow look in detail at the treatment in artistic forms of all kinds of a series of key events and aspects of the war which occurred in its central year – 1916 – although references have been made to works on related themes dating from other periods where they reveal similar, or significantly different, stances or techniques.

1916 was the intellectual and emotional heartland of the war, the year in which so many of the events we now see as being essential to its experience and pivotal to its progress took place. In the first years of the war, after some transitory initial successes, things had not gone well for Britain. In 1915, Churchill's plan to change the war into one of rapid movement by a quick assault on the Dardanelles degenerated into yet more trench attrition when it was ineptly organised and clumsily executed. The attack at Loos which should have brought victory ended in heavy casualties.

At the end of 1915, though, things began to change. In December, Joffre was appointed Commander-in-Chief of the French armies, Robertson became Chief of the Imperial General Staff (CIGS), and Haig replaced French in charge of the British Expeditionary Force (BEF). In that month, for the first time, meetings about a united allied strategy took place, and the idea of a combined offensive for the spring or summer was conceived. At home, too, there had been changes. In March, Lloyd George had negotiated with the trade unions to increase greatly the dilution of labour in the manufacture of shells, and the creation of the Ministry of Munitions in Asquith's coalition government of May 1915 meant that, for the first time in the war, there was the prospect of an adequate supply of shells. This in turn meant that far more people at home were now personally involved with the war in their everyday working lives.

All this prepared the way for further change the following year. In January 1916 the Military Service Act was passed, introducing conscrip-

tion, which began to be implemented in May. In that month the only meeting of the Grand Fleet and the *Hochseeflotte* took place at Jutland. While the nation was still trying to make sense of the outcome, Lord Kitchener, creator of the New Army but symbol of the old guard, was drowned when HMS *Hampshire* struck a mine off the Orkneys. In July, after the greatest preliminary bombardment ever seen, the Somme offensive opened. Throughout the summer the air war raged over the trenches in France; in August Zeppelin raids in England reached such a pitch that squadrons of fighters were hastily diverted from overseas to deal with the menace, with no little success. In September, with the Somme offensive dragging on, the new British secret weapons, the tanks, were used with startling but short-lived success. At the end of the year, with victory on the Somme no closer and support at home waning, Asquith resigned and Lloyd George formed a coalition administration.

These were tumultuous events, carrying with them a change in attitude and outlook in both government and people from an amateur involvement in the fighting to a grim commitment to total war. This is reflected in, and in many ways created by, the treatments of current events in popular and fine art. At the beginning of the year accredited press correspondents were still something of a novelty, there were no official war artists and only one official film of the war: at its end press correspondents were being given far more freedom to visit the war zones, the official war artists' scheme had begun – albeit fitfully – and film had become accepted as a major instrument of public information. In all, the role of the press and popular art of many kinds had become considerable – and above all, officially accepted, even if only grudgingly – both in keeping the public informed and in influencing government policy. The role of the arts in reporting and re-creating the events of this year is thus of much importance, spreading out beyond the recording of events into guiding public responses and directing government policy to an unprecedented extent. It is fitting that detailed studies should concentrate on this year, to show how events were treated by writers and artists of all kinds but also, incidentally, to offer a new perspective of the history of these turbulent months.

This study is also selective in another way, in that it focuses more on the popular and less well-known works than on the great achievements of the war years. Partly this is because of the concentration on 1916: Owen's mature poems date from the next year, as do Nash's canvases as a war artist, and most of the output of Nevinson, Lamb, Roberts, and Blunden, Sassoon and Rosenberg comes later in the war. The desolate landscapes of Nash, the distant, haunting orchestration of Vaughan

Williams's *Pastoral Symphony*, as much as the finest poems of Wilfred Owen, are statements of a personal response to war which have a grave, often fearsome beauty. Yet they stand apart from the more popular artistic responses for reasons other than their dates of composition. They are instruments of survival on a different plane, both personal and universal in the manner of all great art, but distanced in some ways from the preoccupations of daily continuity. As a result they must, in the last analysis, be held apart: to us, in a later age, they are the foreground of intensely moving personal artistic response which we see against the background of the quotidian efforts to make sense of the fighting in more popular art forms. For those who were there, the relation is reversed: the press reports and popular illustrations occupy the foreground, with the views of the artists coming later, if at all, to extend the perception of the reality of those years. Consequently, the familiar works of this kind are not dealt with at great length, although they figure in some chapters. In place of such analysis, this study attempts to offer some kind of understanding of the specific roles of war art which, looked at in one way, constitute the background against which these later works must be seen, so that in one sense this book is a prelude to a wider grasp of the significance, and the context, of these more celebrated compositions.

But placing such art in context is a subsidiary aim. The role of both popular and fine art as a means of finding order and ensuring some kind of survival in this pivotal year of war is the primary concern of the following pages. Fully to understand the ways in which these functions were possible, and the constraints under which writers and artists of all kinds operated, however, it is necessary first to look briefly at the range of material available for consideration, and the various official and semi-official forms of organisation which governed its production. This is the subject of the next chapter.

2

The Range of Response

Anyone wishing to acquire even a superficial knowledge of the popular and fine arts of the First World War in its central year is confronted by a bewildering volume and variety of material. Photography, painting, newspaper reportage, film, poetry, music of all kinds, cartoons, novels, factual accounts and personal reminiscences – all these and other forms must be viewed in order to achieve some idea of attitudes and responses, and thus of the role of art as an aid to psychological survival, either witting or unwitting. Since the boundaries between official and unofficial productions are often uncertain, and the machinery governing the issue of material of all kinds is highly complex – even assuming that it is documented, and such documentation available – it is also necessary to summarise the official constraints under which writers and artists operated, as far as we may now ascertain them, before anything like a clear picture may emerge. A summary of both the material and the controls upon it is thus needed before the detailed discussion of the individual facets of the war in 1916 which follows. It may most conveniently begin by considering the changing fortunes of the press reporters in the field during the first years of the war.

On the outbreak of war many correspondents went to France without official aid or blessing, to report whatever they could of the war's progress. In the first days they attended briefings at the War Office in Paris, but these were so insubstantial that many decided to see things for themselves. They encountered open hostility from the authorities, and Richard Davis, correspondent of the American Wheeler Syndicate and the London *Daily Chronicle*, well summarises the military attitude in saying that the correspondent was 'as popular as a floating mine, as welcome as the man dropping bombs from an air-ship.[1] Philip Gibbs, sent out by the *Daily Chronicle*, records[2] independent forays he made along with Massey of the *Daily Telegraph* and Tomlinson of the *Daily News*, sending back their reports by obliging King's Messengers or even honest-looking strangers returning on the leave boat. These led to his arrest at Le Havre in the war's earliest months. Illustrators working for the glossy weeklies made similar trips, and endured the same official

wrath. Julius Price, artist-correspondent of the *Illustrated London News* and the *Evening News*, teamed up with Seppings Wright and Frederic Villiers. Price constantly experienced the authorities' determination that the correspondent 'should see as little as possible of what was going on':[3] whenever he was seen sketching, he was promptly arrested. Basil Clarke was another victim of official wrath, and his persistent efforts to report what was actually happening in the war zone led to his being 'hunted down and expelled'.[4]

'Those attempting to obtain war news from official sources in London met with similar difficulties. The Defence of the Realm Act gave parliament the power to close down any paper publishing unsuitable or classified information and, though the power was rarely used, it was a constant threat over the editors' heads. The release of information was handled by a Press Bureau, set up on 7 August 1914 in a small, shabby building in Charing Cross Road.[5] Under the direction of F. E. Smith, a team of naval and military censors released edited information from the war zones in a form approved for publication. Since its largest interest was apparently the concealment of information, it immediately became known as the 'Sup-Press Bureau'. In September a move to larger premises – the Royal United Services Institution – aided the Bureau's efficiency, but its attitude remained unaltered: in official circles the press seemed to be thought of as a useful medium in which to make announcements or stimulate recruiting, but one which should be given no freedom for factual reporting, let alone interpretation or comment, of its own. Published information consisted largely of official dispatches – those of Sir John French being 'models of hard fact and plain statement'[6] but few in number – and reports from the official 'Eye-Witness', Sir Ernest Swinton, which were heavily censored, unfailingly optimistic, and generally lacking in any sense of the atmosphere of the war. That they were seen as an important record of events in the official mind, as well as a way of boosting morale at home, is shown by their publication in two volumes during the first years of the war.[7]

When the great propaganda value of Churchill's dispatches from the South African battlefields is considered, it may seem strange that the power of the press was not utilised more effectively, or that greater freedom was not allowed in the early stages of the war. But the military mind is always mistrustful of the press in principle and uncertain of its handling in practice, as the more recent experience in the South Atlantic has made clear. As the war progressed, though, it became apparent that a change of attitude was essential if anything like the willing co-operation of the press was to be achieved. A catalyst in this was F. E. Smith's

treatment of a dispatch from Arthur Moore of *The Times* dealing with the fighting at Amiens. Instead of censoring the report, Smith added more explicit comments of his own about the seriousness of the English position in France and the need for more men, before passing it for publication.[8] Shortly afterwards he resigned, to be replaced by Sir Stanley Buckmaster who, in response to the growing demand, appointed the experienced journalist and editor Sir Edward Cook[9] as an assistant director, so that at last there was someone on the Bureau's staff who understood the needs of the reporters and editors. In May 1915, Cook became co-director with his former partner as assistant director, Sir Frank Swettenham, an ex-colonial civil servant, and under their joint direction the Bureau at last began to attract less virulent attacks from the Fleet Street editors for its dogmatic and insensitive attitude.

Changes at home were matched by changes in France. Early in 1915 Philip Gibbs's book *The Soul of the War* appeared, 'having by some miracle passed the censor or slipped by him'.[10] It revealed to many for the first time some measure of the extent and nature of the British and French losses in the retreat from Mons. In the spring, the first accredited correspondents were appointed. Gibbs represented the *Daily Chronicle*, Tomlinson and Perry Robinson wrote in alternation for *The Times*, Battersby for *The Morning Post*, and Percival Phillips the *Daily Express*. Later they were joined by others, including Beach Thomas, reviled by the fighting men for his simplistic jingoism in the *Daily Mail*. Three official censors were appointed and the correspondents, in uniforms without badges of rank but with green brassards, were accompanied everywhere in the field by Press Officers. The correspondents shared the information they had gathered, a circumstance which sometimes gives the reader today the impression that they were simply being fed with official information. It is difficult to assess the degree to which censorship impinged on their writing, despite claims by Gibbs and others that they were not 'spoon fed'.[11] But, as will emerge in later chapters, there was often a striking similarity, not only of content and attitude, but also of language and imagery, in what they wrote. Certainly there were constraints on what they were allowed to report: the preparations for the Somme offensive and the mechanical details of the first tanks are two examples of such restricted areas which will be discussed in more depth in later chapters. What seems most likely, however, is that they were told what they could not say and left to work out for themselves how to fill the gaps left by censored material. It is probably this, and the sheer circumstance of a group of like-minded people living and working in close proximity, that accounts for the similarities in many of their reports.

In January 1916, MI7 took control of censorship of the press – and of film material – as well as organising various aspects of the collection and release of information. But though controls remained strict until the end of the war, the general attitude towards those whom Haig had disparagingly dismissed as 'writing fellows'[12] began to move towards greater tolerance. Haig himself, after his initial scorn, came to see the value of an efficient press corps and, at the end of the war, standing on the Hohenzollern Bridge over the Rhine, thanked them for their service and awarded them his accolade in words which are revealing about his social, as well as his military and personal, scheme of values: 'Gentlemen you have behaved like men.'[13]

As well as reporting the events of the war, the press – especially the popular press – must also be considered to have influenced it. Northcliffe's campaign in *The Times* and *Daily Mail* after the setback at Neuve Chapelle did much to hasten the fall of Asquith's Liberal administration and the creation of the Ministry of Munitions to remedy the 'shells scandal' in the spring of 1915. Campaigns in the popular press were not, of course, a new phenomenon in 1914, and they should not be regarded as peculiar to the war years: but they are significant in revealing another function of the press in channelling anger towards Whitehall during moments of uncertainty in the war when policy seemed to lack direction.

By the beginning of 1916, then, the principles under which the press reported the war had evolved into a system which could be said to function with some efficiency and tolerance in coverage of fact and presentation of opinion. There were still areas of discontent, and editors still attacked restrictions which they considered unfair; but it is clear that the authorities had become aware of the place of the press in the prosecution of the war and were providing something approaching adequate facilities for them. The machinery was more efficient in the treatment of the Western Front than of other areas, and the Admiralty still showed little grasp of the needs of press or public, as their treatment of the Jutland engagement makes clear. But the various systems of releasing information did at least exist, and they allow us to examine the nature of the role of the press in revealing and directing stances towards the conflict in a way that is not possible in the early years of the war.

Although the daily and Sunday newspapers fulfilled the function of conveying the initial statements about the main events of the war, and the first responses to them, journalism of other kinds was also of much significance in providing treatments of a more reflective or interpretational sort – the 'features' or background articles with which today's press now complement the initial news coverage provided by television.

These are important in revealing opinions and stances but, since weekly magazines tend in most cases to have smaller circulations and more specialised approaches than national dailies, they must be approached with more caution in seeking to find evidence of widespread feelings or attitudes. Some remain representative, though: in its cartoons and articles, *Punch* is typical of a response to the war which goes further than the clubland middle classes with which it is usually associated, and even journals such as *The Bystander* often share the attitudes of mass-circulation papers.

More representative of popular attitudes, however, is the genre constituted of the new popular histories of the war which began to appear shortly after its outset and continued to its conclusion. The mere fact that they remained in production throughout the war indicates that their views were concordant with those of their readers since, even today, publication of extensive part-works is a risky undertaking. The magazines vary both in intended readership and quality of production. *The War Budget,* for example, appealed very much to the popular market, of the kind exploited before the war by Newnes and Harmsworth in their cheap, large-circulation magazines. Similar in nature are J. A. Hammerton's *The War Illustrated* and *T. P.'s Journal of the Great War,* the latter edited by T. P. O'Connor and published from the offices of *The Daily Telegraph* – though these tended to adopt a more serious, less sensational approach.

They were later joined by more scholarly accounts. Newnes's *The War of the Nations* was edited by William Le Queux (vol. 1) and Edgar Wallace (vols 2–11). The Amalgamated Press produced *The Great War,* edited by H. W. Wilson and J. A. Hammerton, which offered a different approach. Whereas the others dealt with the events of each week of the war, it concentrated on a single aspect of the fighting for each issue, such as individual engagements, the role of various regiments, the role of women in war, and so on. *The Times History of the War* is the most reliable and authoritative, appearing in annual volumes and dealing with campaigns on the various fronts in retrospect. For both these reasons, it is of less interest than the truly contemporary histories, but it does provide some index of the changing feeling about the war's earlier events while the conflict was still continuing.

All of these offer striking insights into contemporary stances to the war, *The War Budget* being of especial value, for example, in chronicling responses to the Zeppelin raids of summer and autumn 1916, since it is aimed at a largely working-class audience who were beginning to experience the war at first hand with the raids on London. Yet their value lies

as much in the visual material which they contain as in their articles; and the range of visual material created as a record of the war is another important area for our consideration.

As already mentioned, the illustrated papers quickly sent artists to France, although official opposition to them was if anything greater than that encountered by writers. Such sketches as were returned to London had to be re-worked by staff artists to make them acceptable for the censors. The *Illustrated London News*, for example, employed Frederic Villiers in France and Frederic de Haenen in London to provide this balance of accuracy and acceptability. Often staff artists in London produced illustrations 'from information received' or 'from information supplied by an eye-witness'. Such illustrations were often reproduced in several journals in England. In addition to its own drawings, which tended towards the more sensational aspects of the fighting, *The War Budget* contained plates from the *Illustrated London News*. The latter's illustrations also appeared in the *Illustrated War News*, the *ILN's* weekly record of the war intended for circulation in English-speaking countries abroad, and also in the official *War Pictorial*. In addition, many of the drawings from *The Sphere* and *The Graphic* were reproduced in books or magazines, or produced as picture postcards and sold widely at home and in France. This is important in showing that illustrations appearing in what would, in peace-time, be magazines with a limited, upper-middle-class readership, achieved far wider currency in war. From this it follows that their influence in the public's perceptions of the war was considerable, and they thus deserve more scrutiny than might otherwise be the case.

Drawings of this kind are complemented by photographs. The first cameramen to visit the various fronts were treated with the same disdain as reporters and illustrators but, in the 1915 reorganisation, official photographers were appointed, and a steady flow of 'official photographs' appeared in the papers and magazines from then on.[14] The Imperial War Museum holds roughly a quarter of a million photographs, many familiar from reproduction in subsequent books and television productions, but others offering powerfully fresh views of all areas of the war. To them must be added the products of the Canadian War Records Office, taken under a scheme begun by Beaverbrook in 1915, and those of freelance photographers such as H. J. Mortimer, whose prints are a strange combination of Victorian salon plate in their meticulous organisation and powerful emotional statements about the war in the subjects they record.[15] By 1916 the production and circulation of official photographs was an established procedure, so that the subjects selected

represent an important record of those aspects of the war the authorities wished the public to be aware of – a selectivity which, as will emerge later, had considerable effects in influencing the precise area in which public interest was directed. Yet photographs did not replace drawings or 'artists' impressions' in the popular magazines: instead, the two continued to work in tandem throughout the remaining years of the war. Sometimes drawings were used when photographs were not available, but more often both were used together. This is simply because, although a photograph can never be entirely free from subjective elements of interpretation, a drawing offers far more scope for creating an attitude towards the scene it depicts, by selecting or re-ordering the elements of the composition, by altering groupings or by making subtle changes of perspective and proportion. For this reason, the pairings of photograph and drawing which appear frequently are of much value in revealing attitudes and approaches towards the subjects they deal with.

Although the Press Bureau exerted much influence over the day-to-day presentation of events in print, the over-all influence of the various successive propaganda organisations was far greater.[16] At first, propaganda was given little priority. In September 1914 C. F. G. Masterman was asked to form a propaganda department at the headquarters of the National Insurance Commission, of which he was chairman. The department was run in secrecy and known only by the name of the building it occupied – Wellington House. The great bulk of its work was at first concerned with overseas opinion, particularly in North America. From the outset Masterman insisted on using only material that was factually accurate, and worked largely by commissioning writers to produce books and pamphlets which were then issued by commercial publishers and sent to prominent individuals abroad, in the hope of influencing their opinions in Great Britain's favour. In this sense it was a restrained, gentlemanly approach to an activity more generally carried on by underhand methods.[17] Many well-known writers produced material for Masterman, among them John Masefield, Hilaire Belloc, Alfred Noyes, Anthony Hope, and respected academic figures such as Charles Trevelyan, Bertrand Russell and Arnold Toynbee. Masterman's first report, in June 1915, recorded the distribution throughout the world of 2½ million copies of books, pamphlets and reprints of political speeches, in 17 languages, since the start of the war.[18] The second, in December 1916, gave the figure of 7 million.[19]

In January 1916, Lord Newton was made director, his full-time staff now including Alfred Noyes and John Buchan. While employed by Wellington House, Buchan was given access to the preparations for the

Somme attack, the result of which was *The Battle of the Somme: First Phase*. This achieved wide sales in this country when it was published by Nelson in November 1916 – a remarkably rapid accomplishment, especially since it was illustrated with stills from the Somme film which was not available until late in August. With other books it is difficult to assess the degree of involvement of Wellington House, though it seems clear that many volumes were produced with its aid, certainly in the provision of facilities for visits to the front and other war zones. Books such as *England's Effort*[20] by the popular novelist Mrs Humphry Ward seem most likely to have been written in this way, with Masterman providing the facilities needed for research and then arranging publication with a commercial organisation to avoid the charge of propaganda being laid at the volume when it appeared. Such procedures marked the extension of activities into the area of domestic propaganda to a greater extent than hitherto, and were also significant in establishing the concept of publishing books written in a direct, popular style which described serious issues and were intended to increase awareness and stimulate discussion amongst the people. This was an important precedent, later to be developed in the booklets published by the Ministry of Information during the Second World War[21] and the *Penguin Specials* of the 1930s and 1940s.

Wellington House was also concerned with the distribution of visual material. By 1916 1000 photographs were being despatched each week: next year the figure was 1900. Early in 1916 a pictorial propaganda department was set up under Ivor Nicholson.[22] It produced an illustrated paper, *War Pictorial*, in ten languages for world distribution, and four other picture magazines aimed at readers in Latin America, Portugal, Greece, Arabia, and later China, Japan and the Indian sub-continent.[23] The importance of these ventures is considerable, since they reveal an awareness of the great value of visual material in propaganda, especially in the recognition of the role of the artist this contains, as from the need for more visual material grew the essential framework for the employment of official war artists. The *War Pictorial*, though, is of major significance for the present purposes because it contained many illustrations taken from the London glossies, revealing them once more as statements of establishment attitudes towards specific aspects of the war, since clearly they would not have been used had they reflected any other stance. Posters, postcards and 'cigarette stiffeners' were also produced by the pictorial department of Wellington House, again using visual material familiar from its appearance in the London Magazines.

What has come to be known as the official war artists' scheme was in

fact a far less formal arrangement. Its germ lay in a letter from the literary agent and Wellington House adviser A. S. Watt, to Ernest Gowers, also on Masterman's staff, suggesting the employment of Muirhead Bone to produce lithographs of the war's main theatres and events.[24] Bone was appointed in July 1916 and given the rank of Second Lieutenant. A condition of his appointment was that all his drawings should be the copyright of the War Office.[25] Bone was sent to the western front on a six-month contract in August 1916. The resultant drawings appeared in *The Western Front*, a two-volume work issued in ten monthly parts in 1917, published 'on the authority of the War Office from the offices of *Country Life Ltd.*'. Each volume was prefaced by a note from Haig – an indication of how far his attitude had changed since his early scepticism about the value of press correspondents. Bone's drawings are restrained, if not tame, in character, and well fit the official aim of providing an impartial record of the events of the time; but the fact that the volumes of repro-ductions sold badly[26] perhaps indicates that the public wanted more than simple factual reportage in visual depictions of the war, preferring the greater measure of interpretation found in the popular artists' impres-sions. At the end of 1916 Eric Kennington replaced Bone at the front, and Francis Dodd was commissioned to paint a series of portraits of admirals and generals. As yet the choice of artists for official employment had been conservative, but in the next year more experimental figures, in particular John and Paul Nash, Nevinson, Lamb, Roberts and Spencer, were to be given commissions. [27] These developments do not properly concern us here, but they do serve to suggest the changing temper of the later years of the war, in which not only were more avant-garde artists employed officially, but those artists also began to go against official attitudes by adopting a more cynical stance towards the war and the system of values it aimed to perpetuate.

As well as the use of artists to record the war, Masterman was also responsible for the production of a series of official films, feeling strongly that British footage should be produced for screening in neutral countries where German material was already being shown. The novelty and immediacy of the form, coupled with the fact that, apart from titles, no translation was needed, made the film an ideal medium for inter-national propaganda. The first official film was produced in 1915, and showed the enlistment, training and review of the army, and concluded with an account of life aboard HMS *Queen Elizabeth*.[28] It was shown in Switzerland, Russia and the USA after its English première in December 1915, and was received with much enthusiasm despite the fact that the

naval sequences were cut when the *Queen Elizabeth* sank after striking a mine. Following its success, two official 'War Office Kinematographers', Geoffrey Malins and J. B. MacDowell,[29] were appointed, and in 1916 the War Office Cinematograph Committee was set up, chaired by Beaverbrook. This took charge of production and distribution, and in 1916 the first full-length account of the fighting and conditions at the front, *The Battle of the Somme*, was produced. Lasting some 80 minutes, it provides a record of preparations for the battle, the bombardment, scenes purporting to show the attack itself, and the aftermath. It is easy with hindsight to criticise the rudimentary technique of the film; we must remember, though, that seeing the troops in the line was an extraordinary experience for those at home, and for many it was the first intimation of what conditions in France were like. It was shot early in July and screened in Britain in August, taking 2000 bookings in its first two months and raising over £30 000 for service charities. The King is reported to have declared 'the public should see these pictures',[30] and Lloyd George called it 'an epic of self-sacrifice and gallantry',[31] but some cinemas refused to show it. 'This is a place of amusement, not a chamber of horrors',[32] one proprietor declared, and according to one source, 'Those who were there remember screams from the audience'.[33] The Somme film was followed by others, dealing with war in the air,[34] the involvement of women,[35] and domestic issues such as national savings,[36] so that film rapidly became a major means of giving information and influencing opinion. The Somme film, in particular, reveals much about official attitudes, and deserves consideration in the same manner as accounts in newpapers and contemporary histories.

The various departments of Wellington House and its successors were not the only public bodies to commission work from artists and writers of all kinds during the war years. A group of writers who produced what came to be known as the 'Oxford Pamphlets' were important in influencing public opinion early in the war,[37] and many other charitable organisations fulfilled a similar role, though their functions had in the main been taken over by Wellington House in 1916. The Parliamentary Recruiting Committee was of much importance through its production of posters, leaflets and pamphlets to stimulate recruiting before the introduction of conscription. By May 1916 it had produced 164 posters, with a total print run of 12 million copies. Some were commissioned from printing firms who simply employed the artists they had used for peacetime subjects: others, like Alfred Leete's study of Kitchener, were taken over from designs which had appeared in popular magazines.[38] Some posters were

produced by other organisations, such as the National War Savings Committee, the Red Cross, and private companies including the London Underground, who commissioned a series of posters in 1916 for distribution and display in the war zones.[39]

In addition to works of this sort, there was a vast outpouring of books of all kinds about the war.[40] Some had semi-official aid, as is the case with Bruce Bairnsfather's two volumes of stories of trench life, which show the adoption of a popular writer and cartoonist for purposes of morale-boosting both at the front and at home. Accounts of battle experiences of all kinds, letters from the front, humorous anthologies and romantic war adventures are all of much importance in showing the role of popular art as a means of ordering and surviving – and in some cases temporarily escaping – the war. In performing this function, they deserve consideration more than the better-known recollections of Blunden,[41] Graves,[42] Sassoon,[43] and the rest: while these are ordered recollections full of analytical insight, the former are products of the times they describe, and thus are infinitely more suggestive in revealing the feelings of the age and the place of writing within it. Privately printed volumes of letters and diaries fall into this category most strikingly, most poignantly: Lady Marchmain's treasured volume of pieces by her dead brother in *Brideshead Revisited*[44] is a fictional example of a great number of such books, all of which have their place in the rites of passage of their authors and the psychological survival of the bereaved.

Poetry, too, was produced in great quantities,[45] ranging from individual verses appearing in newspapers and magazines, often of a highly patriotic nature, to statements of personal belief and experience. An important anthology is *The Muse in Arms*,[46] which includes poems on a wide range of themes in response to the war, from the frankly jingoistic to the deeply personal and introspective. And, of course, there are the great works of Owen,[47] Thomas,[48] Rosenberg,[49] Sassoon[50] and Blunden,[51] which have become the official voice of suffering and endurance of these years. Novels reveal a similar range of attitudes: H. G. Wells's *Mr Britling sees it Through* is a rare attempt at a philosophical analysis of the war in popular form, while John Buchan's *Greenmantle* (1916) is a spy-thriller written as a sequel to *The Thirty-Nine Steps*[52] which none the less shows a recurrent and recognisable stance to the war. Both appeared in 1916: other novels[53] of a similar diversity form an important part of the literary landscape of the year, and are equally important in the attitudes and responses to war that they reveal.

Such, then, are the major forms of war art in its widest interpretation

which present themselves for consideration and analysis. The ways in which some of them contributed to psychological survival and physical continuance in the face of key episodes of this central year of war are the subject of the chapters which follow.

3

Jutland

Although by 1916 the army had begun to allow press correspondents far greater freedom in visiting the main battle areas, and had become both more co-operative and more efficient in the official release of news, such advances had not been made by the Admiralty. The press were allowed to visit the fleet on carefully-organised tours when it was in port, and occasionally important individuals were allowed to go to sea with the fleet on manoeuvres for a short period, but there was no question of correspondents remaining aboard for a protracted term, or of reporting naval engagements at first hand. True, the land forces had had more battle experience than those at sea by this year, forcing them to take account of a vociferous press; but in many ways it is true to say that the Admiralty regarded the release of news to the press as a very low priority in time of war.

In consequence, the handling of the release of information concerning the Battle of Jutland seems to typify the official attitude towards the press during the earlier years of the war – authoritarian, aloof, and with no conception of the needs of a civilian population, to say nothing of opinion in neutral countries, in wartime. Although the practical difficulties of obtaining accurate information in the first instance were considerable – and we should do well to remember this in assessing the first bald announcements – the uncertainty of purpose and confusion of execution in the Admiralty's dispatches after Jutland show a complete lack of understanding of the public's need for accurate, reliable, and up-to-date information. As a result, the editorial responses of the press during the first impact of the battle are of great importance. The editorials written immediately after the first Admiralty dispatch show how those responsible for forming opinion suggest ways of coming to terms with what, from the Admiralty's own words, appeared to be a serious reverse, if not an outright defeat; and those written later, when the dispatches had been revealed as misleading and pessimistic, show important attitudes towards censorship and the release of information which may well have been influential in changing the way in which subsequent episodes were handled by the authorities.

The events of the battle itself have been well chronicled elsewhere,[1] and it is no part of the intention here to re-examine events or contribute further to the various controversies of tactics and strategy. It is enough to say that, on the afternoon of 31 May, the German battle-cruiser fleet under Hipper drew Beatty's similar fleet from Rosyth to within range of the *Hochseeflotte* commanded by Admiral Reinhard Scheer. The intention of this ploy was to inflict damage on the British fleet before Jellicoe's Grand Fleet could arrive from Scapa Flow to support them. However, the Admiralty had, since the beginning of the war, been able to read German wireless signals,[2] and Jellicoe was aware of the presence of Scheer and so put to sea early in support of Beatty. When the two fleets met, Beatty turned away and, in a running engagement, led the Germans towards the Grand Fleet. After an engagement lasting some five minutes, Scheer withdrew, firing torpedoes, which Jellicoe in his turn drew off to avoid. This was just after 6.00 p.m. Within the hour the two fleets engaged again but, after that, despite steaming round each other for much of the night, did not join battle again. The British losses had been greater in both men and ships, largely because of the inferior armour and fire-power of their vessels; but the Germans had broken off the encounter and sustained heavy losses. In strategic terms, the greatest significance of the battle lay in the German navy's increasing adoption of submarine warfare instead of open confrontation with the Grand Fleet.

Clearly, with what at the time could only appear an indecisive result, much was to be gained by the combatant first to produce an acceptable account of the action for circulation both among its own people and to the neutral powers. In this objective the Germans were aided by the greater proximity of the fighting to their shore, but also by the much more efficient propaganda organisation they commanded. Accordingly a communiqué appeared in Berlin on the afternoon of 1 June. It claimed that the battle had been 'successful for us',[3] and listed the British losses in detail, while making only passing mention of the cost to the German fleets. It was rapidly sent off to Washington, Berne and Madrid, to make full capital of the assumed victory at sea. In London it was received by Reuters and sent to the Admiralty for censorship before release. The chief naval censor, Sir Douglas Brownrigg, then telegraphed Jellicoe asking for details of the British losses, to supplement the limited information the Admiralty had already received from the fleet, still returning from the battle. Jellicoe's reply seemed to confirm the German claims, since it said little of enemy losses – largely because such information had not been requested and, because of the confused and broken nature of the battle, it was in any case difficult to assess fully the extent of enemy

casualties. After lengthy deliberations between Balfour, the First Lord, Admiral Sir Henry Jackson, the First Sea Lord, and Vice-Admiral Sir Henry Oliver, the Chief of Staff, an official dispatch was issued at 7.00 p.m. on Friday 2 June. It was from this that the nation first heard officially of the battle, when it appeared in the newspapers on Saturday morning.

As well as being released at a poorly-chosen time, too late for the mass-circulation evening papers, which in itself showed an ignorance of the workings of mass communications, let alone propaganda, the release was almost wholly negative in content and depressing in tone. After first stating that 'the losses were heavy'[4] it listed them in the baldest terms:

> The battle-cruisers *Queen Mary, Indefatigable, Invincible* and the cruisers *Defence* and *Black Prince* were sunk. The *Warrior* was disabled, and after being towed for some time, had to be abandoned by her crew. It is also known that the destroyers *Tipperary, Turbulent, Fortune, Sparrowhawk* and *Ardent* were lost and six others not yet accounted for.

The dispatch continued by saying that 'No British battleships or light cruisers were sunk', a statement which must have seemed close to tragic absurdity after the catalogue of destruction which had preceded it. After this it was small consolation to read that 'The enemy's losses are serious', or that 'The exact number of enemy destroyers disposed of during the action cannot be ascertained with any certainty, but it must have been large'.

In defence of the dispatch, it must be said that it did endeavour to reveal clearly and directly the full extent of British losses, doubtless from the understandable motive of wishing to quash rumours of an even greater defeat. This was certainly a considerable strength: the clear realisation of the full extent of loss is an essential stage in the psychological process of grief and renewal, as well as being a key priority in strategic planning. Yet while this was a strength appreciated and valued in the corridors of Whitehall, it could hardly be expected to appeal to a civilian population which had had little news of a positive kind since the war had begun, had been brought up since childhood to believe that Britain's security rested upon her naval might, and many of whose individual members had sons or husbands serving in the fleet. This is not to suggest that the Admiralty should have concealed the losses until further details could be obtained from Jellicoe on his return: but it is striking that Jellicoe apparently had no concern about the release of accurate infor-

mation to the public as soon as possible after the engagement. In comparison to this, the degree of co-operation shown by Haig on the Somme appears generous in high measure. What is also striking is that what has been judged by many later commentators to be the decisive element of the battle, the departure of the *Hochseeflotte* in preference to pursuing the conflict to a conclusion, was not regarded in a more positive light by the authors of the dispatch, who might after all be expected to realise the full strategic implications of any naval engagement. The dispatch was negative in its reporting of this fact, failing to seize on what was afterwards to be regarded as a very positive and encouraging outcome for the British:

> The German battle-fleet, aided by low visibility, avoided prolonged action with our main forces, and soon after these appeared on the scene the enemy returned to port, though not before receiving severe damage from our battleships.

Before the editors and leader-writers could have a chance to assimilate this statement, Jellicoe had sent further information to the Admiralty, and a second dispatch was issued at 1.05 a.m. Most of the national dailies carried this as part of their main coverage, but others, including the large-circulation *Daily Express*, were able only to shoehorn it into a 'Stop Press' or 'Late War News' column. Once more the timing of the release was unfortunate, and might have been avoided had a fuller report been available earlier from Jellicoe.

The second dispatch began by confirming that 'our total losses in destroyers amount to 8 boats in all,'[5] and went on to give some information about German losses. One 'battleship of the Kaiser class' had been blown up, and another 'believed to have been sunk'; and 'at least two more German light cruisers were seen to be disabled'. This was clear, positive news; but the dispatch contained much that was more cautious:

> Of three German battle cruisers, two of which it is believed were the *Derfflinger* and the *Lutzow*, one was blown up and another heavily engaged by our battle fleet, and was seen to be disabled and stopping, and the third was observed to be seriously damaged.

This, too, was good news, but hedged around with so many reservations – 'believed'; 'observed'; 'seen' – as seriously to reduce its impact on a public unaware of the complex and confusing nature of a large-scale naval battle, making the claims appear tentative. Finally, the last paragraph of the dispatch was couched in terms which, though asserting

strength, did little to convince the reader of the accuracy of the British guns:

> Further, repeated hits were observed on three other German battle-ships that were engaged.

Overall, then, when the news of the battle first appeared in the British press on Saturday 3 June – four days after the first stage of the encounter, and three after the triumphant announcement from Berlin – it took the form of a statement of British losses factual in content but depressing in tone, followed by a necessarily vague and cautious list of enemy casualties.

Rumours had been circulation for some days, from the reports received in neutral countries and from preparations to receive heavily damaged ships at Rosyth,[6] as well as telegrams sent by sailors confirming their safe return on the previous day, before such communications were stopped. A cursory, uninformed reading of the two official dispatches would rather confirm than deny the worst rumours for most readers: the reports came from the Admiralty itself, after all, and if their Lordships could neither assert victory nor even deny the claims of the Germans, then things must indeed be in a poor state.

In the absence of further official explanation or comment, it was left to the editorialists to make sense of the apparent gravity and confusion of the action, and to provide reassurance for the nation and suggest appropriate responses to what seemed like a serious defeat. The large-circulation dailies approached the task with a notable similarity of tone and purpose. Many leaders began with a frank acknowledgement of the seriousness of the situation. *The Times*, for example, was unequivocal:

> it is clear that we have suffered the heaviest damage at sea that we have met with during the war.

The *Daily Mail* stated baldly that 'the British navy has to mourn heavy losses', while the *Daily Express* had a more complex treatment of the same theme:

> We have always agreed that losses should be promptly published. The British people are strong enough and masculine enough to accept misfortunes without any risk of panic.

In complimenting the people on being 'strong' and 'masculine', the

writer is not simply recording the reaction to the news, but suggesting a way in which the shock could and should be borne, like a benevolent uncle praising the courage of a child recovering fron an illness. The reader is drawn to follow the lead of the writer and respond bravely, for fear of failing to display the attributes for which he or she is being praised. Thus the writer skilfully employs the supposed national virtue of steadfastness in adversity to guide and reassure the reader in a moment of crisis.

A further significant strand in these first responses is the stress laid on human suffering and loss. *The Daily Telegraph* referred to the battle's 'grievous loss of life' and said that 'this is the aspect of the action which will occasion the deepest sorrow': the *Daily Express* added 'we deeply deplore the death of so many gallant sailors'. This is an inevitable and quite proper statement of consolation, but it also had other functions. First, it encouraged sober realisation of the true loss involved in the battle, as an essential first stage in mourning; secondly, by directing attention towards personal suffering, it moved away from the idea of a national disaster of the first order and so made the apparent enormity of the news more acceptable, though still woefully severe, because it was put on a personal level. In all these ways this response was of much importance in providing support and guidance in the moment of first shock.

Most accounts go on to assess the immediate effects of the encounter on Britain's naval supremacy and thus the nation's security. *The Daily Telegraph* urged:

> The naval outlook must be studied largely. Our battle fleet has not been touched. It remains today in all its magnificent power. It is on that embodiment of might our fortunes in the last resort depend, and on that our confidence rests to-day as unfalteringly as it did a week ago.

The *Daily Express*, again guiding as well as recording, reassured its readers:

> If our losses were three times as great, and the enemy had not lost a ship, maritime superiority would still be ours. The whole thing is an unfortunate incident. Nothing more.

This runs the risk of dismissing the whole encounter too lightly, but in the context of the whole article, which stresses heavily the loss of life and

sacrifice of the fighting men, its effect was to present the action in a much longer view, where it becomes part of a crusade which will inevitably end in victory. This stance is also taken by *The Times* and the *Daily Mail*. Within the notion of eventual success, the idea of sacrifice is prominent: the men have died to ensure the freedom of the seas, as the *Daily Express* leader emphasises in its final paragraph:

> Other cruisers and other destroyers are ready to take the place of the ships that have been destroyed. Other brave men will step into the places of the splendid fellows who have died for the nation, of which in very truth they were the salt. We mourn for them in the certainty that they have not died in vain.

The *Daily Mirror* had a similar apotheosis:

> we will shrink from no sacrifice that we may be called upon to endure, now and in the future; for the maintenance of supremacy in the seas, which is not only in the fine words of the king, 'Britain's sure shield', but a living guarantee to all humanity of freedom and justice between free peoples.

In these passages is perhaps contained the most important single element of psychological survival: the idea that, whatever occurred on the night of 31 May, the nation retained its naval supremacy. This reassurance was of very great importance in guiding the public response to the battle, and reveals a subtle awareness of the importance of their own role and influence among the leader-writers.

The passage quoted from the *Daily Mirror* also moves towards another reaction typical of these first assessments: the placing of the battle within the heroic traditions of the Royal Navy. According to *The Daily Telegraph*, for example, the sailors' sacrifice was 'henceforth to be incorporated in the pages of the glorious record of British sea-power'. It was the *Daily Mirror* which adopted this stance most purposefully, though. Psychologically, it fulfils a complex but necessary group of functions. By placing the battle within the context of the heroic past it stresses continuity and permanence at a time of fear and uncertainty. Furthermore, the reference to a sacrifice for freedom implicitly assumes that freedom has been maintained, which subtly changes the outcome of the battle from defeat, at worst, or mere continuity of the *status quo ante* at best, to clear victory in the larger context. It also evokes the image of an ideal, historical Britain in whose service all can unite, and thus uses past glories

as a means of comfort in a period of present loss, encouraging the reader in the belief that this, like earlier reversals, will pass, and that ultimate victory is assured. These assumptions are implicit within the whole of the article, but most evident in this passage:

> Some of us who live in these later days may have been prone to accept the heritage of sea power as something bequeathed to us by right without a just realisation of the fact that it is a heritage which can only be maintained at the price of sacrifice such as our forefathers so gladly made to endow us with an inheritance of freedom.

The *Daily Mirror* gave further patriotic force to the idea of Britain's historical power at sea by the use of a quotation from Browning on its front page: 'Here and here did England help me; how can I help England – say?'. The same page carried a photograph of Jellicoe flanked by the names of the ships lost in the engagement, striking a mood of solemnity yet assurance that the nation will receive the news 'with a traditional calmness and steadfast resolution that are in themselves as inherent qualities of sea power as are battleships and guns', as its editorial continues in the same guiding and reassuring manner seen in the *Daily Express*. This passage brings together the ideas of national steadfastness in meeting the loss and resolution in fighting on to ensure the supremacy at sea which has traditionally been the nation's inheritance, and for which the present battle was a necessary sacrifice. In this it is a further reassurance to the public, and fulfils a significant function in assuring continuity and survival.

Taken together, these first editorials stressed that, though the losses at Jutland were serious, they will be faced with traditional stoicism, and that the encounter must be seen in a long-term context, as a sacrifice for the ultimate victory which is assured, now as in the heroic past, by the courage and strength of the navy. The suffering and loss is thus given a purpose which is of profound psychological importance: the editorials meet the losses head on, accept them, and place them in a context which uses past triumphs to ensure future secruity and, in so doing, suggest a pattern of response to the news which is far more constructive than a mere refutation of the German claims of victory would be. Writing of this kind shows no little insight into the workings of the public mind, and must at the time have constituted an important aid to survival and the continuance of normality at a time when both were under severe threat.

The initial editorial responses must also be considered in the light of the other material which appeared alongside them. In most papers this

included the two Admiralty dispatches, the text of the German report – along, in some cases, with excerpts from the *Berliner Tageblatt*[7] – and a series of eye-witness accounts, mainly from seamen aboard Danish fishing vessels. Seen against the German reports, hectoring in tone and forcefully assertive of victory, but vague about German losses, the Admiralty dispatches appear as models of restraint, reinforcing the national virtues of understatement and resolution in crisis, even allowing for their depressing tone and lack of positive detail. The excerpt from the German paper was a target for ridicule rather than a source of anger; and neutral reports spoke glowingly of the valour of the British forces and the heavy damage inflicted upon the fugitive German ships, reinforcing the ideas of sacrifice and heroism. As a single entity all these served to strengthen the reassuring effect of the editorials, so that the over-all effects of these first press reports was to present a sombre but secure sense of continuity in the face of what might have been seen, from the Admiralty dispatches alone, as a full-scale defeat.

II

When the editors and leader-writers had had time to digest the true significance of the events of 31 May, they began to be aware of the discrepancy between the first Admiralty dispatch and the larger picture revealed by the eye-witness reports and the second dispatch. The development of a larger awareness of the true effects of the battle along the lines of the later reports became a primary concern for those writing editorial comments on Saturday afternoon and Sunday morning, fulfilling the important role of reassuring the readers that the result of the encounter was nothing like as grave as had at first been suggested. At the same time, the first notes of anger and impatience at the way in which the Admiralty had handled the reporting of the battle began to be heard. The *Evening News* of Saturday afternoon is typical in the way in which it contained both these elements, devoting most space to the task of finding the larger truth of the incident after briefly attacking the Admiralty's clumsiness and delay.

> If we supplement the bald and too long delayed British Admiralty despatches by the stories of eye-witnesses on neutral and British merchant vessels we find that the battle took place in close proximity to German waters and their minefields, that the action opened with an attack by a small British force on a large German one, and that the

former was very severely mauled owing to the superior gun-power of the enemy before the British Dreadnoughts arrived. When our Dreadnoughts did appear the enemy sought safety in flight.

Clearly, reassurance was the main intention here: the attitude seems to be that the public must first be shown that the battle was not nearly as disastrous as had been suggested by the Admiralty, and when this had been done the authors of the first dispatch could be attacked. The rapid dismissal of the 'bald and too long delayed' dispatch suggests that this official ineptitude can be left aside for the moment in the effort to reassure the reader: it is a responsible attitude, and one which is shared by many of the papers on Sunday. Some, like the *Sunday Pictorial*, were content to do no more than stress that the battle was not the reversal it was at first reported to have been. It asserted that 'Wednesday was not "The Day". It was – Wednesday', and took refuge, like so many other reports and comments, in the longer view of Britain's traditional naval supremacy, that 'The trident remains in British hands'. An article by Horatio Bottomley takes a similar view, but is also critical of the release of the information, asking 'Had no wireless message reached the Admiralty, even by Thursday?'

The Observer offered commonsense reasoning about how the public should judge the battle. Because all British naval actions must be regarded in the traditions of Hawke and Nelson, traditions 'of shattering and decisive victory', we must not engage in petty arguments with the German reports or construct balance-sheets of comparative losses, but instead seek to redress the position by planning greater naval victories for the future. In its statement of Britain's continued supremacy, this article represents an approach common to all the Sunday papers, but it is also of interest because it reveals a clear realisation of its own importance – and, by extension, that of all such editorials – in guiding public response. This it does after the reference to the assertion of tradition, before moving on to talk of future actions, where these words occur:

So much for asserting our national tradition and restoring the public sense of proportion.

This is the first and clearest overt mention of the role of the press in guiding reactions to the battle, yet it seems to speak for all the early editorialists in its desire to set the first dispatch in a larger and more positive context and thus forestall depression and despair.

The importance of taking a larger view of the events had also been realised by the Admiralty. Late on Saturday night the Press Bureau had

issued an 'Official Statement' written by Winston Churchill, to whom the full texts of the various telegrams and reports received from Jellicoe had been made available, in the attempt to make clear the full significance of the encounter after the somewhat contradictory early reports and dispatches. In many ways this was an excellent idea. The Sunday papers had a larger circulation than the dailies, and thus the article would reach a large readership; and, in the nature of things, people had longer to consider and digest what they read on Sundays. In Mr Churchill, still out of office and out of favour after Gallipoli, the Admiralty had chosen someone who could hardly be accused of willingly concealing the blunders of his political confederates, but who at the same time had a great deal of successful experience as a war correspondent. These factors made Churchill appear an ideal choice as the writer of the statement; but the Admiralty had failed to consider the mistrust with which he was still held by the public after the Dardanelles failure, and also completely overlooked the possibility that the public might prefer an explanation from those responsible for the initial dispatches as to why their tone was so depressing and their content misleading. Both these factors demonstrate how little Whitehall was aware of the public temper. It was an ignorance which, as will be shown, was to call down further anger and resentment upon their Lordships' heads.

Churchill's statement asserted briefly that, though the *Queen Mary* had been lost, a German vessel of comparable size had also been sunk; that the loss of two 'vessels of the second order',[8] the *Invincible* and *Indefatigable*, was only slightly greater than the German loss of 'A dreadnought battleship of the Westfalen type'; and that losses in armoured cruisers and destroyers were 'about equal'. It went on to stress that 'Our margin of superiority is in no way impaired', and that the 'persevering efforts of our brilliant commanders' had been frustrated only by 'the hazy weather, the fall of night and the retreat of the enemy'. The statement ended with an expression of sympathy to the bereaved, and an assurance that the battle would 'more and more be found to be a definite step towards the attainment of complete victory'.

This account of the action, and the comparison of losses carried alongside it in the Sunday papers, was hard to reconcile with the sparse, depressing news of Saturday morning. Instead of the severe reversal suggested in the first dispatch, the Admiralty was now claiming it as 'a step towards victory' in which the enemy had sustained 'grievous' losses. Reaction was swift and strong. *The Sunday Times* railed against the Admiralty, who had 'fallen miserably into their old policy of belated, indefinite and insufficient news' in reports which were 'not only meagre

but misleading' and in which 'the details everybody was looking for, and had a right to expect, were withheld'. *The Observer* called the dispatches 'tardy and unsatisfying', and thought that 'it ought to have been possible by now to throw more light on the origin of this extraordinary struggle and to make an authoritative statement to the nation in reply to German claims'. Much anger was also directed against the choice of Churchill to provide the statement. *The Sunday Times* raged:

> What in the name of all that is wonderful we are to infer from this display of enterprise rather baffles us . . . Such a display of feebleness and futility does the authorities no credit and serves only to render Mr Churchill ridiculous . . . the country will not be content to be fobbed off by an ex-First Lord while men like Admiral Jellicoe and Admiral Beatty still have power to hold a pen.

Similar invective was to appear in Monday's papers: once again, the Admiralty had shown a complete lack of awareness of public mood and public need. It was an account of the fighting by those involved in it which was required, certainly not one by a politician still held in contempt, however unfairly, as the progenitor of a campaign which had resulted in untold misery and suffering in the spring of 1915. The Admiralty had failed to realise what was quite clear to the press: that a public accustomed to seeing dispatches signed by the military leaders in France was quite unwilling to accept reports written by faceless men in Whitehall, since this gave an impression of concealment and subterfuge, instead of blunt, soliderly directness.

Late on Saturday night another dispatch was issued by the Admiralty. It appeared in Monday's papers, and gave the enemy losses as 18 ships in comparison to 14 British, and concluded firmly:

> the Admiralty entertain no doubt that the German losses are heavier than the British – not merely relatively to the strength of the two fleets, but absolutely.[9]

This simply increased the anger at the way in which the original release of the news had been handled. The *Daily Express* directly attributed the widespread 'misgiving' after the battle to the 'unintelligent brevity of the Admiralty reports', and claimed that there was 'a right way and a wrong way of telling the truth'. The *Daily Mirror* commented on the 'bald statement of our great losses' and speculated whether it were possible that 'the action and its result represent a false strategical move'.

It went on to criticise the lack of airships as an aid to naval observation, and the way in which Jellicoe had been 'hampered by Whitehall' in the handling of the naval blockade of Germany. *The Times* found the first dispatch 'unduly depressing' and unbalanced in giving only British losses, but accepted the 'frankness and honesty' this represented. It continued to ask whether the use of Churchill to write Sunday's 'appreciation' was not 'the most amazing confession of weakness on the part of the Admiralty'. Of the third, and more optimistic, dispatch, it was wary, and concluded with a plea for accurate information from the man most intimately involved:

> We trust it may be so, but there are signs of a certain official anxiety to counteract the supposed effects of their first blunt announcement. We look forward to SIR JOHN JELLICOE'S full dispatch'.

The *Evening News*, however, was the most vociferous and prolonged campaigner against the first dispatch. It began on Monday 5 June by judging the 'whole tone of the message . . . depressing and apologetic'; it was an example of 'official blundering'; to the question 'Who wrote it?' the answer 'one of those civilian amateurs' was given; and it concluded that 'The navy has done splendidly, and the politicians have hopelessly let it down'. On the following day, it carried a leader headed 'Who is the idiot?'. It asked if 'the idiot who wrote the first Admiralty dispatch is still drawing the nation's pay', and claimed that its 'deplorable general tone' showed that its author 'had not even begun to understand the elements of his business'.

On 7 June Balfour addressed a meeting of the Imperial Council of Commerce. He defended the decision to issue the first dispatch before full details of the battle were available, claiming that it would have been unthinkable to trouble Jellicoe for further information whilst he was returning from the engagement and 'the strain can never have been for one moment relaxed'.[10] The *Evening News* commented next day that 'there is something quite disarming in his innocent surprise at the effect which that document the first dispatch produced'. On 15 June, having just received newspapers from New York in which the German claims about the battle were recorded, the paper renewed its campaign for the removal of 'this Dismal Jemmy' from his position. It described a cartoon which had appeared in the *New York World*, a paper usually friendly to the allied cause, in which the British Lion emerged from the sea 'with a black eye and a can tied to its tail'. It then went on to quote from the same paper and give its judgement on what it showed about the effect of the German propaganda advantage in neutral countries:

'In spite of conflicting reports from Berlin and London and a common
suppression of details of the battle, it is plain that the British Fleet was
outmanoeuvred, outshot, and outfought by its adversary'. That is
how it struck a friendly neutral after reading the Admiralty dis-
patches.

It continued to state its objections in more reasoned terms. They reveal
beneath the invective a genuine understanding of the value of careful,
accurate and prompt information for the public:

> The real trouble is the apparent lack at the Admiralty of an official who
> is able to give the public news in a form which it is able to grasp. The
> question is one of sheer clumsiness of diction, but we have a right to
> expect something better than clumsiness.

It then suggested that the Admiralty follow the German example and

> employ the services of a skilled and experienced journalist whose
> business it is to understand and appreciate varying forms of publicity.
> But throughout this war the Admiralty have greatly under-rated the
> importance of publicity.

The final sentence of the editorial asks pertinently: 'When will the
Government learn the supreme importance of the right handling of
publicity?'.

Although the *Evening News* was more extreme in its campaign against
the dispatches and their writer, it is also representative of opinions voiced
in other papers and also of a widespread feeling that the public had been
woefully and dangerously misled. Its strictures against the government
show a secure grasp of the importance of quick, accurate press releases
emanating from the source of action, not only to gain support in neutral
countries, but also to reassure the public and keep rumour at bay. The
outcry against the anonymous writer of the dispatches did, however,
have one more important function: the cathartic release of emotion held
back under the strain of an apparent national defeat. The public was
asked to bear the reverse stoically: with the aid of the press, it did so,
controlling its dismay and fear. When it learned that the reverse was in
fact closer to a victory, these emotions turned to anger: the anger needed
a target, which the press quickly found in the Admiralty. In directing
this anger at official quarters, the papers performed another psychologic-
al function of the utmost value, in allowing national feeling to be express-

ed rapidly and violently in a direction where it could do little harm and possibly some good. Mere hate against the enemy would achieve little, and doubt in the abilities of the services would be deeply damaging, and in any case was not felt by most people, since the navy had fought courageously. Anger against a government apparently careless of public opinion might well lead to improvements in the situation. Seen thus, the diversion of the storm onto the officials of Whitehall was an achievement of much value, in providing an outlet for emotion held in check, not only during the Jutland affair, but for a long period of inactivity in the war and inefficiency in official reporting.

By the time the anger had died down, other means of treating the Jutland encounter had been found. On 10 June the Summer Number of *The Graphic* appeared, with a four-page supplement of illustrations and a pictorial map. *The Sphere* carried similar material in the ensuing weeks, and many of the illustrations were reprinted in more popular journals, thus reaching a wider readership. Depictions of 'A German battleship sinking',[11] 'The Gallant "Onslow" '[12] attacking the German battle-cruisers though crippled, and 'The Destroyer *Ardent* torpedoing a German battleship'[13] continued to appear well into the autumn. The *Daily Chronicle* issued a *Souvenir of the Great Naval Battle*, which contained a list of 'North Sea Heroes who gave their lives for freedom' and asserted 'Long shall the tale be told of the heroism that day. It shall shine brilliantly in the company of the brightest events in Naval History.'[14] Thus the event began to be seen as a national heroic myth. Beatty began to be hailed as the true hero, the gallant underdog who had engaged the full might of the *Hochseeflotte*, though hopelessly outgunned, until Jellicoe at last appeared. Always more popular than Jellicoe because of his forthright manner, Beatty was seen as the essential British hero, and the Beatty v. Jellicoe controversy dragged on for many years, colouring the official history and later books about the battle.[15]

On 6 July the full reports of Jellicoe and Beatty, together with an 'appreciation' by Julian Corbett, appeared in the *London Gazette*, to be reprinted soon afterwards in the national papers. It seemed that the full facts were at last beginning to emerge, though the uncertainties were to continue for some years, and many still felt that the first dispatch had been written to conceal an Admiralty blunder of tactics severe in nature and implications.

The press coverage of Jutland is important because it demonstrates at a simple and direct level the importance of a very practical art form in the psychological survival of the nation. The editorial treatments of the first dispatches gave readers a sense of direction, a paradigm of response to

guide them through the first shock and confusion of what seemed to be a serious reversal. In its outcry against the Admiralty, the press channelled off the public emotion, providing a catharsis of much psychological value. This release accomplished, the nation could return to the battle and see it in mythic terms, as another episode in the glorious history of the sea-girt isle. Only at such a stage in the war could the press fulfil such a function in such a way; with long experience in reporting restrictions, the papers knew how far they could go in criticising the action of the Admiralty without incurring either official censure, or the anger of their readers, as had happened during the 'shells scandal' campaign of 1915 when *The Times* and the *Daily Mail* had been burned on the floor of the Stock Exchange for having the temerity to criticise Kitchener. Later events would, in general, be handled by the authorities with greater efficiency and consideration for the public's needs – although the Admiralty never had to deal with any event of comparable nature either in scale or circumstance, and we may only conjecture how they would have been dealt with.

In the context of official mechanisms for handling the release of information, a chance juxtaposition is striking. Opposite the two Admiralty dispatches in the *Daily Mirror* of 3 June appears a report of the King's birthday honours list. Prominent in the list is the award of a baronetcy to Sir William Maxwell Aitken, M.P. who, as Lord Beaverbrook, was to become Minister of Information in 1918.

III

When Beatty's report was published early in July, one incident caught the imagination of the public as an expression of the finest traditions of bravery and steadfastness: the heroism of Boy, First Class, John Travers Cornwell. Cornwell was a sight-setter for the forward 5½″ gun of HMS *Chester*, setting the gun's range from instructions telephoned to him from the control room. Early in the engagement the ship was severely damaged, and the rest of the gun's crew were killed or badly wounded. Cornwell himself was mortally injured, but did not leave his post, remaining there throughout the action in case another crew should take over from his dead companions, and dying in Grimsby Hospital shortly after the fleet had returned to England.

In the midst of a complicated battle, the main events of which were still none too clear to those at home, this was a shining example of individual heroism in the finest British traditions, and it is therefore perhaps not

surprising that it aroused a great deal of interest. The *Daily Mirror* referred to the episode as 'what might be termed the "Epic of the Modern Casabianca" ',[16] and went on to see in it an example to uplift the boyhood of the nation:

> The example of the brave boy John Cornwell, who gave his life with such simplicity of devotion during the great Jutland battle, is being proposed now to countless little boys in Britain; and we may be sure that it will prompt them to great deeds in any similar crisis to come. They will pre-figure themselves as Casabiancas of tomorrow, standing immovable amongst the flame and roar of battle. The young hero will serve as a pattern to lift them in imagination above an existence full of common things.[17]

The reference to Casabianca is important, revealing much about the way in which the event was seen. 'Casabianca' is a poem by Felicia Dorothea Hemans which celebrates the refusal of the young Casabianca to leave his father, commander of the French ship *L'Orient*, during the Battle of the Nile, when he was mortally wounded and the ship was on fire. The poem was immensely popular with the Victorians and, though much parodied even before the First World War, it must still have had strong popular appeal if a paper such as the *Daily Mirror* could be sure that the reference would be understood by simple mention of the poem's title. The act is celebrated in the poem as one of selfless virtue, and again held up as an example, though by implication rather than overt statement:

> The boy stood on the burning deck
> Whence all but he had fled;
> The flame that lit the battle's wreck
> Shone round him o'er the dead.
>
> Yet beautiful and bright he stood,
> As born to rule the storm;
> A creature of heroic blood,
> A proud, though childlike, form[18]

The circumstances of the two deaths are similar, the main difference being that Cornwell died in his country's service instead of his father's, which served only to stress the patriotic moral more strongly. But the fact that the deed was seen in terms of the poem suggests that, almost from the outset, it was seen as an icon of heroism, a mythic story to be held up

as a moral example, rather than a real, actual event of horrific suffering. Clearly such an icon was felt – consciously or unconsciously – as something that was needed at the time: an uncomplicated act of pure heroism which could be held up to the nation's youth as an example on which they should model themselves. Other references to the Casabianca story are frequent in discussions of Cornwell but, even when they are not explicit, the approach to the story and the use made of it – a distant heroic myth as a pattern to follow – reveal a fundamentally similar approach.

Nowhere is this attitude clearer than in the popular visual representations of the Cornwell story. Many were designed specifically for adult audiences, but far more significant in terms of the attitudes they reveal, both to the legend and to the uses of visual art in wartime, are those directed primarily at an audience of children. One of the first to appear in large numbers was a print issued free with *The Boys' Friend* of 4 September 1916. Cornwell stands before the gun-turret, with spouts of water rising from the sea behind him representing the violent shell-fire of the engagement. Apart from this, though, there is little sign of the conflict: the figure is not shown as wounded in any way, nor are his dead comrades shown. The caption reads ' "The Bull-Dog Breed": John Travers Cornwell, the hero of the Navy', and this patriotic theme is echoed in an advertisement for the picture in *The Sunday Pictorial:*

> The Spirit of Old England still lives in the hearts of our lads to-day. Frame this picture as a memento of a glorious deed.[19]

It seems clear that the depiction is intended as an emblem of bravery rather than an accurate portrayal of suffering, showing its presenters' desire to re-kindle a patriotic sense in abstract rather than reveal a true picture of the suffering of the battle.

Other portrayals have a somewhat greater accuracy, but still present the event in what would now be termed a 'sanitised' form. A painting by R. James Williams, which forms the frontispiece of *The Post of Honour*, a collection of stories of bravery by Richard Wilson published in 1917, shows Cornwell at his post with the bodies of sailors before him. The gun by which he stands is wreathed in smoke, and plumes of water shoot up in the background. Yet still the figure is not shown as wounded in any way: Cornwell simply stands in a rather wooden posture holding the elevation-wheel of the gun and wearing his headphones. In all, this places far more emphasis on the idea of staying at one's post than on the physical bravery of enduring terrible wounds, and once more, despite the slightly greater realism, the impression gained is that the intention is to instil a

sense of duty without the concomitant suffering. This approach may also be seen in children's books published after the first interest had subsided. John Lea's *Brave Boys and Girls in Wartime* (1919), for example, has a crude line drawing[20] of the incident, in which Cornwell is surrounded by smoke and dying sailors, yet stands doggedly at his post. He is again shown as quite unharmed.

There are, however, more realistic interpretations. An illustration by F. Matania achieved considerable currency, appearing, amongst other publications, in *Stirring Deeds in the Great War* by Charles E. Pearce[21] (see illustration 1) and *Golden Deeds of Heroism* by G. A. Leask,[22] both popular gift-books appearing just after the war on the high-tide of mythological re-creation of its events. As before, Cornwell is shown standing next to the turret, but there are far more signs of devastation, the gun shield being pierced by shells, the deck strewn with wreckage, and sailors lying dead in the foreground. There is no smoke, and no spouts of water, however, and the mood is one of calm endurance. Cornwell stands holding the gun shield with one hand and presses the other to his side, in a stylised but very limited representation of his suffering so that, again, there is little idea of pain or anguish. The idea of an icon is plain here: that it was intended as an example is perhaps also shown by its reproduction on the cover of Pearce's book, where it is crudely blocked in the manner of the cover of a cheap edition of an Edwardian Henty. This resemblance is more than a visual one: clearly the legend of Cornwell is meant as an example and inspiration in the same way as Henty's tales of pluck and endurance were intended.

A similar purpose is clearly present in a line drawing which appeared in Herbert Strang's *The Blue Book of the War*[23] (see illustration 2). On the preceding pages a drawing of Cornwell is paired with one of no less a figure than Jellicoe himself, giving some idea of the importance with which he was regarded in such publications. The depiction of his heroic deed is important because it shows the battle scene in far greater detail than many of the illustrations so far discussed. We see the gun in profile, swathed in smoke and surrounded by wounded and dying sailors. Cornwell is shown standing to attention, despite having a heavily-bandaged head and torn tunic. Certainly this is more authentic in showing the effects of the battle, even if the head wound is more akin to a well-treated cut earned on the playing field than the scarifying wounds from shell fragments actually received by Cornwell. Yet what makes it clear that this is intended to depict the idea of duty and nothing more is the omission of the headphones. The whole purpose of Cornwell's remaining at his post was in conveying the instructions he received to the

guncrew which might appear to take over from those who had been killed: without the headphones, the deed becomes a simple legend of heroic courage, without practical purpose and remarkable purely because of the simple steadfastness and endurance it represents, and so the idea of an icon of duty is most clearly represented in this illustration.

It is to what might be seen as an unlikely source that we must turn to find a more truthful depiction of the event for young people: a colour frontispiece by Sir Robert Baden-Powell which appeared in *The Scout's Book of Heroes*, another book published in 1919. The foreground shows the bodies of sailors, and in the background one who is badly wounded is trying to raise himself from the deck. Cornwell leans against the gun shield clinging to the controls in a posture which, whilst it conceals the nature of the wounds, contrives to convey the idea of pain and suffering. That the battle is still being waged is shown by the waterspouts which have become almost an essential feature of the composition. Taken as a whole, the illustration does convey something of the anguish and suffering of the event, and this impression is strengthened by a passage from the text:

A man falls at his side, cut in pieces by the splinters of an enemy shell – dead . . . A fragment of shell rips across his body, piercing, stabbing, tearing his flesh . . . Jack Cornwell is standing all alone, with nothing to shelter him against the shot and shell, and he has been terribly wounded. Alone. Around him the dead and dying; himself torn, bleeding, very faint from pain and the horror of the sights and sound of battle. For war is very, very horrible.[24]

Given the exaggerated style, this is certainly a more accurate portrayal of the suffering and heroism of Cornwell, conveying his adherence to his scout-like duty at the same time as conveying its terrible cost: as a depiction of the scene it is rare in both aspects. For the most part, illustrations of the deed present the events with little concern for literal accuracy, showing Cornwell unwounded and stressing only his perseverance and adherence to duty. This reveals much about attitudes towards the involvement of children in the war's ideology, and the way in which visual art of a popular kind was used – presumably unconsciously – to support and disseminate them. Cornwell's bravery is held up as an example to follow, but in terms redolent of an adventure story rather than of the harrowing reality of the events. Doubtless there is no overt intention to falsify, or even to present war as glorious or painless: certainly there is no guiding propagandist hand from a government

agency keen to instil selfless devotion to the nation's cause. Instead there is an instinctive feeling that Cornwell's bravery should be presented to children in a manner which they could understand, without being too distressing, but which would present an emblem of duty and bravery in the country's service. Beneath this, of course, is the assumption that such suffering is justified because of the rightness of the cause. In all, popular art is being used to mould moral attitudes to the war in young people in a manner wholly akin to the narrative paintings of the Victorians, and in this it demonstrates another psychological function of art in war which, although best demonstrated in the treatments of John Cornwell, is by no means confined solely to his act of bravery and devotion.

Revealing as these illustrations are, however, far more important in terms of the psychological role of war art are the various paintings executed in connection with the Cornwell Fund, and their relation to the larger issues revealed by this endeavour. While the preceding paragraphs have looked at various illustrations in isolation from their larger context, it is impossible to approach these other canvases without examining the whole hero-cult of which they are a part, and a brief account of its growth is consequently necessary.

On his death Cornwell had been buried quietly in East Ham but, when the news of the manner of his death became widespread, it was announced that he would be given a public funeral, with a procession starting from East Ham Town Hall. At the funeral a national fund was announced, with the aim of endowing a naval scholarship, building cottage homes for disabled sailors, and creating a special ward for the Star and Garter hospital at Richmond. The fund was to be administered by the Navy League, and had the support of Lord Beresford, Sir John Bethell and other public figures.

Meanwhile, a suggestion had been made for a more immediate memorial, with the publication of a letter in *The Times:*

Sir,
 Don't you think it would be a good thing to get a few thousand good photographs of little Jack Cornwell and frame them quietly and hang them up in schools throughout the land?[25]

A week later, on 15 July, it was announced that the suggestion had been taken up by *The Teacher's Friend*, and at the end of the month that journal included 'a Rembrandt photogravure portrait of John Travers Cornwell'.[26]

This was a simple photographic portrait for display in classrooms to serve as a moral example. It did not show the actual deed, however, and had no connection with the fund for the Star and Garter ward. These functions were performed by another illustration which was made available by the League for 'John Cornwell Day', celebrated in September in schools in over 200 education authorities. Cornwell had been awarded the VC posthumously on 16 September, and the Cornwell Day had two purposes: to celebrate the heroism of the act as an example to future generations, and to raise money for the Star and Garter fund. It was celebrated by 'the reading of a little book, prepared by the Navy League to chronicle Cornwell's heroism',[27] and by other means, such as pupils filing past Cornwell's portrait and saluting.[28] Collections were made in part through 'the sale of stamps bearing a portrait of Cornwell'.[29]

The major incentive to fund-raising, however, was an anonymous engraving (see illustration 4) prepared by the League which would be presented to all schools subscribing £1 or more. The engraving – much reproduced in later children's books[30] – followed the pattern already described, with the familiar composition of dead and wounded sailors, bursting shells and rising spouts of water, with Cornwell standing gallantly at the gun shield. As elsewhere, there is nothing to suggest that Cornwell is wounded. There is, however, one slight difference. The illustration is much larger, clearly showing enemy ships in the distance, and the presentation of shell bursts near them as well as next to the *Chester* gives far more directly the impression of a battle being waged. In consequence there is a greater sense of adventure and involvement, and we may conjecture that this made the engraving more popular with young people towards whom it was directed, and certainly preferable to the more abstract moral icons discussed in the preceding pages. It has only a conventional representation of death and suffering, presents Cornwell as a heroic, isolated figure within an exciting battle scene, and above all lacks the arid instructional air of some of the other treatments of the theme, its caption 'Faithful unto Death' stressing bravery as much as duty. In short, it is well calculated to appeal to schoolboys raised in the tradition of Drake and Nelson, and as a consequence was very suitable for its purpose both in inculcating a sense of duty and in encouraging contributions to the Star and Garter fund.

In the latter aim it – and the associated campaigning – was successful. Over £15 000 was raised in collections in schools in the first month, given by more than four million children. The fund was kept open until Christmas, and in February 1917 £18 000 was presented to the Queen as the total of the schools' collections. The dual aim of the engraving is well

shown by *The Times*, which concluded a report of the presentation ceremony by saying that the reproductions placed in schools 'will serve to remind future generations of scholars in those schools of the lasting glory that attaches to the performance of duty'.[31]

This engraving was not the only painting to be used in such a practical manner as part of the hero-cult. A portrait[32] by M. Elwell was presented to Grimsby Hospital as a memorial by Admiral Stuart Nicholson, who suggested that a copy be placed in every school 'so that the children could keep their memory refreshed of the 16-year-old boy's heroism'.[33] More celebrated is the portrait by Frank Salisbury,[34] (see illustration 3) which had been announced as part of the fund-raising activities at the Mansion House meeting of 14 September. It was completed in March 1917, after studies executed aboard the *Chester* with Cornwell's brother acting as model. It is certainly more accurate in its representation of the event, and also more concentrated in composition: yet it is still limited in the presentation of the violence and suffering of the scene, as we might well expect. The element of moral example is still powerfully present here: of all the paintings it comes closest to the style of a Victorian genre study, and its inscription is strongly instructional: 'Thou hast set my feet in a large place' appears above part of the VC citation. At the Mansion House meeting it had been announced that reproductions in photogravure would be produced, with the cost borne by Sir William Dunne. Six thousand copies were accordingly made available in March, all proceeds going to the fund.

Of the three versions, the Salisbury and the Navy League engraving had the dual function of raising money for a memorial and acting as a moral example. It should be emphasised that this was a radically new departure for the visual arts in wartime, however strongly it rested on the earlier use of more generalised Victorian narrative paintings. It recalls most immediately the use of Socialist Realist art in the USSR in later decades, in which outstanding achievements of individual workers are depicted in schools and factories as examples to be followed by their fellows. This was certainly a striking combination of practical and moral functions of visual art in war, and to these must be added a third – that of creating a heroic myth worthy to be placed, as it frequently was, alongside those of Drake and Nelson. These functions become the more significant when it is recalled that, as far as we may ascertain, there was no official impetus behind the cult and its various manifestations, though clearly the authorities did nothing to impede its progress. In all, the paintings of Cornwell represent a group of functions of popular art of almost unparalleled significance in the moral and political climate of

1916, and show a unique further psychological use – this time largely intentional – of popular and academic art in wartime.

One further comment remains to be made about the Salisbury painting, and the moral example it was intended to represent. In his speech at the presentation of the painting, Sir Edward Carson called it a 'magnificent work of art in commemoration of the great deeds of a great hero,'[35] and stressed the high example of John Cornwell as one who stuck to his post and never grumbled. The remainder of the speech is worth quoting at length:

> I am disappointed with some of the men in our shipyards . . . who from time to time delay the repairing of our ships by strikes and other matters of that kind. I ask them to think of John Travers Cornwell. It is not a question now of capital and labour, nor is it a question of those other matters which tear us asunder in times of peace.
>
> I hope that this picture will arouse the imagination of people who refuse to get out of the old grooves . . . I feel that this boy, who died at the post of duty, sends this message through me as First Lord of the Admiralty for the moment to the people of the Empire: 'Obey your orders, cling to your post, don't grumble, stick it out'.

Not only was Cornwell's act seen as an example to young people: it was also an inspiration to idlers and strikers that they must do as they were told and do their bit without grumbling. Carson's use of the act of heroism was an understandable extension of political analogy at a time when official unhappiness at the disaffection of some quarters of the industrial population was strong. His use of the Salisbury portrait as a visual emblem of this concept is a use of painting quite without parallel in the war years and with few analogies since. It comes closest, again, to the Socialist Realist school on the one hand: yet many may find the use of this portrait, and the incident it depicts, to emblematise instructions to 'obey orders' both politically and socially disturbing. These points should not be pressed too far, as the political and moral mood of the country in 1917 was subject to all kinds of special constraints. Yet this final use of the portrait reveals much about attitudes to duty, and has an important place in the list of psychological functions – here quite intentional – performed by visual art and those who presented it as a moral example within the hero-cult of John Travers Cornwell, VC.

4
The Somme (1)

I

At about half-past seven o'clock this morning a vigorous offensive was
launched by the British Army. The front extends over about 20 miles
north of the Somme.
The assault was preceded by a terrific bombardment lasting about an
hour and a half.[1]

Thus did the public at home learn of the opening of what was to become
known, early in the fighting, as the Battle of the Somme. Historians have
seen it as senseless massacre or as costly but necessary strategy: the
opening day has been mourned as a cataclysmic loss of life or seen rather
as proof that Britain was at last fully engaged in war on the same scale as
the other major combatants.[2]

Such considerations have no immediate place in the present discus-
sion, but it is inevitable that our view of the events should be coloured by
previous judgements. To look at contemporary treatments of the early
stages of the attack, however, is to see not only how events were per-
ceived by the first chroniclers, but also how these perceptions – and the
attitudes and intentions they reveal – have determined later treatments.
A study of how the attack was treated by popular and fine art thus reveals
not only the main threads of interpretation which emerge as aids to
practical and spiritual survival, but also goes some way to explain the
polarity and depth of feeling aroused by the battle in subsequent com-
mentators.

These considerations are made all the greater by the fact that it was, in
many ways, the first attack in which full use was made of the newly-
developed publicity machine. Unprecedented facilities were provided
for the press correspondents during the opening of the battle. They were
driven to a ridge outside Albert – 'two beetroot fields on high ground'[3] –
to witness the initial assault. This was several miles from the fighting,
though, and the reporters could see little because of the heavy mist: but
they were able to see the last stages in the bombardment, a factor highly
significant in the earliest accounts of the battle, as will shortly emerge.

Official concern that reporters should witness the events was matched by a desire that official communiqués be issued at the first opportunity:

> Soon after twelve the news of it was in the *Daily Mail* office, and very soon afterwards, just as the Saturday half-holiday workers were streaming homewards, the Press Bureau, electrified at last into speedy action, were out with the official communiqué.[4]

Official awareness of public interest in the attack, and a determination – for whatever reason – to maintain it by careful nourishment, was also shown in other ways. During the barrage official photographs were taken and issued with such speed as to be available for publication in the Sunday papers, and a steady stream followed in the ensuing days. As well as showing the acceptance amongst the high command that the public must be kept informed of movements in France, they were also of importance in guiding the public's first perceptions of, and hence reactions to, the attack. In this they fulfil a significant role in moulding response according to certain patterns which, as will become clear, were of much importance to those in authority so that, as well as simply informing, these photographs have in many cases a function which is less impartial.

Photographs were complemented by moving pictures. In the first six weeks of battle, the first of the celebrated long actuality films of the war, *The Battle of the Somme*,[5] was shot by Geoffrey Malins and J. D. MacDowell. By today's standards it is simplistic and distortive, containing no real account of the actual fighting; but the mere production of a 80-minute, five-reel film at that time was both remarkable technically and a striking advance in the use of the medium for public information. That the film was shown publicly at the end of August is in itself a notable achievement in technology and distribution, and some aspects of the content of the film and the way in which it was used match this advance in terms of exploitation of such material for more pronounced, if not quite overt, political motives.

More traditional forms of treatment were not overlooked in the official desire for publicity. John Buchan's *The Battle of the Somme: First Phase*[6] provided a semi-official account by a writer of great popular appeal, based on first-hand experience of the attack. *A Visit to Three Fronts*, by Arthur Conan Doyle, also appeared soon after the battle had begun, and included accounts of the fighting and of the general condition and morale of the men. A volume of *Somme Battle Stories*,[7] 'recorded by Capt. A. J. Dawson', purported to present the experiences of wounded soldiers, told

as they left the hospital ship at Dover. The enthusiastic tone of the volume was complemented by cheerful illustrations by Bruce Bairnsfather so that, in all, it offered a morale-boosting and highly optimistic view of the offensive to set against the more analytical view of Buchan and the balanced descriptions of Conan Doyle. Between them, these three volumes covered the battle in ways calculated to appeal to a wide range of readers, demonstrating the careful operation of the unofficial propaganda organisation.

The most extensive publication of this kind was *Sir Douglas Haig's Great Push: the Battle of the Somme,* which was issued by Hutchinson in eight fortnightly parts beginning in October. It was illustrated with 700 official photographs, stills from the Somme film, and line drawings, almost all of which had appeared in the press during the earlier stages of the attack. The title page reveals that it was produced 'By arrangement with the War Office', a rare declaration of official co-operation. An early reviewer praised it highly:

> We may indeed almost say it places the reader in the position of an actual spectator of the various scenes and incidents here reproduced, so that he may be able to form some fairly adequate idea of what such a battle really is.[8]

This is a bold, and perhaps also a naïve, claim for any single volume. What is striking about the book, however, is that, in its treatment of specific aspects of the battle and in its over-all approach, it serves as a compendium of the attitudes and stances seen in the initial reports of the attack which are examined in this chapter.[9]

From even this outline, it is clear that the battle was presented to the public at home in a quite unprecedented extent, if not necessarily depth, of coverage in literary and visual treatments of all kinds. This mass of material constitutes the first, and possibly the largest, instance of the *ad hoc* propaganda machine in action, even if this has as its practical result something which is more a working consensus of opinion than a series of officially-directed stances. The recurrent themes and icons of this material reveal much about aims and assumptions amongst opinion-formers of the time, and show further psychological functions of the arts in wartime. What they do not reveal, though, is something of which we must constantly be aware when considering such treatments: that during the first day of the attack 19 000 men were killed, and the total casualties were over 57 000.[10] This is not a representative figure either of the battle or for the whole war. Early reporters were not aware of the over-all

pattern of casualties, nor is it easy to see how they might have treated the attack had they possessed such knowledge. Certainly, stress was laid in many reports on the fact that the cost of the fighting would be high. Yet, however successful the first treatments seem in offering a pattern of sensible and restrained response to the apparent advances, the attitudes they reveal in their treatment were to have important consequences in influencing the responses of those who went to the front in the year after the Somme. With hindsight, it is easy for us to see how these reports must have seemed improper travesties to the generation of Owen and Sassoon, and this is an aspect which will receive consideration later in this chapter. For the moment, however, an examination of the more immediate effects of the first treatments, and the stances they adopt for the short-term ordering and comprehension of the attack, is necessary, and this must begin with an analysis of the way in which the preparatory artillery barrage was treated.

II

During the culmination of the preliminary bombardment in the last eight days of June, 1 732 873 shells were discharged along the Somme front.[11] Totals in later barrages would be far higher; but at the time it represented a colossal figure, which marked considerable advances in the technology of industrial production and the deployment of heavy artillery, as well as signalling a new departure in strategic planning. Looking back, we may diminish the size of the onslaught or seed the strategy as misguided; but to those at home in the early summer of 1916 the scale was awe-inspiring.

It is almost inevitable, then, that the first reports of the battle itself are concerned to a very great extent with the force and extent of the bombardment. As a consequence they reveal much about the attitudes of the correspondents who witnessed the barrage, and contribute much to a view of the intellectual climate of the nation at this crucial stage of the war.

Strategically, the barrage was intended to destroy the enemy's material strength and cause a collapse of morale, so that the infantry could then make sweeping advances without encountering any serious opposition. So strongly was this belief held that, even before the attack was launched, in the days when it was a much-rumoured event, correspondents and illustrators took it as the inevitable pattern of the advance. A drawing by André Dévambez in the *Illustrated War News*[12] (see illustration 5) well demonstrates this. The text describes how the infantry will

attack in waves after 'a sustained and violent bombardment' of the enemy which will 'shatter his defences and make the way comparatively clear for advancing troops'. The illustration shows troops advancing in regular waves over clear chalk countryside completely devoid of wire entanglements and with only a small number of shell-holes in no-man's-land. The scene is shown from a high viewpoint, adding distance to the depiction in presenting the infantry as tiny, unreal figures. The whole is simply idealised in its presentation of the expected result of the bombardment and assault. Clearly, this represents the model which the high command wished the assault to follow: even before the barrage had finished some illustrators and reporters apparently found any other outcome as something beyond the bounds of possibility.

Such a view was also held by reporters just before the actual attack: the most direct example of such writing comes from the *Daily Express:*

It is the methodical destruction of the enemy's defensive works. The infantry only comes in to clean up and complete the work of the artillery.[13]

These expectations among reporters were to have serious effects on the way in which the ensuing advance was reported, as will be shown later. Meanwhile, accounts of the barrage itself report it as almost universally successful, with very few references to areas in which it had failed – of which, as was later to emerge, there were many. In the first days of the attack, however, the bombardment was hailed as a triumph of logistics and organisation in its own right. A passage in the *Daily Mirror* is typical of this response:

The concentration of artillery is literally appalling, every species of weapon, from the gigantic 15-inch howitzer to the quick-firing Stokes' trench mortar, pouring thunderous avalanches on the enemy positions . . . shell bursts often exceeded 500 in one minute.[14]

Beach Thomas, in the *Daily Mail*, referred to the 'incredible artillery fury'[15] of the final onslaught, and the *Daily Express* claimed excitedly that 'millions of shells of all sizes have been vomited out of the mouths of our guns on a front of over ninety miles during the past five days'.[16] Perry Robinson of *The Times* talked of 'an extraordinary and terrible spectacle'[17], finding that the only way to count the shell bursts was to chatter his teeth together several times a second.

This stress on the sheer scale and achievement of the bombardment in verbal reports is matched by visual emphasis provided in official photographs. Of the first batch released just after the start of the attack, the great majority are of guns firing, thus reinforcing the stress on the barrage as an achievement in itself, regardless of its effects on the enemy, seen in the correspondents' accounts. *The Sunday Pictorial* and other Sundays carried several illustrations of this kind, which showed 'British gunners ramming home the shell of a heavy gun on a railway mounting'[18] and shells with 'May it be a happy ending' and 'With best wishes' chalked on them being loaded into the guns. On the following day, the *Daily Mirror's* front page was taken up almost entirely by the 'First Official Photograph of the Preparations',[19] showing a heavy howitzer in the moment of firing. The *Daily Mail* carried all four photographs on the same day, the *Illustrated War News* had two pages of similar ones in its issue of 5 July, and a further three on 12 July, and the photographs soon became familiar from reproduction in almost every paper or journal with the facilities to print them.

As the bombardment had been under way for several days at the end of June, the release of these photographs at the start of the actual attack is no great propaganda feat, but it does show the importance attached to the bombardment as an end in itself by the military authorities, in the desire to give powerful visual emphasis to the barrage at the time the infantry attack was beginning. In this way, the idea that the real work of destroying the enemy defences had been done by the artillery, leaving the infantry only a simple task of unopposed capture, was further stressed in the public imagination. When the film of the attack appeared in August, the same stress on bombardment was apparent (see illustrations 7–9). A large proportion of the first part of its 80 minutes is given over to guns being loaded, manoeuvred and fired. Captions state that 'Hidden batteries were pounding the Germans for five days before the battle' and that 'High explosive shells from 12″ howitzers created havoc in the enemy lines'. Almost every kind of artillery is shown in the film, from 15″ howitzers, through 9.45″ howitzers firing 'flying pigs', 6″ howizers and Canadian 60-pounders to 'Plum Puddings' – spherical bombs fired from trench mortars.

The fact that all these treatments of the bombardment consider it in isolation from its tangible effects on the enemy defences shows clearly that it was regarded as being a major success in itself, independent of the destruction it was causing, and this implied stress on the triumph of organisation involved is significant, for reasons which will be returned to

later. When they are considered alongside the accounts of the effects it had on the enemy positions, which in many cases appear later, it becomes clear that the bombardment was hailed as a major success in a war which had so far offered little in the way of victory. Early accounts of the effects, both physical and psychological, of the barrage on the enemy are almost unanimous in emphasising its immense power, largely overlooking those areas where its success had been negligible or non-existent, as suggested by the models it had been expected to follow. Once again the *Daily Express* is typical of treatments of its physical effects:

> Nothing was left in front of our men but desolation. Everything had been flattened out of existence.[20]

The Times is similarly enthusiastic:

> whole reaches of the enemy's trenches have been battered out of existence; his nearer communication trenches have been obliterated . . . and almost every discoverable shelter where an enemy might hide has been searched out and pounded by our guns.[21]

Desolate trenches also figure prominently in illustrations, both official photographs and artists' impressions showing the destructive force of the bombardment. Generally these started to appear several days after the first stages of the attack. The *Illustrated War News*, for example, included in its issue of July 19 two pages of photographs of 'the devastating effects of the British bombardment' and went on to describe the visual images in words:

> Where formerly there had been orderly and well-established trenches, with solidly-built parapets and dug-outs, and protected by barbed-wire entanglements, there was nothing but a confused heap of rubble and shattered timber.[22]

The Somme film also devotes much footage to the 'Effects of shellfire, Fricourt-Mametz trenches', though notably less than it gives to the actual bombardment. Aerial views before and after the bombardment form a double-page spread in the *Illustrated War News*,[23] and countless other photographs and illustrations show the devastation, adding force to the idea of the bombardment's complete success according to the model foreseen in its planning.

Effects on German morale were also stressed in the first accounts. The *Illustrated War News* describes the enemy trenches as being 'untenable by anything alive',[24] and *The War Illustrated* also claims that 'the continuous bombardment rendered the German front line untenable'.[25] To the *Daily Express* correspondent 'it seemed hard to understand how anything in the shape of human life could survive so terrible an ordeal'.[26] Perry Robinson went further, confessing that 'it was difficult not to be sorry for the men',[27] and Philip Gibbs 'found it in my heart to pity the poor devils who were there'.[28] *The Daily Telegraph* reported that the force of the bombardment had isolated German first-line troops so that prisoners reported they had 'had no food for three days'.[29] The *Daily Express, Daily Mirror* and *Daily Mail*[30] carried similar stories, at the same time stressing the effect of the shelling and the ease with which the prisoners had been taken as a result. Once more, it would seem, the model of success predicted for the bombardment had significantly coloured the way in which its actual effects were being reported, with constant reference to the devastation of trenches and the generation of potent popular legends like the recurrent *motif* that the Germans had had no food for three days.

It is, of course easy to suggest that the writers of these first reports falsified the effects of the bombardment for reasons of simple jingoism, or because they had been fed by the Press Officers a selective account of the damage caused. Yet a deliberate falsification of this kind is unlikely to be the real motive behind such writings. It is far more likely that, in the lack of accurate over-all information in the first stages of the battle, the reporters fell back on the reports of success that they had received, and interpreted these with the understandable optimism of those who had witnessed the largest barrage ever seen, and who longed for a positive change in the war's direction as much as anyone at home in the summer of 1916. Nor should it be assumed that the correspondents dealt exclusively with the successful aspects of the barrage. That they did not is shown in some accounts. The *Daily Mail* is representative of these in stating that 'in some places the artillery failed to cut the wire',[31] and *The Times* refers to 'a sight of pure horror'[32] in the emergence of German troops from deep dug-outs to attack British troops who had passed beyond them and felt secure in their advance.

Yet references to the limited success, or even outright failure, of the barrage in some places are very few in the early reports. Even the first comment from the *Daily Mail,* quoted in the last paragraph, hurries on with 'though for the most part they made a masterly job of destroying both trench and fortifications'. We know now, of course, that this was

not true in the simple terms of the statement. As George Coppard has
pointed out,

> Any Tommy could have told them [the generals] that shell fire lifts
> wire up and drops it down, often in a worse tangle than before.[33]

Furthermore, as later historians have made clear,[34] the kind of fuses
used in the Somme barrage were not designed to destroy wire, and it was
only when the type 106 shrapnel shell was introduced in 1917 that this
method of attack was to have any significant effect upon wire entangle-
ments. The sheer weight of explosive did in many places clear the wire;
but this had the effect of causing advancing troops to bunch together in
these gaps, forming simple targets for enemy machine-gunners. A fur-
ther factor, then only dimly known to reporters at the front, was that the
German dug-outs were of such depth in many places as to be secure from
any bombardment, so that it was an easy matter for the troops to man the
guns when the barrage had finished and attack the British troops when
the latter thought they were safe, as *The Times* had reported with such
despair.

For the most part, then, these facts were overlooked by the early
writers, either through ignorance or a desire to stress the positive aspects
of the initial attack. It is likely, too, that another cause for this approach
was the perception of the bombardment as part of a strategy, and the
feeling that, as it had been so enormous, the rest of the plan of which it
was a part could not conceivably fail. It has been shown that, even before
the assault began, it was being depicted as a relatively simple matter in
which the infantry merely advanced through the shattered defences to
consolidate the gains won largely by the artillery. The barrage, with its
awesome might, could not conceivably have failed and, in consequence,
early reports showed the advance as taking place exactly according to the
model illustrated by Dévambez. A drawing by Albert Forestier in the
Illustrated London News, for example (see illustration 6), shows troops
advancing in waves over a no-man's-land wholly devoid of enemy wire,
while its caption makes a reference in trivial terms to 'the remnants
of barbed-wire entanglements which here and there had escaped destruc-
tion by the preliminary bombardment'.[35] There were places where
advances did take place under conditions of this kind,[36] but the presenta-
tion of such episodes as the normal pattern of events, rather than
one element in a highly varied over-all pattern, shows the degree of
distortion, witting or unwitting, which was common in early verbal and

visual reports of the advance as a direct result of the approach towards the bombardment taken by both military high command and press corps.

Clearly there is a strong element of wish-fulfilment here, in addition to the simple acceptance that, because the barrage was so vast, it must have been successful. So much seemed to hang on the bombardment and the attack to which it was crucial that it *must* be seen to succeed, and therefore – through the pressures of psychological necessity – it *was* seen to succeed. There is also another point of relevance here: the sheer size of the barrage meant that those who witnessed it found it almost impossible to conceive of anything surviving it, and therefore the desolation was assumed to be universal until tangible evidence was produced, at a later stage, to show that this was by no means the case. All these factors underlie, and to some degree explain, the stress on the success of the bombardment and the subsequent assault, aided in no small measure by the release of official photographs of the guns in action timed to coincide with the first reports of the attack itself, so that in this way there was a measure of official involvement, though not connivance, in this falsifica- tion. Taken together, these factors and their result provide fascinating examples of perceptions being altered by the mental needs and attitudes of the onlooker, in this case the reporters and illustrators who, like the great mass of people in Britain, were willing the attack to succeed and, once they had witnessed the first stage executed with such apparent might in the bombardment, could not conceive of failure.

Most of all, though, the treatment of the bombardment fulfilled a psychological function of much importance, as it offered simple and strong reassurance in the power of the British forces, which was so desperately needed after the confusion over the reporting of Jutland and the shock and rumour after the death of Kitchener. To these should be added the awareness of the appalling French losses at Verdun in a campaign which, though apparently successful, was sustained only at the gravest cost and which inevitably heightened the desire of the public for a strong, vigorous attack on the German forces. That, in their enthusiasm, the reporters and illustrators veered towards the assumption that the whole strategy, of which the bombardment was but one part, was as successful as the logistic feat of the barrage had been, was perhaps understandable under these circumstances, even though it contributed to misunderstanding later in the year when the offensive lost momentum. This perceptual shift, slight but real enough, is a revealing and tragic glimpse of the way in which a group of those responsible for recording the reality of war see it not as it is, but as it was planned that it should be –

as the longed-for great push. In fairness, too, it must be stressed that, after the earlier reports, more accurate accounts of the reversals in battle and the more limited advances were published.

Yet there is another reason why so much attention was directed, both officially and unofficially, to the bombardment, why it seemed to be hailed as a success in its own right, and why its only partial fulfilment of its aims was – at least at first – overlooked. This was the desire to justify the efforts of the great and rapidly-expanded body of munition-workers, whose efforts were only now being seen to bear fruit, and also to quell any possible industrial unrest in their number by stressing the immense value of their work as the basis on which the nation's war effort rested.

Relations between government and organised labour had been strained since the outbreak of war. After the first months of fighting, it had become clear that large numbers of new workers would be needed, especially in munitions and shipbuilding. In March 1915 an agreement was reached under which the unions consented to accept the dilution of labour for the duration of the war in these key areas, but many were uneasy about it. In 1915, shipbuilders on the Clyde struck in protest at the high profits made by the owners while their own wages remained unchanged, despite rampant wartime inflation. The dispute was eventually resolved, and the agreement was made legally binding in the Munitions of War Act. But soon afterwards the South Wales miners struck, and disagreements in other industries led to an Amendment Act being passed in 1916. Not all of these events had any direct bearing on the production of shells in great numbers, but they all contributed to an atmosphere of industrial unease and, to the government and the press – controlled by those not well disposed towards organised labour – they were all part of the same threat to the nation's war production. Memories of the industrial unrest prior to the war were strong. Coupled with them were recollections of the movement for women's suffrage and the feeling that, although most of the leading suffragists had thrown themselves enthusiastically into the war effort, the great numbers of women employed in munitions would be easy prey to those elements seen as subversive – the militant unionists and the militant suffragists.

Preparations for the Somme bombardment had necessitated great efforts and sacrifices from the munition-workers. Going without the Whitsun Bank Holiday was only a further step in the relinquishment of holidays and the regular working of long hours, week after week, in conditions that were often poor. Those in authority, and those responsible for influencing public opinion, were uneasily aware of these sacri-

fices; the opening of the Somme offensive, to which the munition-workers had contributed so much in material terms, was seen as an opportunity to placate and encourage them, and the whole working-class community, which was seen by those in authority with the traditional middle-class mistrust born of fundamental ignorance and misunderstanding. Any references to the success of the bombardment would emphasise the success of the workers in supporting Britain's struggle, and show that the nation was working together to ensure victory. This is not to suggest that a deliberate campaign to placate the workers was launched under official instructions: rather, it is to imply that those in authority or positions of influence, either consciously or subconsciously, saw the reporting of the bombardment as a chance to stress the involvement of the industrial community in an unprecedentedly positive way – and at the same time stress the need for continued unremitting effort amongst the munition-workers.

In this context it must be remembered that the press at this time was at best doubtful of the merits of organised labour and strongly pro-establishment – though not always pro-government – in tone. Thus, while it saw the importance of stressing the value of the contribution of the munition-workers, it approached the task with considerable unease. A passage from the *Daily Mail* of 3 July is typical in the way it makes a positive statement about the workers and then passes on hurriedly, as if anxious that too much stress would serve to emphasise the division it had intended to heal:

Now that the great enterprise has started, for which our munition-workers have toiled and our troops have watched and waited these weary months, let us try to see it in a right perspective.[37]

This stresses unity by mentioning munition-workers in the same breath as the soldiers, but shows its unease by doing so only in a subordinate clause. A similar tone is seen in a paragraph from the *Daily Express*:

Many millions more [shells] will be used up during the next few weeks. And now our munition workers at home will understand why they were asked to forgo their Whitsuntide holiday.[38]

A title from the Somme film which introduces footage of munition depots in France reinforces the idea of the involvement of munition-

workers as something almost taken for granted, but important enough to deserve mention:

> Along the entire front the Munition 'Dumps' are receiving vast supplies of Shells: Thanks to the British Munition Workers.

This might at first appear to be a passing reference of the kind noted in the press, but its significance is greater than this. The title appears early in the film – it is the fourth title of the first reel – and introduces a sequence of several minutes' length devoted to the bombardment and the kinds of guns being used, as mentioned earlier (see p. 53). Thus it acts as a caption to all these later scenes, during which each worker might identify the kind of shell he or she worked on, stressing the importance of these shells and thus of the munition-workers. This was commented on by the *Illustrated London News*, which saw the sequences as revealing 'the results of the invaluable work of the munition-makers, whose labours in the production of guns and shells in a very real sense prepared the way for the great advance'.[39] This is intended, like the passages quoted above from popular papers, to make clear to the readers – in the main not themselves industrial workers, and of a social class more accustomed to complain about the attitudes of such people than to praise their dedication – the great efforts made by munition-workers in providing the massive quantities of munitions for the attack.

This in itself is an important piece of attempted social unification, but the sequence from the film performs a more direct function – that of simply making clear to the munition-workers themselves the importance of their work. Although the reports in the daily and Sunday papers stressed the force of the bombardment, and illustrations in popular magazines showed the guns in action, the film had an infinitely greater impact because it showed the bombardment actually happening. Consequently, the catalogue of guns firing made absolutely clear to the munition-workers the place of the shells they made within the attack, enabling them to appreciate very directly their importance in the nation's struggle. That many were aware of the need to show the munition-workers how vital their work was is shown in a passage from a review of the film appearing in *The Bioscope*. The review also shows well the awareness of the role of film propaganda amongst the cinema trade, for whose members the journal was produced:

> The opportunity provided by these pictures of actually seeing the results obtained by an adequate supply of shells, the enormous wast-

age and the difficulties of transport, overcome by perfect organisation and indomitable persistency, will do more to maintain that supply than the most eloquent appeal ever delivered from a platform.[40]

Other references to the labours of the munition-workers are frequent in popular journals and papers, in both verbal and visual forms. For example, the *Daily Mirror* captions a photograph of women munition-workers with the assertion 'The women of Britain are winning the war for us at home,'[41] showing the uneasy, grateful patronage already encountered in other references. However strongly the 'us' was intended to refer to the whole nation, it is hard to avoid seeing in it a social, or even a sexual division, in which 'we' are the ones for whom 'they' – the women – are toiling in the munition-factories.

Cartoons are also of importance in revealing current attitudes towards munition-workers. One in the *Evening News* of 3 July is more successful than many treatments of the theme. It shows a man clutching a sledge-hammer to which a label inscribed 'Munition Worker' is tied, standing against a sea of shells and factory chimneys. The caption reads simply 'Mentioned in Despatches'. This avoids the charge of patronage, and succeeds in conveying praise and gratitude in an effective manner: it places the worker in a position comparable to that of a soldier in battle, who would not regard being mentioned in despatches as patronising or offensive. This asserts that the worker is just as important to the nation as the soldier – an effective way of stressing national unity. Yet at the same time it contrives to hint that, like the soldier, the worker is subject to military discipline, making a political point about the proper stance of labour in wartime. It thus continues to reveal the dual attitude to industrial workers found in almost all responses throughout the war, except for those in small-circulation labour journals – an uneasy tolerance and cameraderie born of an awareness of the country's need for industrial production of an unprecedented volume, combined with a fear that they might undermine the war effort by striking. L. Raven Hill makes a similar point in a *Punch* cartoon in which a munition-worker pushes a barrow of shells out of a factory, saying:

Well, I'm not taking a holiday myself just yet, but I'm sending these kids of mine for a little trip on the continent.[42]

This is a statement of gratitude; but it also contains a hint that the effort must be maintained, and that not only the Whitsun but also the August Bank Holiday must be sacrificed for the need to produce shells.

But although both these cartoons show some measure of uncertainty and duality in their attitude to the working men, they are nothing like as forceful in their condemnation of unionist activity as Bernard Partridge's famous cartoon of March 1915, in which a soldier says to a 'disaffected workman', 'What'ld you think of me, mate, if I struck for extra pay in the middle of an action? Well, that's what *you've* been doing.[43] The difference between these cartoons is largely explained by the different circumstances to which they respond: but it is also the result of the need, at the outset of the Somme offensive, to see the whole nation, including the industrial population, as working together for the same end.

This statement of unity finds slightly more assured expression in some later accounts. Mrs Humphrey Ward, in a volume aimed specifically at American readers, is serenely confident. The idea of a nation united in purpose, with all classes working together to support those in France, is expressed with certainty, and no hint of patronage:

> The apparently endless supply of munitions which now feeds the British front, and the *comparative* lightness of the human cost at which the incredibly strong network of German trenches on their whole first line system was battered into ruin, during the last days of June and the first days of July 1916; – it is to efforts like these that all that vast industrial effort throughout Great Britain . . . has now steadily and irresistibly brought us.[44]

There is much over-simplification here, most clearly in the statement about the lightness of the losses in the attack: but the passage does stress the involvement of the munition-workers in a way which shows a more genuine desire to portray a nation united in purpose and effort.

Perhaps John Buchan, in *The Battle of the Somme*, is the most successful in avoiding distinction or hectoring encouragement, by a combination of factual statement and simple assertion of unity through the use of the first person plural:

> Britain was manufacturing weekly as much as the whole stock of land service ammunition which she had possessed at the outbreak of the war. The production of high explosives was sixty-six times what it had been at the beginning of 1915. The monthly output of heavy guns had been multiplied by six in the past year, and that of machine-guns by fourteen. We no longer fought against a far superior machine. We had created our own machine to nullify the enemy's and allow our man-power to come to grips.[45]

Over-all, the treatment of the bombardment preliminary to the Somme attack reveals much about the psychological state of the nation. The simplified, general treatment of its awesome scale and devastating effects reveal a longing for success of a kind not encountered for many months in a war dominated by stagnation, uncertainty and reversal. In this the reporters, illustrators and writers are responding to a public need, and it is hard to see how they could have regarded such a bombardment as anything other than a triumph in its own right. In this they provided a fillip for the nation of a kind not seen since the earliest days of war, a kind of interim victory in which, rather than defeating the enemy, the nation had shown itself to be capable of an immense feat of arms. This was a means of providing reassurance at the very start of the battle in a way which stressed that, whatever was the final outcome, the outset had been a triumph, and the implied realisation that the conclusion of the battle might be long delayed shows perhaps an awareness of public need rare in the treatment of earlier episodes of war. But in the desire to see the bombardment as a success, early reporters were too eager to see the whole plan of which it was a part as a success too, and this was to have serious consequences, not only in the reporting of the battle's later stages, but upon people's attitudes to the conduct of the war in general as well as artistic treatments of the war by a later group of poets and writers, as will be shown in a future section.

The value of reports stressing the involvement of munition-workers in the assault is also considerable. There is little to suggest an official propaganda offensive to mollify the munition-workers: more likely, those in a position to influence public opinion developed a tacit consensus. The psychological function of this is considerable: it reassures those at work in the factories that their efforts are essential and valued, at the same time exerting pressure upon them to continue these efforts, so maintaining the uneasy stance towards industrial workers in the very act of trying to assert the nation's unity.

At Jutland, the role of early leader-writers was to reassure in the face of official incompetence, and go against the negative statements issued by Whitehall. In reporting the Somme bombardment, opinion-formers in the press and other forms were resolutely behind the high command. The fact that this led them to overstate the effects of the bombardment, and to emphasise divisions in the nation at a time when its unity was a signal objective, reveals both the willingness of press and public to see a success in any positive action in France, and a social divisiveness which was to remain throughout the war, and to which we shall have cause to return in later chapters.

5

The Somme (2)

If one function of the popular treatment of the Somme bombardment was to stress the role of the munition-workers in making it possible, a principle fundamental to the reporting of the attack itself was that the fighting was being done by men who, a few months ago, had been ordinary members of the working community at home. Of the 53 divisions involved in the offensive on 1 July, 25 were formed from Kitchener's New Army. For the first time civilian volunteers were being employed in strength in an attack, and this was a new stage of great significance in the war's progress. It was the very basis of the idea that the whole nation was now committed to the struggle. No longer was the fighting solely in the hands of the regular soldiers; it was being done by ordinary men who had volunteered to serve the nation.

This imposed considerable pressures on those reporting the attack. If the idea of a nation united in battle was to have any credibility, then clearly the members of the New Army must be seen to be courageous and triumphant in battle. On a more immediate level, since almost everyone in Britain now had a friend or relative in France, it was essential that the conditions under which the soldiers were living and fighting be presented in as positive a light as possible. At the same time, of course, the courage and skill of the regular battalions could not be overlooked. Thus to sustain support for the attack at home, reporters would have to present all its combatants as conducting themselves with fortitude in battle and living in conditions that were at least tolerable. Only if these demands were met could the idea of a nation united in the struggle be sustained, and the sacrifices of both those at the front and those at home be justified.

We may assume that it was largely in response to these unspoken but implicit demands that references to the New Army in the first reports were frequent and prominent, and unfailing in their commendation, verging at times on idolatry. Many simply refer to a wide variety of regiments by name, to stress the breadth of those involved and also to provide material of interest to people from all parts of the country.

Censorship prevented the identification of specific regiments in the first reports, but later treatments frequently catalogue those involved. In this, the Somme film is typical. Its second title names the Buffs, Bedfords and Suffolks, and early scenes show the London Scottish and East Yorkshires marching to the lines and the Manchesters' service before the battle. The Lancashires and the Essex Regiment are among the others shown, and the penultimate section of the film shows the Worcesters off to continue the advance, 'seeking new laurels' as the title claims, in an assertion of the continuance of the regiment's glorious traditions.

As well as showing a range of regiments from both the regular and the New Army, with the aim of simply making known the sheer number and extent of the sections involved in the attack, the film attempts to show the living conditions of the men at the front, and reveal something of their morale. Early on we are shown the troops at rest, cooking and playing cards, to give a general impression of physical wellbeing. Clearly these scenes are carefully selected to give the most favourable idea of conditions at the front to those at home: the same is true of the many sequences of troops marching into battle, moving towards the camera smiling, laughing and waving helmets and rifles. This must surely have been a source of consolation and reassurance to many of the film's viewers at a time when it was still widely believed that a camera could only record literal truth. But we must remember that those who were being filmed knew that the pictures were destined for projection at home, so that the only possible response was to adopt a façade of content and assurance. In addition to the careful selection of passages of film which show the most optimistic side of the soldiers' morale and conditions, there is here the further suspicion that the camera created, as much as recorded, the reality it encountered.

Such selectivity in observation and interpretation is also apparent in the more traditional kinds of reporting. Perry Robinson's account in *The Times* of men marching to the lines is representative of many such passages:

Now and again a laugh broke out at some unheard joke, a completely careless laugh, as of a holiday maker. And, knowing what it was they were going into, for the fiftieth time one marvelled at the way in which British manhood has proved itself in the most terrible of all wars.[1]

It is easy, with hindsight, to assume that this is a piece of facile journalistic fabrication, written with the intention of perpetuating a myth of insouciant British gallantry and minimising the suffering of those at the front, and so calming the fears of those at home. We must guard against a

totally cynical view of this kind, however; many of those involved had at this stage strong hopes for the success of the attack, and this is especially true of those in the new battalions who had not seen active service. Certainly, reports such as this did much to comfort those at home in agonies of uncertainty about the conditions of the men close to them, and it is unrealistic to expect a press that was solidly in favour of the war and the offensive to do anything other than present the morale of the troops as uniformly high.

If the idea that the attack was made possible by all orders of British society, both New Army and regulars, working together at the front with the support of the munition-workers at home is strongly present in these reports, so, too, is the fact that it was the first joint venture between the British and the French. Simple statements of co-operation inform the reader of the new nature of the attack. In this, the lead is set by Haig's dispatch which first broke the news:

An Anglo-French attack north and south of the Somme, on a front of about 25 miles, began at 7.30 a.m. on Saturday morning.[2]

The *Daily Mail* followed this with the simple statement that 'our troops are fighting in the closest co-operation with French armies on both sides of the Somme'.[3] The *Daily Mirror* talked of 'a considerable advance, in conjunction with the French'[4] and the *Illustrated War News* asserted that the British and French were 'working magnificently in conjunction'.[5] The stress on French support is echoed in all early accounts. The *Daily Express* is typical:

The splendid support we have received from our French allies is, of course, so far as my knowledge goes, hearsay, but everybody says it has been magnificent.[6]

Even *The Times* asserted:

On our right the French fought with great brilliancy and notable success . . . Our Army is proud to be fighting side by side with soldiers so staunch and so heroic.[7]

Once the initial idea of co-operation had been established, subsequent reports maintained the emphasis by referring to it constantly. 'The day is going well for England and France';[8] 'Allies' victorious advance';[9] 'More gains by Britain and France in the Great Push';[10] 'The Allies Advance'[11] are typical of the references which maintained awareness of this co-

operation. Photographs of Haig with Joffre and other key personnel of the British and French high command give visual emphasis to the idea of working together.

As well as these formal reminders of the new-found unity, frequent emphasis is laid on the personal help and comradeship between individual soldiers of the two nations. Images of such unity are far more direct embodiments of the new co-operation, and were employed frequently to express the new spirit. *The Daily Telegraph* reported one such incident, real or invented, to show this feeling:

> It was the spirit of France saluting their comrades in arms when the oldest 'poilu' there raised a wrinkled hand to his helmet and said to an English soldier, 'Bonne chance, mon camarade'.[12]

A similar incident is reported in *The War Illustrated*, given added force by a drawing in which a column of youthful English soldiers is being saluted by an aged poilu, with the heading 'The Great Push! France salutes the Ally!'[13](see illustration 10 on p. 000). The accompanying text continues the tone, as well as the situation, of the account in *The Daily Telegraph:*

> Many a war-worn 'poilu' of the earliest class raised a hand to his helmet in saluting his ally with the words 'Bonne chance, mon camarade!'[14]

The same technique of embodying the co-operation of the allies in one simple and direct icon is seen in three accounts from early reports of the offensive which describe troops marching to the lines. *The Daily Telegraph* notes that 'some of them were whistling the "Marseillaise", though they were English soldiers'.[15] Perry Robinson uses the same image but makes its symbolic strength more obvious:

> always as they passed they whistled softly in unison. Some whistled 'Tipperary', some 'Come back, my bonny, to me', and some, best of all in the place and surroundings, 'La Marseillaise'.[16]

Beach Thomas elaborates the story further, by adding the stereotype bluff Tommy, always at his best in a tight situation and constantly dispensing Cockney humour:

> One platoon hummed the 'Marseillaise' in harmony. 'Not a bad tune, the old Mayonnaise,' said a listener.[17]

We may be sceptical about the ability, or the desire, of troops march-ing into battle to whistle or hum in harmony. But the literal truth of these passages is less important than the way in which they create an icon representing both the high morale of the British troops and their respect and admiration for the French allies with whom, for the first time, they were fighting in close co-operation. By stressing such unity, the early reporters were showing that not only was all Britain united in the struggle, but that the nation was also fighting in concert with the French, and this new unity could do nothing but improve morale and increase hope at home during this key stage of the war.

So far the accounts considered have all referred to the preparations for the battle, and seen in them a stress on unity and high morale. When we turn to accounts of the fighting itself in its very first stage, however, a more complex set of aims and functions emerges. They are ones which a modern sensibility perhaps finds harder to accept, because of the relationship between duty and death they present, and because of the way death itself is reported. Early accounts make clear that the conduct of the New Army in the attack was of the highest order, being what was to be expected from the best traditions of the regular army. This is certainly true. It is no part of the present intention to denigrate the courage and determination of those involved in the fighting. But it is possible to question the way in which the fighting was presented, since in almost every case abstract ideals of bravery and iconographic conventions of courageous advance are utilised in place of realistic accounts of the attack, so as to present the attack in a distanced and mythologised fashion. The most common technique is the practice of relating the current events to the heroic past and glorious traditions of Britain's fighting services, in the manner already encountered in some treatments of aspects of the Jutland encounter. Of these, the *Daily Express* is representative:

> I am informed that the vigour and eagerness of the first assault were worthy of the best traditions of the British Army . . . it may be taken as certain that our men entered into the grand assault in the true spirit of a sane and cheerful manliness. Death might come or suffering, but the soldier recks not concerning these things; he hears only the call of duty and he does it.[18]

Here the idea of traditional heroism is combined with the idea of simple obedience and duty. However false the high tone of this passage

may seem to us today – and presumably appeared to the soldiers them-
selves at the time – it was effective at home in stressing that the new
citizen army was behaving in the greatest traditions of Britain's heroic
past. Immediate solace is thus provided by the use of large, abstract
truths at a time when individual realities were not available, and the
sacrifice of those at the front placed in a context of heroism and duty
which few would question at that time.

Other accounts use similar techniques. *The War Budget*, writing of the
attack some weeks later, quotes some words by Lewis Namier which it
feels are 'never more truly applicable': 'Then was seen the majesty with
which the British soldier fights'.[19] Beach Thomas, in the *Daily Mail*,
employed an analogy which, in the context of the unprecedented co-
operation with the French armies, was less than diplomatic in its desire to
show the surpassing of earlier glories: 'It will always remain a day of days
in our history: Waterloo is an episode compared with it'.[20]

That the New Army fought just as courageously as the regulars is an
assumption which underlies all these statements, further reinforcing the
idea of unity in the attack and in the nation. It is, though, given open
expression in a passage from the *Daily Mail*, in which Beach Thomas
supposedly quotes from a wounded soldier:

'We were all over them,' he said. 'We did as well as the regulars would
have done, I *do* think'.[21]

A similar spirit lies behind illustrations and captions in *The War
Illustrated*. These show the London Navvies' Battalion 'doing their
strenuous bit in the vicinity of the firing-line'.[22] The caption goes on to
record how a German advance was halted 'by the Welsh Fusiliers and a
party of Navvies'. The inference is clear: both the regular battalions and
the civilian army were fighting with great determination and success in
France, and once more the idea of national unity is stressed.

Once the concept that all fought with the traditional bravery to be
expected of the British soldier, whether volunteer or regular, had been
firmly established, those who wrote the first press accounts made up for
the lack of a clear over-all picture of the offensive by presenting it in
terms which, while having some roots in actuality, create a mythology of
the advance which has certain recurrent iconographical elements.

This tendency was manifested in two ways. First came the generalised
impressions of the advance, which generate conventions of reporting
which stress the eagerness with which it was undertaken. Characteristic

of such accounts are images of rapid movement and youthful, manly vigour in the first leap from the trenches. According to the *Daily Express*, for instance;

> all rushed for the trench wall, eager to be out first and get it over. Like runners panting to reach the tape the men struggled into the roaring hell.[23]

This is interesting for two reasons. First, it does include reference to the opposition encountered by the advancing troops, which is unusual in such reports. However, the reference is general – 'the roaring hell' – and lacks the impact of any more specific reference to resistance in the form of machine-gun fire. This gives it the tone of something from an adventure story, in which opposition is always stated but always overcome; and the vigour and impetus of the language used in the first part of the passage is far more forceful, leaving a deeper impression on the reader's mind, so that the 'hell' can easily be overlooked. Secondly, it is almost a parody of Rupert Brookes's line about 'swimmers into cleanness leaping',[24] with all its associations of youth, vigour and the highest traditions of British manhood. It is perhaps unlikely that this is a considered reference, but the poems of Brooke were immensely popular early in the war, and the language used here could perhaps represent an unconscious harking back to the simpler, more direct and more abstract ideas of 1914. Whether or not this is a conscious – or more likely a subconscious – reference, it is striking that very similar terms are used in other reports. *The Daily Telegraph*, for example, reported that

> British and French troops leaped from their trenches and fell with irresistible force on the first German lines.[25]

The *Daily Mail* echoed the tone and vocabulary of this sentence and also, like *The Daily Telegraph*, avoided any mention of German opposition in its description of 'that first gay, impetuous and irresistible leap from the trenches'.[26] This is perhaps the least acceptable version: to talk of such a leap as 'gay' and 'impetuous' seems absurdly incongruous now and must, even to those at home in 1916, have seemed unlikely. The desire to assert victory and reassure those at home of the gallantry of the fighting men seems to have got out of hand here – though we must remember that the *Daily Mail* was a very popular newspaper, and it is likely that it was only telling its readers what they wanted to hear. But Beach Thomas was disliked and reviled by those at the front, and the

short-term consolation and reassurance offered by passages such as this must be offset against the deep resentment and anger provoked in a later generation of poets, artists and thinkers who rebelled against the jingoistic over-simplifications of writing of this kind, as will be shown in the last section of this chapter.

The iconography of rapid movement from the trenches is present, too, in the sequence from the Somme film in which a group of soldiers leap from a trench, led on by their young officer who stands, pistol in hand, on the parapet. Some fall back into the trench, but the rest go forward with a rapidity quite in accord with the accounts given in the press. That this sequence has become one of the most enduring icons of the battle, and indeed of the whole war, is shown in its reproduction in still form in many books, and as a passage in television programmes. This is the more remarkable since soon after the war it was shown to be a simulated sequence specially filmed to present a suitable impression of the assault for those in Britain. By a strange irony, Bertram Brookes-Carrington, a Gaumont cameraman who was in Belgium at the time of the German occupation, took part as 'one of the blokes that fell down dead in the trench' when it was filmed at a training-ground at Roclincourt, near St Paul.

Once the trenches were cleared the advance, according to most reports, proceeded with continuing heroic vigour. Of this the account in the *Daily Express* is typical:

> The men leaped across the ruined trenches and rushed towards the wall of smoke and fire . . . for many yards . . . their feet never touched the earth, so thickly was the ground carpeted with the dead. Shrapnel fell in sheets, men fell stricken, but the ranks closed automatically.[28]

Beach Thomas went further:

> The very attitudes of the dead, fallen eagerly forward, have a look of exuberant hope. You would say that they died with the light of victory in their eyes.[29]

There is certainly a stress on heroism in these passages, along with a very forceful expression of the inevitability of the attack's progress which, while it makes nothing explicit, clearly implies that victory is in the long term assured. What is most chilling about these accounts is their acceptance of the number of deaths as something quite inevitable, and a price which the soldiers themselves are quite willing – if not eager – to

pay for success in the battle. There is an unspoken assumption that the cost of the battle will be high – an assumption which, it is true, is made explicit elsewhere, but which is no less terrible as a result. It is as if the reader is being drawn into a conspiracy, in which the heroism of the troops is first established, and then death is made an implicit part of that heroism: having accepted and gloried in the first, the passages seem to reason, the reader must accept the second, and see death as something which is the consummation of glorious service and duty. This introduces a new element into the role of such accounts. The reassurance and stress on unity and bravery has turned, without the reader's awareness, almost, into an attempt to show that the losses of the battle will be great, but are acceptable because the dead showed the traditional heroism of the British in battle, 'the light of victory in their eyes'. In performing this subtle shift of emphasis so that the high casualties become a source of glory rather than mourning, these reporters are fulfilling an important role, in conveying the strategic aim of the battle, which was never intended to win the war overnight, even though it was expected that the bombardment would all but eliminate opposition from the front line German trenches during the initial advance. Such points are made explicitly in editorials: but the inclusion of these notions by assumptions of this kind in accounts of the fighting is a significant revelation of the degree to which the press followed and endorsed the policy of the high command, which puts into a different context the earlier assurances about the high morale and good living conditions of the troops. The press, it seems from these passages, stand foursquare behind Haig and his strategy, and are attempting to do all they can to make the public support it by the assumptions which underlie the heroic iconographies they develop.

Similar techniques are seen in the accounts of individual episodes of heroism. Most had a factual basis, and were without question acts of great courage. Once again, though, their presentation in terms of myth and legend gives a false impression of the nature of the attack as a whole, and also makes death seem inevitable but glorious. Prominent among these mythic episodes is the story of the East Surreys kicking a football towards the German trenches. According to Reuter:

> The Captain of one of the companies had provided four footballs, one for each platoon, urging them to keep up a dribbling competition all the way over the mile and a quarter of ground they had to cover.[30]

This was the British ideal of 'playing the game' given tangible form in battle, and the popular press were keen to seize on it. Since it was

much reproduced elsewhere, a double-page drawing by R. Caton Wood-ville in the *Illustrated London News*[31] assumes importance as a treatment of the event. As in other depictions of the advance, the ground is almost entirely free of wire – a further instance of the modification of reality under the influence of the sheer strength of the bombardment – and only in the middle distance do we see shells bursting and soldiers falling. Like the illustrations of Cornwell at Jutland, the context is that of the heroic adventure story, the wounds clean and aseptic. The heading reads: '"The Surreys Play the Game": kicking footballs towards the German trenches under a hail of shells'. The accompanying text quotes from a poem published shortly before in the *Daily Mail:*

> On through the hail of slaughter
> Where gallant comrades fall,
> Where blood is poured like water
> They drive the trickling ball.
> The fear of death before them
> Is but an empty name:
> True to the land that bore them
> The Surreys play the game.

The heroism is clear, as too is the national value of 'playing the game', itself an echo of the desire to state national unity, here through re-statement of a value seen by the British as one of their major virtues – playing the game, both literally and metaphorically. The fact that foot-ball, always a far more democratic game popular with all classes, has been chosen rather than cricket, with its social divisiveness, enhances the value of the heroic myth as an assertion of national unity and courage. Once again, though, the acceptance that death is inevitable within such advances is implicit, woven into the myth's fabric in such a way as to be its essence in moral terms, yet at the same time of little significance physically. Once more the reports echo the strategy, and fulfil the role of justifying it to the public through unstated assumptions as well as that of reasserting national unity and the national characteristic of fair play.

Other episodes assume similar symbolic proportion. Accounts of the Highlanders advancing to the music of the pipes[32], the heroism of sergeants playing the mouth-organ[33] to entertain the men when under fire, are prominent amongst them. They provide further evidence of the idea of the nation's fighting men who had, until recently, been ordinary citizens, leading the attack with immense bravery and spirit:

they also show once more the willingness with which death and suffering were accepted as the natural concomitants of glory by the press, and one part of their function must thus be seen as the communication to those at home that the death-toll of this battle would be high, and showing this as a glorious culmination of service in the highest British traditions.

The stress on national unity, in which all are seen as playing their part, must be seen alongside the earlier emphasis, albeit uneasy, on the role of the munition-workers: each was regarded as helping the other in a struggle involving all sorts and conditions of Englishmen. In addition, the frequent references to Anglo-French co-operation stress a new factor, showing the allies as working together in a major offensive for the first time in the war. In making clear the greater involvement of the whole population of Britain and France, the reports undoubtedly perform a psychological role in offering reassurance and renewal at a moment when it was so severely needed. At the same time, though, the assumptions concerning the inevitability and rightness of the high casualties – seen as the highest form of service to the nation – showed early reporters, in verbal and visual media, propagating the strategy of the high command in a manner that was probably as effective as it was implicit. It was also, as the next section will show, to have a lasting effect on later treatments of the war, in the reaction it generated in the finest poets of the Western Front.

II

These, then, are some of the forms and functions of the earlier reports of the Somme attack, in response to specific aspects and events of the advance. What, though, was the general attitude to the over-all effect and importance of the first days of fighting? Given the pressures acting on them, it might well be expected that correspondents should base their assessments on the successful outcomes of some episodes, seeing them as representative of the whole, and treat the heroic myths discussed in the preceding pages as accurate accounts of the events along all the front. However, the general attitude to the advance as a whole, evident in reports destined for a wide range of audiences, differs considerably from such expectations. Once again the similarity of outlook is revealed: once again, too, the attitude is one which appeared appropriate and sensible to many at the time, but which was to contribute much distress and dissent in slightly later treatments of the war.

Perhaps the best summary of the over-all response of the press to the

battle as a whole in its earliest stage comes from the *Daily Mirror's* editorial of 3 July, headed 'Better News':

> Bitter and repeated experience has shown us that nothing is more imbecile than to cross bridges before you come to them, or to shout 'Victory!' before victory is achieved. Nevertheless, there can be no harm in welcoming the weekend's better news of our considerable advance, in conjunction with the French, along a front of many miles.

This makes clear that there was considerable awareness of the limitations of the attack's aims from its earliest stages: it was not to be seen as the harbinger of rapid victory. As the *Daily Mail* put it, 'Our troops do not expect to be in Berlin this week'.[34] Other papers echoed these warning tones. *The Times*, for instance, stressed that the attack was 'not being understood to be in the nature of an attempt to force a final decision', and advised its readers that 'an operation meant to be prolonged cannot be judged on the results of the first day or two'. *The Daily Telegraph* shared this feeling:

> It is not yet a victory, for a victory comes at the end of a battle and this is only the beginning.

The *Evening News* called it 'a good beginning to a long struggle'; and similar ideas appeared in the *Daily Express:*

> though our success may be assured, a speedy ending to the battle is not at the moment to be looked for.

These comments certainly contradict the view that the attack was being seen as the rapid breakthrough to victory which had for so long been the hopes of so many. In this we may see a sense of responsibility towards the readers on the part of the correspondents, by their wish to keep in check any immediate impulse for rejoicing through making clear the longer-term nature of the attack just begun, even though that desire had had little fulfilment since the start of the war and the appearances of the preliminary bombardment – and the way in which it was reported – seemed to suggest that there was now cause for celebration. Instead of this, there is a sense of guarded optimism, well expressed by *The Manchester Guardian:*

> We are fighting a strong, determined and resourceful foe . . . it would be very unwise to underrate his powers of resistance, particularly in

the face of a highly menacing position. Great events may follow. But let us wait for these before clearing our throats preparatory to shouting.

The extent to which this restraint was apparent in the readers is hard to gauge; yet a passage in the *Daily Mail* is significant in the way it records the mood of the day, while at the same time seeming to guide the reader's response, rather along the lines of some of the early reports about Jutland. In its leader of 3 July, the *Daily Mail* commented that there had been

> no 'Mafficking' in the accepted sense of that almost forgotten word . . . But there was solid, sincere enthusiasm and a well-found hope that in the immediate hours there would be greater news to come.

In these ways, then, the first reports stressed firmly that no total victory was imminent, but instead advocated a response of tempered optimism. In this they revealed a responsible attitude by not inculcating premature hope in their readers, and thus fulfilled the important role of averting groundless rejoicings. Another function was the factual one of making known to the people that there was no hope of immediate victory implicit in the plans of the high command. But there seems an incongruity between this caution and the more inflated mythic accounts of episodes in the advance and the awe-stricken tone of descriptions of the bombardment, and we might well ask whether the injunctions to caution were as effective as these more ebullient responses. It seems as if the papers wanted to have it both ways, with the joy of victory in these two strands of reporting as well as the responsible restraint of their over-all judgements. This is true: but the questions might equally be answered by saying that this was an effective way of accentuating the positive aspects of the attack while remaining aware that it was, after all, only the start of a much larger campaign, and thus allowing a brief moment of longed-for triumph before stressing that total victory still lay some way off. In this compromise response, the press appear to present the advance as a whole with some measure of honesty and responsibility, at the same time as satisfying the desire for positive news, guarding the reader from undue rejoicing while at the same time offering some measure of delight and reassurance at the success of some aspects of the action.

Another element is common in these early accounts, and serves to reinforce the idea of caution: the emphasis on the inevitability of high casualties during the fighting. The *Evening News* warned; 'we must not

forget that the battle must inevitably be long and costly'; and the *Daily Mail* asserted that 'The Allies are well aware that heavy casualties will be inevitable when the final assault is delivered'. *The Daily Telegraph* sustains this response most fully, in an editorial written when the bombardment was at its height, which is striking for the manner in which it refers to the expected heavy cost of the barrage and the advance which would come after in the words 'We must look with stern composure for bitter losses in the campaign which has just begun'. It then goes on in a passage which is worth quoting at length as it shows an awareness of both the high cost and the long-term nature of the battle to come:

> But, though we are strong, the enemy is also strong, and people in England will be wise if they do not place their hopes too high because our shell-fire is spreading up and down the line. As I said yesterday, the object of these bombardments is to kill Germans.
>
> That is being done, and the number of the dead is rising. But behind the dead is a great living army strongly entrenched, and able to strike back heavy blows.
>
> There must be bloody fighting this year or next year before the end comes. But enough for the day, and the spirit of our troops is high because after much waiting our guns are speaking loudly and in great numbers.

This open stress on the high cost of battle is an unexpected facet of the early reports. It shows that there was no desire on the part of the correspondents to conceal the expected toll of the assault, which may again be seen as evidence of a responsible attitude in which the public are made aware of the nature of the battle and warned of the likely heavy losses. Once again, this goes against the heroic myths of the advance, but once more it may be seen as offsetting the rejoicing against a true awareness of the cost of battle, again striking a balance between mythic contextualising and clinical realism. Whether or not this balance is effective in literal or moral terms is a deeper question. In the values of the time, such reports must have appeared to many as the height of responsible journalism, in which the British quality of resolve and determination praised in many editorials on Jutland is shown once again. Such reports must also be seen in the context of the other strands of writing discussed in these pages – the stress on national unity and the idea of glorious advances in the best traditions of the British army. These make clear what is implicit beneath the references to high death tolls: that the deaths will be a sacrifice for the nation, in the glorious tradition of British

heroism. To a patriotic reader at home, whose belief in the rightness of the war was strong and still unshaken, the reports thus provided reassurance and the longed-for hope of victory, while not arousing false hopes, and were thus an acceptable and valid treatment of the attack.

There are, of course, other interpretations of this attitude which many would now find unacceptable, and these will be dealt with in later pages. Before this, though, we must consider a further aspect of these reports which, like the stance adopted towards the high losses, may be described as representing the received standard opinion of those in favour of the war who, it must be remembered, were still the overwhelming majority in 1916.

Although the accounts repeatedly stress that the campaign is not intended to defeat Germany overnight, they do convey the idea of change and progress by suggesting that a completely new phase of the war had begun with the attack on 1 July. This rests on the concept that, until the Somme offensive, British involvement in the war had been limited and unwilling. The nation had entered the war unprepared, it argued, and had consequently fared badly. Now united, its munition-workers solidly in support of its citizen army, and its high command in close alliance with the French, it had begun to fight with a total commitment of physical and moral resources. The concept is widespread, and reveals the single underlying motive beneath the separate stresses on munitions and the New Army which were so intensely pursued in the early reports.

This interpretation is best demonstrated in a typical article from *The War Illustrated* of 15 July.[35] Titled 'One hundred weeks after; Britain's Great Military Miracle and how it was brought about', in contrasts the mood of the beginning of the war with that of July 1916, to show the new preparedness with which the whole nation was now tackling the war. It takes as its starting point the idea that 'In a military sense no nation was ever less prepared to wage war than Britain' in 1914, for the reason that 'militarism and, particularly, conscription were anathema to the British constitution and temperament'. In 1916, after a hundred weeks of war, it claims, 'the state of affairs has been reversed, and it is now Britain who is the chief military antagonist of Germany'. The article goes on to praise the 'spontaneous patriotism' of Kitchener's volunteers, while not forgetting that 'the conscripts will do their share', and sees evidence of the 'resolve' of the British people in their willingness to abandon 'the cherished tradition of volutaryism'. Here, the idea of the nation united is given a much larger context: the whole country is working together for the first time, in a united effort of a kind never before seen, all making

sacrifices for a war which none wanted but for which everyone is now prepared to give everything.

The *Daily Mirror* had an editorial on 3 July which made similar points, but took them a stage further to establish the second major strand of this view of the attack:

> greater preparation heartens our men in a way last year's vaguer hopes could not hearten them. What tells is science first, reinforced by the courage we know our men possess. Last year they had the courage but not the science. This year . . . Well, this year they know they still have the first, their birthright. And they tell us they have the second too. Such a combination should in good time bring the victory they have toiled and fought for during nearly two years of sacrifice.

The attack is here presented, not as an instant change of fortune, but as a major turning point in the war, since it was the first tangible evidence of total commitment and preparation throughout the nation. Before 1916, it is implied, the British fought unprepared and unwilling, thrown into war by German militarism and territorial ambition. Only when the proper groundwork had been laid – by the British principles of voluntary recruiting and the selfless devotion of the munition-workers – could the nation be said to be fully involved in waging war. According to this argument, it is almost to the credit of the British forces that they suffered setbacks in the earlier years of war, since this was due to an unpreparedness which demonstrated to the world that no one in Britain wanted war. Now that the nation had roused itself, however, things would be different, even though the fighting would still be hard and long.

There is much truth in this view. Lack of preparation in military tactics and a complete failure to comprehend the logistic problems of a war on this scale had caused reversals in the earlier stages of the fighting. Yet there is another way of seeing these claims, which shows these articles, and the others which they represent, as performing a psychological function of much importance in readjusting the nation's concept of the war.

Social psychologists have a concept known as the theory of cognitive dissonance. According to this, an awareness of two circumstances which cannot be reconciled produces in the mind a state of dissonance which is highly disturbing, and must be resolved. Accordingly, in order to provide this resolution, a shift of attitude, or a shift in the way in which the two are seen, is necessary. Before 1 July 1916, the British public could be

said to have existed in a state of cognitive dissonance about the war. On the one hand, they knew from upbringing and tradition that the British were courageous, resourceful, and stood for moral right. On the other, they saw their forces in France persistently and repeatedly failing to secure the kind of victory they hoped for, because of the superior power of the German army.

The reports of the first Somme attack, especially that from the *Daily Mirror* quoted above, provided a means of resolving this dissonance. Up to now, the concept ran, the nation had not been fully committed to the war because of Britain's essentially pacific nature. Thus, despite the immense courage of the fighting men, the victories had not been achieved. But now the nation's resources of industrial plant and manpower were totally involved in the war, and now the path to victory lay ahead. The fighting would still be hard, but now that the whole nation was committed to war there could be little doubt about the outcome.

In offering this explanation of the past reversals, and an expression of hope for the future, these press reports performed a psychological function of very considerable importance. Past difficulties are immediately explained, yet the glory of the soldiers in no way diminished, and the suspicion that those at home have failed to provide sufficiently for the fighting men in terms of shells and *matériel* is dispensed with by the concept of the British being an essentially peaceful people who could only equip themselves for total war after many months of preparation. In tempering the assertion of a new phase of war with caution, and in emphasising the cost and duration of the battle, they acted responsibly in making sense of the new attack and its place in the larger movement of the war. If we accept the moral rightness of the war as a cause worth pursuing to the end, and the idea that death for one's country is a high and noble deed – as the great majority of those at home did – this view of the Somme assault is one which is of very great value, and had immense importance in explaining and justifying not only the new efforts of the nation which was at last working together with a single aim, but also the sufferings and sacrifices of the past 22 months and 26 days of fighting.

Although to the majority the fighting was right, proper and a glorious consummation of the ideal of duty and service, to many it was inexcusable and senseless slaughter, and this has become the view of much of the fighting on the Western Front accepted in popular accounts and histories of many kinds in more recent years. When we look at the reports of the Somme from the standpoint of the pacifist conscience of 1916, they take on a wholly different significance. Instead of showing the New Army as the spearhead of a nation united in the effort to defeat the enemy, the

heroic myths of glorious advance are jingoistic misrepresentations of the usual conditions and occurrences of life on the Western Front. Most appalling of all, though, is the easy acceptance that losses will be heavy before victory is obtained, made worse by its assumption that death for one's country is the highest form of nobility. To a poet like Sassoon, such an attitude is obscene and outrageous, not only because of its facile acceptance of death but also because those who are so enthusiastic about the new fighting have never experienced it at first hand. To this is added the obstinacy of the high command in persisting with an attack both costly and pointless. Consequently satiric attacks on both those who exude ill-formed patriotic zeal at home and those who give orders quite uncaring for the suffering they cause are common in Sassoon's poetry. It would be simplistic to suggest that the treatment of the Somme attack in popular writing and illustration was alone responsible for the changing attitude of many writers and artists later in the war: many had been opposed to it from the start in any case, and others had more direct personal experience of the fighting on which to rest their opposition. None the less, it is true in large measure that a new rejection of the war and its aims and methods was apparent after 1916, largely as a result of the handling and treatment of the Somme offensive, and many features of these elements can be discerned in the accounts of the opening of the attack. To show their influence on the later generation of artists and poets needs far more space than is available here, and would in any case be at best conjectural in many aspects. It is, however, more possible to show the way in which such reports may have influenced the writing of Wilfred Owen.

Owen joined the Artists' Rifles in October 1915, on his return from Bordeaux where he was working as a private tutor with a French family. In June 1916 he was commissioned in the Manchester Regiment, and left for the Somme front in December with the Lancashire Fusiliers. During the intervening months he was in London undergoing training. Thus his own knowledge of the Somme attack came from the accounts he read in the press and in journals of the time. It is not unreasonable to suppose that the discrepancy between these accounts and the reality which he experienced for himself at the start of the next year, when the attack had petered out into sniping and attrition in the mud, did much to develop the rejection of the conventional patriot's view of the war which is so powerful in his poetry.

Certainly, when Owen's wartime poems are examined, several striking instances of the rejection of the values and images of the Somme reports become apparent. Although it owes its origin to a later attack, 'Spring

Offensive' makes reference to many images and ideas from Somme reports. The same image of 'leaping' from the trenches is used to describe the attack itself, but in a very different way from the icon of heroism of the correspondents' accounts:

> Of them who running on that last high place
> Leapt to swift unseen bullets, or went up
> On the hot blast and fury of hell's upsurge,
> Or plunged and fell away past this world's verge,
> Some say God caught them even before they fell.[36]

This could be taken as an image of death without suffering, the dead going straight to heaven as martyrs; and this would place it in a tradition very close to that of the press reports, although lacking the idea of sacrifice for one's country. Yet this comforting idea of eschatological resolution is denied by the poem's final stanza, which conveys the reality in contrast to what 'Some say':

> But what say such as from existence' brink
> Ventured but drave too swift to sink,
> The few who rushed in the body to enter hell,
> And there out-fiending all its fiends and flames
> With superhuman inhumanities,
> Long-famous glories, immemorial shames –
> And crawling slowly back, have by degrees
> Regained cool peaceful air in wonder –
> Why speak they not of comrades that went under?

The iconographic elements of the hell of opposition the advancing men encountered are here, but they are presented in starkly real terms, not with the adventure-story simplicity of the popular press. The 'glories' are there, but they are offset by 'superhuman inhumanities' and 'immemorial shames': the attack is composed of both heroic and brutal elements, and is too complicated to be seen in the simplistic style of the mythic icons of the press accounts. Owen's offensive – representative, we may guess, of those in which most soldiers were involved – is too complicated and contradictory to be seen as a rush towards death and glory. Those that are left do not speak of their dead comrades as having fallen gallantly in action, as the reality is too complex and horrific, and here Owen exposes the falsity of the myth. It is a poem which expresses

its ideas through forceful description of a single incident; but the general point that it includes is made in another horrifically specific poem which describes the death of a soldier during a gas attack. Only those who have not seen such things can talk of death as glory, and perpetuate

> The old Lie: Dulce et decorum est
> Pro patria mori.[37]

Another forceful rejection of the kind of values represented in popular press reports is central to the theme of Owen's 'Smile, smile, smile'.[38] The title itself is a heavily ironic reference to the refrain of the song which soldiers were frequently described as singing. The insensitivity of the press, and its sheer ignorance of the true effects of the fighting on the soldiers, is shown in the first lines:

> Head to limp head, the sunk-eyed wounded scanned
> Yesterday's *Mail;* the casualties (typed small)
> And (large) Vast Booty from our Latest Haul.

The juxtaposition of the dreadful exhaustion of the soldiers and the callous materialism of the press report makes the point appear very strongly, and we cannot avoid being reminded of the great stress on the effect of the bombardment as opposed to the passing references to the high cost in loss of life in the report of the Somme attack. Owen's first draft of the poem[39] has the general word 'news' instead of the name of the paper in the second line. The inclusion of a particular paper not only makes the line stronger by the addition of specific detail, but also indicates the way the *Daily Mail* was regarded by many troops, who found the pronouncements of Beach Thomas, such as that quoted on p.71 above, callous and misleading about the real nature of the fighting. The poem continues to ridicule the contents of the paper, which promises better housing after the war but stresses that 'Meanwhile their greatest need is aerodromes'. The bitter parody concludes with a forceful rejection of the values of glorious service so popular in accounts of the fighting:

> The greatest glory will be theirs who fought
> Who kept this nation in integrity.

The idea of glorious sacrifice is here ridiculed, along with the idea that

the soldiers are upholding the nation's 'integrity' – both its moral purity and its physical wholeness. The repetition of the word 'nation', with a question mark, in the next line continues the ironic attack: the men exchange smiles, knowing that their secret is safe – that the 'nation' is now buried in France after endless attacks. In the final three lines, Owen attacks the response of those who, seeing the pictures of smiling soldiers in the papers, assume that they are happy:

> Pictures of these broad smiles appear each week,
> And people in whose voice real feeling rings
> Say: How they smile! They're happy now, poor things.

The misleading nature of photographs of smiling soldiers – much akin to those of the Somme film – is here attacked with a cynicism which is the more striking because of the realism and understanding which underlies it. Again, an element basic to the reporting of the Somme is revealed as intrinsically untrue and morally wrong.

Owen's attitude to the press in general, and his own personal philosophy, are both expressed in the final stanza of 'At a Calvary near the Ancre'[40] – the river around which the later stages of the Somme fighting took place.

> The scribes on all the people shove
> And brawl allegiance to the state,
> But they who love the greater love
> Lay down their life; they do not hate.

The uncaring zeal of the patriots, among them Beach Thomas and Horatio Bottomley, which calls for glorious acts of sacrifice in the defence of one's country, is here replaced by what Owen elsewhere referred to as 'Passivity at any price', and supported with the injunction 'Suffer dishonour and disgrace . . . but do not kill'.[41] For Owen, there is no concept of sacrifice for one's country along the lines of the jingoists: instead there is a pure sacrifice, a Christian doctrine of passive endurance which has as its consolation the avoidance of killing or hurting others. Only in this way can the 'superhuman inhumanities' be avoided. Owen here shows his awareness of the dehumanising effect of war on all who take part: there can be no glorious death for an idea, since defending that ideal necessitates brutality in killing others. In this, Owen moves farthest away from the early chroniclers of the Somme. To him, *The Daily Telegraph's* quite blatant claim that 'the object of these bombardment is to kill Germans' is anathema. Instead of this assertion of destruction

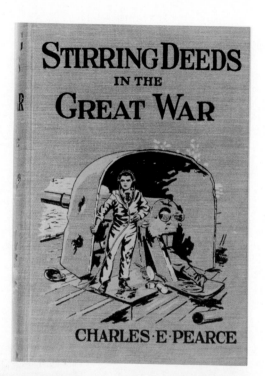

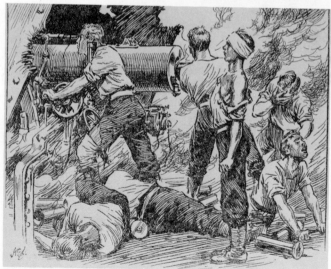

The death of Jack Cornwell presented in popular icons of bravery and devotion:
1. F. Matania's illustration used as the basis of a pictorial book-cover. (Cambridge University Library)
2. An anonymous illustration from Herbert Strang's *The Blue Book of the War*.
 (Cambridge University Library)

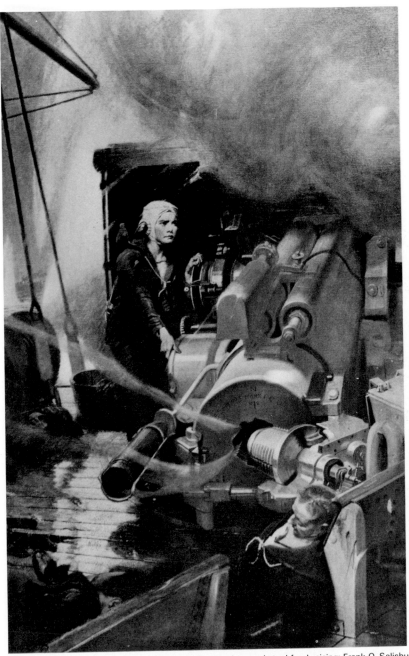

3. The tradition of Victorian genre-painting used for moral example and fund-raising: Frank O. Salisbury *John Cornwell, V.C., on H.M.S. Chester.* (Cambridge University Library)

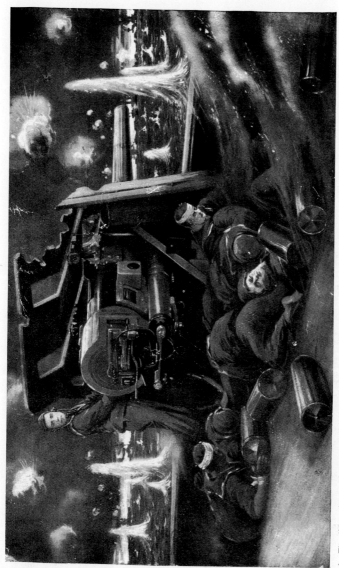

4. The 'Navy League' engraving of Cornwell's death: gallantry and adventure replace any real presentation of suffering.

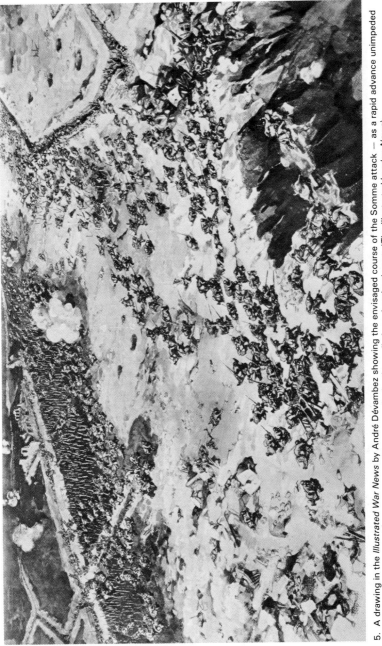

5. A drawing in the *Illustrated War News* by André Dévambez showing the envisaged course of the Somme attack — as a rapid advance unimpeded by barbed wire, with the enemy stunned into surrender by the preliminary bombardment. (*The Illustrated London News*)

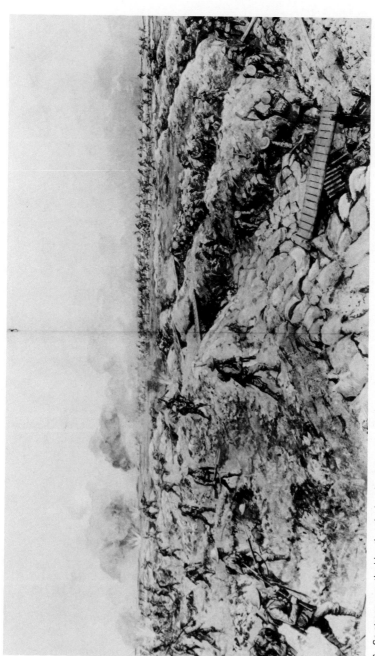

6. So strong was the idea that the bombardment would destroy the wire and make the advance easy that early illustrations assumed that this had happened. A drawing by Albert Forestier in the *Illustrated London News*, 15 July 1916. (Mansell Collection)

7–9. Stills from *The Battle of the Somme* which, by showing the storage, unloading and firing of shells in France, showed the munitions workers what happened to their products and by implication stressed the importance of high output. (Imperial War Museum)

The New Alliance. A drawing from *The War Illustrated* showing British and French troops working together for 'The Great Push'.

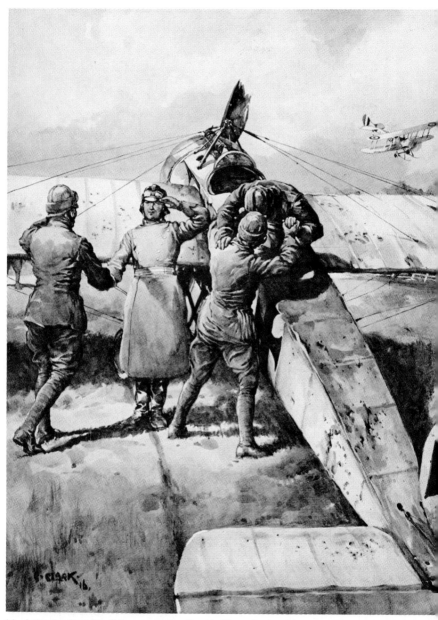

11. A drawing from *The Sphere* presenting the chivalric myth of aerial combat. (Mansell Collection)

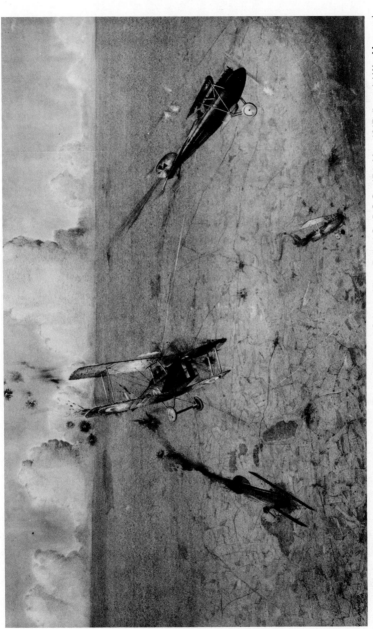

12. Chivalry, ecstasy and death: Norman Arnold's *The Last Flight of Captain Albert Ball, V.C., D.S.O., 17th May, 1917.* (Imperial War Museum)

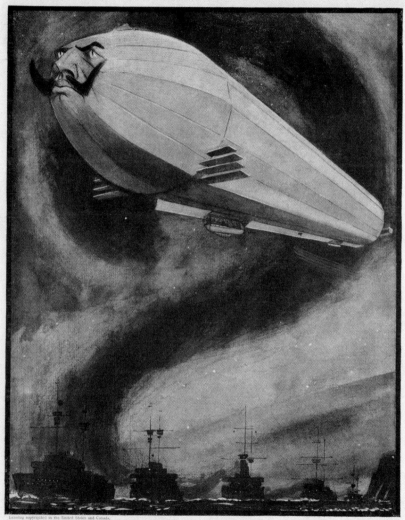

13. A cartoon by David Wilson in *The Graphic*, 16 January 1915. Conquering fear through ridicule was a frequent response to the Zeppelin threat in its earlier stages. (Mansell Collection)

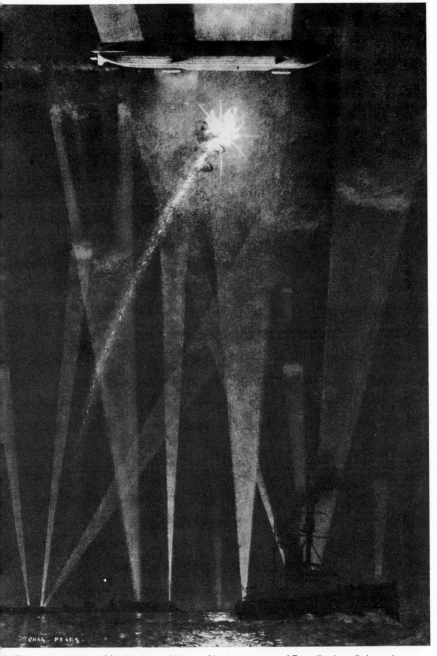

4. The curious mixture of fascination and horror of later treatments of Zeppelins is well shown in Charles Pears's *The Attack on the Zeppelin*. (Mansell Collection)

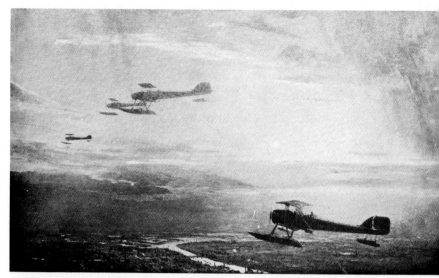

15. The exhilaration of Apocalypse: Donald Maxwell's *The Avengers*, as it appeared in *The Graphic*. (Mansell Collection)

16. A cartoon by Percy T. Reynolds. Published in *Punch* before the release of photographs of tanks, both makes the weapons appear comically familiar and pokes gentle fun at the language used by early reporters to describe them.

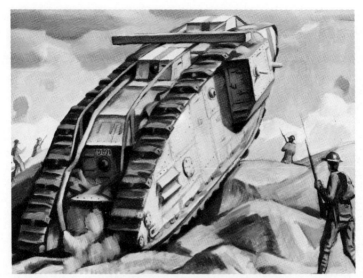

17. Seen from the rear — the viewpoint of the advancing troops — the tank has a human scale. Bernard Adeney's *A Mark V Tank Going into Action*. (Imperial War Museum)

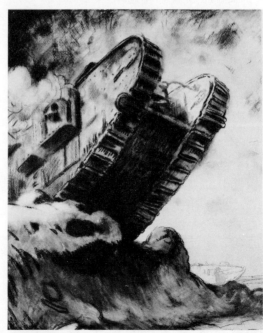

18. Seen from the lowered viewpoint of an enemy trench, the tank becomes menacing and deadly: William Orpen's *A Tank*. (Imperial War Museum)

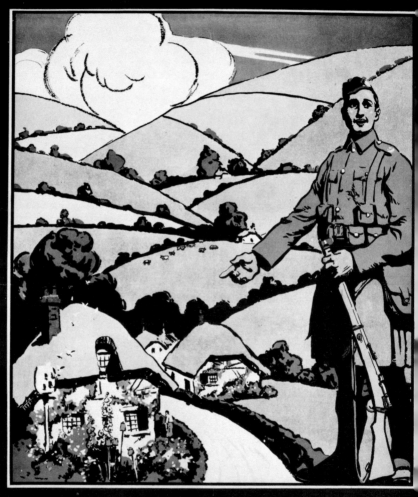

19. The ideal pastoral for which battle was joined. A poster produced by the Parliamentary Recruiting Committee, 1915. (Imperial War Museum)

20. One of the very few glimpses of industrial Britain in the art of the war years: *The Balloon Apron* by Frank Dobson. (Imperial War Museum)

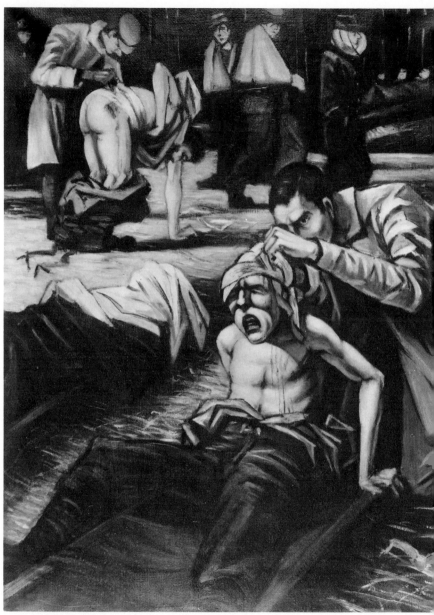

21. After 1916, much war art combined a savage anger at the war's perpetrators with a grave compassion for its victims. *The Doctor*, by C. R. W. Nevinson. (Imperial War Museum)

through nationalistic aims, he puts forward a sense of individual compassion and understanding, expressed most directly – along with a terrible awareness of the brutality of war – in the line from 'Strange Meeting': 'I am the enemy you killed, my friend'.[42]

These passages show clearly the rejection of recurrent icons and ideas of the Somme correspondents' accounts in Owen's poems in a manner which suggests that he was thoroughly familiar, if not with these passages, then with the kind of writing which they represent. A rejection of similar nature may be seen in the paintings of Paul Nash. Here, though, we can be far less sure that the artist saw the popular illustrations of the Somme battlefield which his own paintings so powerfully reject. Like Owen, Nash had joined the Artists' Rifles, but on the outbreak of war, and was later commissioned in the Hampshires. Thus he was in France during the actual Somme attack, so that his paintings rest as much on personal experience as any of the official artists, and he may have been quite ignorant of the misleading artists' impressions of the fighting which appeared in all the popular journals. An exhibition in the Goupil Galleries in the summer of 1917, and a letter from Edward Marsh to John Rothenstein which pointed out that 'this boy Paul Nash is very good indeed',[43] led to his becoming an official artist later that year. The paintings produced by him in 1917 show the perfection of his personal style, a kind of cubist abstraction which uses the distortion of its elements as a powerful symbol of suffering and destruction. The careful, exact compositions of Caton Woodville, Forestier and the popular illustrators are totally rejected: although they depict the soldiers with meticulous detail, they remain naturalistic, not realistic. As well as showing the way in which the attack was intended to proceed, instead of how it actually happened, they are deeply unreal in their portrayal of the soldiers, who with their cheerful faces and aseptic wounds have the apparent reality but underlying emptiness of characters in television soap operas.

Instead of these caricatures, Nash presents us in canvases like *The Mule Track*[44] and *The Ypres Salient at Night*[45] with a reality that is psychologically true yet unnaturalistic in literal terms. The landscape is torn and broken, distorted into new planes and angular intersections. Such figures that appear are strained and broken, expressionless ciphers. Yet this apparent abstraction succeeds far more effectively in conveying the reality of the experience of war. Standing before the latter painting, a veteran of the Salient told me that it captured just what it was like to be there: the individual perception and broken forms create a symbolic and inner reality which is far more accurate and incisive than the slavish draughtsmanship of the popular illustrators.

The same is true of the paintings which simply record landscapes. *Hill 60*,[46] *Ruined Country*,[47] and *Sunrise: Inverness Copse*,[48] are examples of many paintings which show the landscape as a semi-abstract composition of broken trees and earth churned into wave forms by endless artillery attack. They lack naturalistic truth – though the devastation in many places was such that some landscapes are hard to conceive in other than semi-abstract terms – but the recurrent elements of devastated nature reveal in symbolic terms the suffering and destruction of the bombardments in a manner that is frighteningly effective.

Both Owen and Nash thus reject, consciously or unconsciously, the attitudes and conventions of the reports of the Somme. In this they are representative of many other writers and artists of the later years of the war. It is also striking that, in place of the collective, national stance of the more popular reporters, they have a strongly personal vision. In many ways this is to be expected of the artist, but in others it signals a change of thinking in the later years, away from the idea of duty and collective responsibility towards a more personal moral code – a development fundamental to the change in artistic and social thinking in the later years of the conflict, and one to which we shall have cause to return. As works of art in themselves, they provide evidence of the triumph of compassion in the desolation of war, and offer a forceful alternative view to that of the establishment as reflected in the earlier reports of the Somme. To say that the earlier treatments generated the later would be a grave oversimplification, but it is fair to say that they are part of the ideas and images which the later artists reacted strongly against. We may thus add a further important function to the contemporary accounts of the Somme: in some indefinable degree they provided a striking-board against which later artists and writers of a different mind could rebel. As well as seeing the attack as a turning point in the war in terms of preparedness and national effort, then, the popular accounts may themselves be seen as contribution towards the new, more personal and more compassionate response to the horrors of the war in the years that lay ahead.

III

Among the hectoring claims of advance, and the subsequent anger and cynicism, of the diverse responses to the Somme attack, there seems little room for compassion for the bereaved. The rituals of mourning seemingly have no place in the assertion of triumph or national unity: and the

compassion of Owen, though grave, offers little consolation or support in loss. These gentler and more personal roles are fulfilled in a book which appeared some time after the battle, in December 1917 – John Masefield's *The Old Front Line*.

The most immediately striking feature of the book is that it is not primarily concerned with the fighting. Apart from an account of the preparations, the bombardment and the moment of initial attack in the last two chapters, the whole of the book is concerned with giving an account of the 'old front line' – the line from which the troops advanced on 1 July. It is a gentle, yet detailed, survey of what the troops saw from various places in the line just before the assault, and is full of small, almost intimate, observations:

Right up on the top, well behind our front line and close to one of our communication trenches, there is a good big hawthorn bush, in which a magpie has built her nest.[49]

In many places, the likeness between the French countryside and the English downland is noted, to make it closer and more accessible:

This gap is the valley of the Ancre River, which runs here beneath great spurs of chalk, as the Thames runs at Goring and Pangbourne.[50]

Although the stress on landscape is strong, the book does not conceal the more awful realities of the battle. The bravery of the soldiers is shown, but so, too, is their suffering: 'These roads were indeed paths of glory leading to the grave'.[51] The passage quoted at the end of the last paragraph continues by saying that, near the place described, 'there used to be two bodies of English soldiers, buried once, now unburied by the rain . . . The rain of war lay all around them'.[52] Other passages refer to 'the lice, wet and squalor of the dugouts',[53] and emphasise the strange coming together of beauty and suffering: 'It was a day of an intense blue summer beauty, full of roaring, violence, and confusion of death, agony and triumph, from dawn till dark'.[54]

Perhaps most significantly, the ruined landscape becomes both symbol and representative of the suffering and decay, human and natural, as this passage about the Beaumont Hamel mine crater makes plain:

The inside has rather the look of meat, for it is reddish and all streaked and scabbed with this pox and discoloured chalk. A lot of it trickles

and oozes like sores discharging pus, and this liquid gathers in holes near the bottom, and is greenish and foul and has the look of dead eyes staring upwards.[55]

The value of this writing is considerable. In detailing the landforms around the line, it allows the reader imaginatively to share the view of the soldiers in the last moments before the attack: as the text makes clear, the landscapes were 'the last things seen by many brave Irish and Englishmen, and cannot be passed idly by'.[56] In this there is a tacit understanding of a basic need of bereavement, to share and try to understand the last moments of the dead. In the confusion of battle a complete sharing is impossible: by presenting a view of the landscape, Masefield goes some way towards making it possible within the fragmentary situation of the war. The awareness of this need is also shown by the frequent mention of the graves in the battle areas, and by the reference to the fact that relatives will be unable to visit them for 'some years'.[57] This is a realistic awareness of the need to see a grave as an essential stage of realisation and release in the progress of bereavement.

This attempt, within the confines of a published book, to make possible this kind of sharing and understanding as a necessary instrument of psychological survival in the anguish of loss is something of great insight and much rarity. That it is combined with a tough realism in the accounts of the ruined landscape – both literally and as a metaphor of human suffering – serves only to strengthen it, since it approaches death and decay directly, putting aside the half-protective, half-patronising concealment of other accounts in which the dead are 'the fallen', and language is used to distance the suffering and consequently prevent it from being accepted as real. This shows an intellectual honesty lacking in almost all other accounts, and serves to negate any impression of sentimentality or ease in the view of death and suffering presented.

A further element in the use of the landscape is important here. As well as the idea of sharing the last moments of the dead, the emphasis on the countryside allows the idea of some measure of regeneration and renewal. There is the suggestion of healing in the growth of nature which, although it will not erase the suffering, will at least offer a pattern of new life and fresh beginnings. In passages of this kind, when they are seen in conjunction with the accounts of suffering and squalor in battle, there is some hint of consolation. No attempt is made to make sense of the struggle as a whole, save in the references to the bravery of the soldiers, yet such writing as the following paragraph must surely have been more effective in its understanding of the complex needs of the

bereaved, and also in its efforts to meet them, than the blatant, easy assertions of sacrifice of the more popular and superficial works:

> The trees are alive and leafy, the shrubs are pushing, and the spring flowers, wood anemones, violets, and the oxlip (which in this country takes the place of the primrose and the cowslip) flower beautifully among the shell-holes, rags, and old tins of war.[58]

6

The War in the Air

While first the bombardment and then the actual fighting was taking place on the battlefield of the Somme, another kind of conflict was being waged above it – as it had been, with increasing severity, since the earliest days of the Royal Flying Corps (RFC) in France. However, apart from technical and tactical advances, the texture of experience in the air in 1916 was fundamentally the same as in any other year of the war. As a result, we may usefully set aside the limitation of time demanded by the aspects and engagements discussed in the other chapters, and examine the treatment of a major area of conflict throughout the course of the war. What emerges from this wider survey is that a number of specific approaches dominate the treatment of aerial combat. The most common amongst them is well shown in this account of the fliers:

> They are the knighthood of this War, without fear and without reproach. They recall the old legends of chivalry, not merely by daring individually, but by the Nobility of their spirit, and, among the multitudes of heroes, let us think of the chivalry of the air.[1]

Of the war's many re-orderings of reality through conventions of imagery, one of the strongest is the use of chivalric legend to enshrine the deeds of the RFC and RAF. As the lines quoted above suggest, politicians made eager use of such language, doubtless expressing a more widespread desire for glory in an otherwise wretchedly inglorious conflict. That this desire was powerful and pervasive is shown in numerous contemporary accounts. A description of the war in the air by one of the combatants is prefaced thus:

> The ancient age of chivalry is past, its glory and adventure are forgotten, the glamour of its romance has faded, but from the ashes of the old regime has risen a new and far more daring order of knighthood – the 'Cavalry of the Air'.[2]

The War Budget concludes a description of aerial combats by saying that 'there is nothing in the realms of old romance so swift, so full of courageous cunning, so entirely blended of luck and skill'[3] and that 'these examples are a few loose straws which show the way of the wind in the realms of the new knight-errant'.[4] The combination of ancient and modern to generate romance and place the new in the context of the old is also common:

> We see our knights-errant of the air go forth in an aeroplane furnished with wireless telegraphy and a photographic apparatus; and we stand looking on with open mouth and distended eyes, admiring at once the gallantry and the ingenuity of the enterprise.[5]

Often simply the titles of contemporary books and articles reveal the attitude of romantic admiration in their chivalric imagery: typical are 'Chivalry from the infinite',[6] 'Knights-errant of the air',[7] 'The Chivalry of the Air',[8] *Cavalry of the Air,*[9] and *A Paladin of the Air.*[10] This general assertion of chivalric conduct is supported by more detailed references to aspects of aerial combat, either in parallel with facets of chivalry or in terms of exhilarated adulation wholly in keeping with it. The bravery of the pilots is recorded in the language of idolatry. 'Pluck? Determination? Yes! Verily of such stuff are the kings of the air made.'[11] Airmen are 'those shining figures whose courage and presence of mind we heartily admire',[12] whose deeds are 'splendid' and 'plucky'.[13] Each exploit is 'a marvellous display of nerve and daring',[14] 'a splendid feat of airmanship' or 'one of the most thrilling air adventures of the war',[15] and is pictured appropriately in the illustrated journals.

The same papers frequently publish accounts of 'duels in the sky' which, although they make no explicit mention of jousting matches, clearly show the ideals of the honourable knight in battle which are stressed in the more overt uses of the imagery. E. S. Hodgson's drawing in *The Graphic* of 20 February 1915 and C. Fleming-Williams's in the *Illustrated London News* of 19 September 1914, well show this approach early in the war, while G. H. Davis's 'Duelling in Cloudland' (*The Sphere*, 27 October 1917) demonstrates the continuity of such attitudes into the final stages of the war. An important concomitant of the duel is the notion of honour between foes, which is another common facet of the chivalric imagery.

> This war developed between them a kind of free masonry which was the more remarkable in view of the complete absence of chivalry on the part of our foemen on land or sea.[16]

Cecil Gray, editor of *The Aeroplane,* asserts that 'there is always a certain fellowship among aviators, even when they are enemies',[17] and an illustration in *The Sphere* of 12 August 1916 (see illustration 11) is typical of many in attitude, as it depicts a British pilot capturing a German whom he has forced down with the heading 'Saluting the Vanquished Foe'. The accompanying text stresses that 'All the honours of war are accorded to captured aviators by the officers of the Royal Flying Corps'.

The pilots themselves are presented as a sacred élite, appropriate for a chivalric order, who completely refuse to take seriously any form of danger. Deprecating statements about heroic action are frequently ascribed to them: '"It's the greatest fun on earth", laughed an RFC pilot'.[18] In a short story by the popular and prolific Boyd Cable, an observer climbs from his cockpit to the pilot's when the latter is wounded, flies the aeroplane while standing on the wing, and receives his CO's congratulations by complaining about the cold and asking 'If you've s-s-such a thing as a hot rum p-p-punch on the premises, sir.'[19] This sang-froid is completed in the popular imagination by a spirit of recklessness when off duty, with riotous parties and heavy drinking to an extent which, although apparently having little to do with chivalric honour, is inseparable from the larger mythology.

A similar impression is created by film treatments of the air war. *With the Royal Flying Corps,* dating from some time in 1917, includes footage of a group of flying men, one wearing the VC and DSO, to show the comradeship of the Corps, and a sequence whose title once again presents the fighting as a chivalric exercise: 'The pilot and the observer get ready for "Hun" hunting'. *Tails up France: The Life of an RAF Officer in France,* dating from after April 1918, develops the familiar treatment more fully. Flying crew are shown piling into a Crossley tender when off duty, the implication being that they are off for an uproarious celebration or 'drunk'. The devil-may-care attitude is continued when, after a sequence showing a damaged aircraft, with the title 'Effects of a "crash" – The damage will soon be patched up', there is a shot of a wounded officer, with the title 'Same here, old sport'. Both films thus confirm the pattern of the life of an airman established by earlier popular treatments, both in the sequences described here and in shots of aerial manoeuvres, including some footage shot from the air, which at the time must have conveyed a feeling of freedom, exuberance and vigour quite in accord with the idea of a daring chivalric élite.

In the popular imagination, the air war was something of great

romance, full of the resplendent dash and vigour which had so manifestly failed to take form in the attrition of the trenches. Its participants were courteous and considerate even to their enemies, yet with limitless courage and energy for the perpetration of heroic deeds. The chivalric image which generates these responses is familiar even today in the idiom of the best-selling novel and popular film: yet to what degree may it be said to be an accurate portrayal of actuality, and how far may the image be applied with justification to the reality?

Superficially many aspects are appropriate. The single combat of highly-trained individuals, often in complete isolation from other fighting men, is similar in situation to a mediaeval joust. Similarly, the flier was as dependent upon complex equipment of pitot, flying-wires and ailerons as was the knight upon his hauberk, jambarts and sollerets; and both required the support of many others to make fighting possible. The composition of flying units was, on the whole, not dissimilar from that of a chivalric order in that both were largely aristocratic, within the different standards of the periods, and also predominantly youthful: pre-war flying was a pursuit of the wealthy and the young, and inevitably these formed the backbone of the early flying services. Ira Jones records an incident not unusual in this respect where the young Lord Doune fought Baron von Saal Saalfeld, 'a duel much in keeping with the gladiatorial affairs of the past – two knights fighting for their respective countries'.[20] Courtesy between enemies was also real enough. A correspondence between the commanders of the Russian and Austrian air forces published in 1915 contains exchanges of information about pilots missing, wounded or killed, and also sending greetings and Easter wishes to their foes.[21] The dropping of wreaths on the graves of airmen brought down in enemy country was a frequent practice: and both Albert Ball and Baron von Richthofen were buried with full military honours by their respective enemies.

Of the bravery of the fliers there may be no doubt: but the presentation it is given in the representative works mentioned above is very limited in both scope and depth, since it focuses on isolated incidents and ignores both the constant danger of flying under any circumstances and the reality of fear and immense tension which underlies individual acts of heroism. To the outsider, the pilots' conditions seemed infinitely better than those of the 'Poor Bloody Infantry', but the vulnerability of man and machine was considerable. The reality beneath the bravery is made clear by Cecil Lewis in *Sagittarius Rising,* one of the most outstanding books about the air war, in a passage which also presents the nature of single

combat in a way which shows the inadequacy of the chivalric image:

> when one of the old hands, as seemingly invulnerable as yourself, went West, you suddenly got cold feet. It wasn't possible to be sure – even of yourself. At this stage it required most courage to go on – a sort of plodding fatalism, a determination, a cold-blooded effort of will. And always alone! No friends right and left, no crowd morale. The lot of the P.B.I. was hopeless enough; but each in his extremity had at least some one at hand, some one to cheer and to succour.[22]

In addition to this exposure was 'the fragility of the machine and the unreliability of the engine'.[23] Recording the death of a comrade while training, the hero of V. M. Yeates's *Winged Victory*, the finest novel of war in the air, reflects 'that was the worst of being in the flying service: you were always in the front line, even in England'.[24] Paradoxically, the great strain of flying which the popular accounts persistently ignore – and which Yeates's novel explores with deep insight – was responsible for the riotous behaviour they so often record: 'Small wonder if, under this strain, pilots lived a wild life and wined and womanized to excess.'[25]

We are drawn to the conclusion that, despite their apparent relevance, the images of chivalric legend are not only inadequate in presenting the nature of aerial combat, but are also a considerable distortion of its deeper reality. The illustrations of intrepid birdmen perched on the wings of aircraft or plunging down in flames are grossly unreal in their cosmetically attractive view of warfare generated by a purity of tone and texture and an avoidance of any pain or injury: they are the origin of so many comic-strip depictions which survive even today. The clear skies, lucid textures and clean lines of the drawings are as unreal as they are pervasive: the style occurs not only in the drawings of Filmore for *The War Budget*[26] and the more popular illustrators of the London journals, but also in the paintings of G. H. Davis,[27] Bernard Sandy,[28] and others officially commissioned to record the war in the air. Coloured illustrations and dust jackets of popular flying books continue the response; Cecil Gray's *Tales of the Flying Services*, for example, has on its cover a pusher biplane plunging down in flames, over the sub-title 'The Adventures and Humours of Aerial Warfare'. A further passage from Yeates shows both the falsity of this and the rejection of the myth by the fliers themselves:

> a bunch of Huns . . . came down on us and got Reeve. I saw him go. I had just got an Albatros in flames; and I can tell you the two made me

feel absolutely sick. Christ! what dupes we are! They tell us all this is honourable, noble and all the rest of it. Murder is murder however much we cover it up with lies and flags.[29]

Clearly the chivalric cleanliness and honour is in no way accurate: the horror of the aerial war was indisputably as great as that of the waterlogged trenches.

Two detailed instances will show the operation of verbal images of chivalry in distorting the truth it purports to present. A passage from a popular contemporary history of war describes thus the increasing importance of daylight raids far behind the German trenches:

They became the cavalry of the air, and, flying over the enemy's country, spread terror there. As aerial infantry they had attacked enemy trenches in the Somme campaign. Now, as aerial cavalry, they particularly ravaged his rear areas.[30]

In literal terms the parallel is valid, the air attacks functioning precisely as rapid cavalry raids. But again Yeates reveals the distortion:

Tom had dived and warmed his guns on Merville and dropped his bombs thereabouts. Once again they were out to kill; to kill by means of machinery; they were lever moving controllers of mechanisms. Was this fighting? There was no anger, no struggle, no straining muscles and sobbing breath; only the slight movements of levers and the rattle of machine guns. The poor strength of soft human bodies was replaced by hard steel and the instantaneous combustion of explosives.[31]

The mechanical horror and inhumanity is something wholly alien to the splendid cleanliness of the cavalry charge: the distortion is again grave. A similar combination of apparent appropriateness with more serious distortion may be seen in this passage:

To preserve the old romantic flavour of these historic battlefields, the French reverted to the use of arrows, making them of steel and dropping them out to the sky.[32]

The arrows in question are steel darts of about five inches in length, known as *flèchettes* and dropped from a canister holding about 250 when attacking columns of infantry or personnel in the trenches. The distortion here is clear: there can be little 'old romantic flavour' about such

weapons, and indeed it is only the distance of time which provides such enchantment for the original arrows used in the Flanders battles of earlier centuries where much of the fighting took place in the earlier part of the war.

The chivalric imagery in all its manifestations, verbal and visual, is, then, an attractive but deceptive re-ordering of actuality, which ultimately has little truth in recording the war in the air. Few books succeed in conveying the complex reality: those which stand out, especially those of Lewis and Yeates, make no use of the imagery except in mild ridicule. The visual depictions which succeed similarly eschew the clarity of popular combat scenes: of them the photographs by the anonymous author of *Death in the Air*[33] are perhaps the most appallingly successful in conveying the shocking reality of aerial warfare. It is perhaps inevitable that the image should fail, since its relation to any actual sequence of historical events is so confused. Each generation remoulds chivalric convention: the Elizabethans re-invented jousting at Woodstock, the Victorians translated *Le Morte D'Arthur* into a contemporary vision of gallantry dedicated to Tennyson's idea of manhood, compounded of Hallam and Prince Albert. The Victorian vision lay heavy on the imagination of the generation of the war: it is not surprising that they put it to use.

Yet in one strangely ironic way the stigmatised vision may have been of value:

Intrepid birdmen, said the newspapers; fearless aviators. The young men jeered, but did their best to live up to it.[34]

For those at home, producers and consumers of the myth, it was ultimately distortive: but for the young pilots themselves in April 1917, when the average life expectancy for a pilot on the Western front was three weeks, it may well have offered a paradigm to impose upon reality and thus keep at bay their dreadful fear and loneliness.

II

While the chivalric imagery about war in the air was largely created by those without direct experience of battle, there is another strand of visual and verbal response which comes from those most intimately involved with war in the air. For this reason, it is of considerable interest in revealing psychological stances to aerial combat, both positive and nega-

tive. It concerns the element of sheer delight in the strangely new circumstances in which the fliers found themselves and, in its most complex manifestations, involves an illuminatory union with the natural world which encompasses the exhilaration of flight and the supreme intensity of life-or-death combat.

As might be expected, the simpler instances of this delight are those most frequently recorded. We should, of course, remember in this context the extreme novelty of flight, both to the public in general and to the individual pilots, many of whom joined active units after less than 20 hours' solo flying. In these circumstances, simply staying in the air, regardless of surviving enemy attacks, must have been an initial source of delighted relief, and this comes across in the exuberant tone of many accounts, including those of Lewis and Yeates, as well as in explicit statements. A more tangible joy lay in getting away from the earth, especially in France, where lines of battered trenches, shattered woods and desolate villages revealed both literally and symbolically the confusion and annihilation of the war. Yeates's Tom Cundall frequently thinks about the physical and spiritual wretchedness of the earth, and we sense his relief at having escaped it when he talks of 'the silly earth, all wounds, pustules, scabs', and asks 'Why didn't she scratch off all these dirty humans making stinks and itchings in her epidermis?'.[35] A visual analogue is provided in W. L. Wyllie's *The Fighting Line from Ypres to the Sea*.[36] The earth is painted in map-like form beneath a British monoplane scout, the main points of the battle zone being presented clearly yet remotely. The aeroplane is fragile and vulnerable, surrounded by bursting anti-aircraft shells, yet there is still a sense of freedom about it which conveys something of the sense of relief and delight – however tempered by fear and loneliness – at being away from the squalor of the earth.

This delight at escape from the earth, however, is of little importance in comparison with the joy of visual experiences of unprecedented kinds. The paintings of Richard and Sidney Carline reveal this beauty clearly. The former's *Mount Hebron and Mount Sannin above the clouds*[37] is typical, in showing mountain peaks above a sea of cloud. What makes the painting particularly effective is its inclusion of the outer section of the wings of the biplane from which the mountains are seen. The onlooker is placed in the cockpit of the aircraft, so that we are put in the exact physical position of the original beholder, coming as close as possible to sharing the experience. This is further enhanced by the brilliant clarity of the painting's tonal values and the hard, brittle light. In its composition and in its luminous quality, then, the canvas conveys the aesthetic experience it records with considerable effectiveness.

Verbal equivalents of Carline's painting are frequent. The young Maurice Baring, for example, responds thus:

> as the machine climbed, the curtains of heaven were rent asunder, and through and over oceans of mist and rolling clouds, naked, majestic, white, shining and glorious, rose the Alps, like a barrier.[38]

The rather conventional expression here – 'the curtains of heaven were rent asunder' – might confirm a suspicion that such joy is the preserve of the over-sensitive aristocrat raised on the conventions of delight engendered by the continental Grand Tour: but such feelings are very often encountered in writing of a decidedly popular nature. *Over the Front in an Aeroplane* by Ralph Pulitzer, one of the earlier accounts of wartime flying, shares the experience:

> It was a magnificent sight. We were flying along in a clear belt between the lower and upper clouds. Below us stretched an unbroken white ocean of these lower clouds. The sun was just high enough to shed its slanting beams along the surface of this snow-white sea. Above us were the lowering masses of the higher clouds.[39]

A slightly more complex kind of response concerns the peculiar effects generated by the interaction of sun and cloud, which are once again recorded in writing of all kinds to show the sheer joy they evoked in those who experienced them. A work which is clearly popular in both conception and destination, *Cavalry of the Air* by 'Flight Commander', describes one such effect and a typical reaction to it:

> I have seldom been so deeply struck by the beauty of colouring as I was at that moment. The dull grey film of mist which a few seconds before had blurred the ground below, was suddenly transformed into a transparent veil of gossamer pink, so delicate in texture that the country immediately beneath us showed through it clearly, struck here and there by thick black streaks of shadow cast by a poplar tree or a building.[40]

This experience, and the delight it creates, is echoed in many visual treatments, most striking being Gilbert Solomon's *The Mist Curtain*. A Fokker biplane is attacking a British RE8, yet the actual event is of almost secondary importance. The use of a Pointilliste technique produces an extraordinary brilliance and purity of colour, with something of

the effect of a back-lit theatre gauze, precisely creating the visual experience described by Pulitzer. As with the canvases of Carline and Wyllie, the viewpoint is that of an accompanying aeroplane, so that we are close to sharing the experience involved, further enhancing the ecstatic mood of the colour and textures employed.

Another striking effect was the 'halo':

The sun pours down with a vivid light, which spreads quicksilver incandescence over the cloud tops. Below is the cloudscape, fantastic and far-stretching. The shadow of our machine is surrounded by a halo of sunshine as it darts along the irregular white surface.[42]

Visually, this feature is given prominence in both official and more commercial art works. Norman Arnold, a lieutenant in the RFC, later specially employed as a war artist, explored the effect in a water-colour named *Halo*,[43] with this explanatory note:

A peculiar phenomenon witnessed when flying between the sun and some direct object such as a cloud. A circular rainbow is observed round the shadow of the machine.

The *Illustrated London News* of 24 August 1918 reproduces a drawing by E. L. Ford under the title 'The Haloed Shadow: an Aerial Phenomenon'.[44] A caption ascribes the effect to 'some trick of the atmosphere', and compares the halo to 'the circular mark that is painted on the wings of Allied aeroplanes', going on to see this as a 'favourable omen' perhaps linked to the many other superstitious beliefs it asserts are 'not uncommon in the air service'. In the difference between Arnold's factual explanation and the interpretation offered by the *Illustrated London News* may perhaps be seen the different responses from those at the front and those at home. The former see the halo as something of beauty to be prized in itself, the latter see in it a rather hollow piece of patriotic symbolism which is not mentioned, for example, in any of the other accounts quoted here, and seems unlikely to survive in the general mood of cynicism towards such national emotions which underlies much writing about the war.

What does survive this cynicism, however, is the tone of instinctive joy and delight at release from the earth and the strangely beautiful effects of the air. As this appears in a wide range of different kinds of work – popular journalistic records, autobiographical writing, official war art and commercial engraving – written and produced by artists of a wide range of

different outlooks and backgrounds, it is reasonable to assume that such delight was a frequent response. This in turn suggests that delight in the effects of the natural world when flying was one antidote to the fear, loneliness and misery of the life of the flier in combat.

Were this the only implication of these records of delight in physical beauty, they would still be of importance in revealing something of the psychology of those involved in the air war: yet a fundamentally similar impulse goes a great deal deeper in recording further layers of complex psychological response. Cecil Lewis, flying above London at night, experiences a feeling of intense and awe-struck unity with the natural world:

> I had entered a new enchanted land . . . a feeling of amazement gripped me, that I, alone, in a frail contrivance, should have been given such keys to the paths of heaven, should have found my way to this undreamed-of paradise of night[45]

C. J. Kennedy's *The Defence of London against Gothas*[46] gives visual expression to this mood. A single DH 44 patrols the south coast, hanging above darkly shimmering water: the entranced stasis described by Lewis is precisely echoed here.

It is to V. M. Yeates that we must turn for the most complete expression of this complex response. Tom Cundall describes the experience:

> Flying towards the sun was as if he were in the apse of an immense temple with walls of luminous gold, and the sun a present blinding-light deity; such beauty and texture did the mind lend to mere molecules and vibrations, if such things were.[47]

Here – and in the passage from Cecil Lewis – it is not the physical beauty of atmospheric effects which is captivating in itself; it is their symbolic significance and spiritual implications. Elsewhere in the novel, Cundall's sympathy with his surroundings is demonstrated by the way his moods fluctuate with the weather through which he flies. On an evening flight, for example, he encounters a 'sinister and depressing purple' area of light, through which he feels, 'Nature seemed to be offering some apocalyptic warning above meteorology'.[48] This is important, not only in its demonstration of great sensitivity to weather – a practical necessity for all fliers – but also in showing in Cundall an unwillingness to become too easily entranced by physical beauty which, along with the general cynicism frequent in the work, serves to make the moments of delight in nature and its implications even more effective when they do occur. We

know that, unlike the young ladies of Butler's *The Way of all Flesh*, he is not given to falling into a 'conventional ecstasy' at the sight of something wonderful in nature.

The implications of the last-quoted paragraph are given full expression a little later in the novel:

> It was summer in cloudland, golden summer, and the sun spilt the opulent colour of ripening corn on the bright hills of his kingdom. The earth was very remote and dim and unimportant; so that Tom thought that this was the mechanical likeness of great emotion; a physical symbol of love, or salvation, or martyrdom, or whatever might make men ecstatic that the earth was remote, dim, unimportant, and the cloudy manor of skiey paradise immediate.[49]

There are elements of Traherne here, in mannerisms of expression ('skiey paradise'; 'mechanical likeness of great emotion') and in the overall tone of ecstatic, childlike vision. More important, the passage has the dual qualities of intense clarity of perception which distances the perceiver from the scene, and equally intense unity with it, which is the hallmark of the illuminatory perception central to English nature-mysticism. Significantly, earlier in the novel Cundall has read aloud a passage from Jeremy Taylor's *Holy Dying*,[50] reinforcing the heightened mode of perception seen in this passage.

The psychological state revealed in these passages is worth close examination as it is one of the few positive stances towards wartime experience in literary or artistic responses of all kinds – and it is significant that most others also concern relationships with nature of one kind or another. Inevitably, because of the complex feelings described, it is not a reaction encountered frequently in writing or painting by those involved in aerial warfare. Yet, lest it be thought an isolated reaction of the very self-consciously literary character of Tom Cundall, it is worth noting the appearance of such a feeling in Lewis's book, a volume of factual recollections much concerned in its later pages with the transience of moments of ecstasy such as that experienced by its author above London. More important, perhaps, are the words written by Yeates himself in preface to the novel:

> My chief difficulty was to compromise between truth and art, for I was writing a novel that was to be an exact reproduction of a period and an exact analysis and synthesis of a state of mind.[51]

It seems clear that the illuminatory response chronicled by Yeates and

Lewis is rooted in personal experience, and is related to the sense of joy in natural beauty seen in those passages examined earlier in this chapter. Yet we should beware of regarding such illuminations as the sole spiritual sustenance of all front-line pilots. Clearly many did not share it, their minds too preoccupied with fear, or with survival. There are also powerful factors to limit the frequency and hold on those who experienced it. To begin with, illumination of this kind, according to Yeates and Lewis, comes rarely, and in contrast to a state of complete bewilderment in which reconciling the beauty of the surroundings and the destructive purpose of the airman's presence in them proved an insuperable task. Cundall ponders on this relationship after seeing the destruction of a German aeroplane:

> in process of this bright ridiculous whirl of coloured shadows two men had been killed . . . Somehow the whole affair must be illusory; but the illusion was so real that it was the only possible reality for human minds. The formless structures of shadowed golden clouds, aeroplanes, shell bursts, death; these absurd overwhelming things were real.[52]

Similarly, after the illuminatory experience quoted earlier Cundall is aware of the transience of such visions:

> the joys of heaven began to fade; Tom became bored with glory that was intangible; he could not remain exhilarated for two hours together.[53]

The transience of such moments is doubtless aided by the cynicism which we frequently sense in Cundall's nature, and which also makes him reject the grandeur of *Holy Dying*.[54] Such visions are themselves, perhaps, the results of the extreme stress under which the pilots lived: at the end of the novel Cundall – like many others – is diagnosed as suffering from 'Flying Sickness D', a condition which we would now probably call acute anxiety and depression. Extreme and abrupt changes of mood are characteristic of such conditions, and Cundall's moments of despair, as well as those of illuminatory union with nature, are certainly in keeping with this. Perhaps they are the intellectual equivalents of the endless 'drunks' and riotous celebrations, a way of transcending the horror and the insoluble problems of the war.

Such moments of vision are indeed transitory, and perhaps the elation is a powerful and involuntary drug: yet they give us an insight into the

psychological states of those most intimately involved in the flying and, as such, are deeply valuable in helping us understand their condition. Keith Henderson, in a letter to his wife published during the war, makes the point that 'It is only when I'm not flying that I dread it; when I'm in the air, I don't care a damn, but enjoy it'.[55] This encompasses the despair and desolation of life as a front-line pilot as well as the exhilaration and joy which, whether in delight at getting away from the earth, in experiencing the new beauty of cloud and sunlight, or in moments of illuminatory oneness with nature, was a powerful force for psychological survival for the fliers. In such moments, life is bearable:

Tom, sustained by the substanceless air, felt himself a million miles away, in that moment immortal.[56]

It is pertinent to ask how far this state of mind is captured in the most celebrated artistic expression of the war in the air, W. B. Yeats's 'An Irish airman foresees his death',[57] since, at first reading, it appears that there are strong similarities. The opening lines convey the assertion about death which is the poem's central issue, but also convey something of the delight in aerial surroundings familiar from other sources, combined with an uncertainty as to the purpose of the fighting which is present in many:

> I know that I shall meet my fate
> Somewhere among the clouds above;
> Those that I fight I do not hate,
> Those that I guard I do not love

Similarly, the lines that are in many ways the poem's climax seem to capture the visionary joy of Cundall and Lewis:

> A lonely impulse of delight
> Drove to this tumult in the clouds

The resemblance is especially striking when we consider Yeats's own interpretation of the lines when directing a broadcast from the BBC in 1936. These imply that it was the desire *for* a 'lonely impulse of delight' which would take place in the air, not that the desire was inspired by an earth-bound 'impulse':

he made Clinton [Clinton-Baddely, reading the poem] speak the lines

'A lonely impulse of delight' as though he was experiencing the physical sensation of flight. 'Ecstasy, Baddeley' he would cry, and repeat the lines lovingly to himself.[58]

It seems that Yeats's imaginative sympathy has caught the mood of illuminatory joy and intensity of the young fliers, perhaps from his conversations with Robert Gregory by whom the poem was inspired. But the poem's closing lines refute this:

> I balanced all, brought all to mind,
> The years to come seemed waste of breath,
> A waste of breath the years behind
> In balance with this life, this death.

They are too conscious and too tidy: they have nothing of the uncertainty and transience of Cundall's representative experience. The single, simple decision of Yeats's airman is a romantic conception very different from the uncertainty of those who were there, glorious though it be. Whereas Yeats presents a reasoned argument in support of ecstatic experience, Lewis and Yeates show the ecstasy as a small part of an intense, anxiety-ridden continuum, which allows some measure of release and joy in a world of confusion and loss.

In one way, Yeats's poem is similar to another strand in the complex skein of response to aerial warfare. Its unquestioning acceptance that combat will lead to death or killing is similar in essence to an attitude which develops this into a kind of exhilaration and a sense of power. A passage from the popular *Cavalry of the Air* shares some of the qualities detailed in Yeats's poem:

> There are moments of paralysing uncertainty when for a few seconds life and death hang in the balance and one's mind seems about to pierce the veil of eternity, and moments of the keenest exhilaration when the machine becomes as a living thing, responding to the controls like a well-trained charger.[59]

This is very close to Yeats's 'lonely impulse of delight' and the balancing of 'this life, this death', but there are new elements here which may be discerned in other responses of a similar kind to air warfare. First there is the feeling of unity with 'the machine', a concept not unrelated to the chivalric myth discussed earlier, but with rather different implications, and secondly, the notion that the intensity of the moment, in which the

writer seems 'to pierce the veil of eternity', is dependent upon the context of combat. Whereas the illuminations of Tom Cundall take place away from the battle, this experience is inseparable from it and, taken as a whole, the passage conveys a feeling of exhilaration in unity with a machine and the knowledge that combat must end in death or killing.

This particular brand of exhilaration is also seen in many paintings. Norman Arnold's *The Last Flight of Captain Albert Ball, V.C., D.S.O., 17th May, 1917*[60] (see illustration 12) shows Ball in an SE 5 swooping among a group of enemy aircraft against a sky of transparent clarity, in a composition of forceful exuberance and movement. Here the exuberance is dependent on the life-and-death tension of the moment. Ecstatic purity of landscape, unity of man and machine and exuberant intensity born of the imminence of death, all come together in an experience of great power, extending the illuminatory visions of Yeates but also altering their nature by the presence of death as an essential element. Arnold's painting is far from unique in this. Nevinson's *Archies,*[61] for example, shows the beauty of bursting anti-aircraft shells close to an allied aircraft. The fact that it is painted on glass and has a deep, extraordinarily intense blue as its predominant tone is important in conveying joy and exuberance; but so, too, is the thrill of danger conveyed by the bursting shells. I suggested earlier that the subject of Solomon's *The Mist Curtain* was almost of secondary importance to the colours and textures. This is perhaps true: but the ecstatic mood of the painting is perhaps due as much to the presence of life-and-death conflict as to the strange beauty of the natural surroundings it depicts.

This kind of experience may also be seen in more popular works of visual art, which again capture the immanence of death so important in Yeats's poem. A series of illustrations of seaplanes by Donald Maxwell in *The Graphic*[62] are particularly relevant here. All show seaplanes flying against a brilliant sun, the composition being most pronounced in *The Avengers.*[63] (see illustration 15). A line from the Book of Revelation appears beneath it: 'And they had breastplates, as it were breastplates of iron; and the sound of their wings was as the sound of chariots, of many horses running to a battle'. The intensity of the sunlight and the stillness of the aircraft gives an air of great calm allied to great force: the stasis between battle and release, life and death, is forcefully present here, and the unity of man and machine and the intense joy of the natural scene further intensify the power of the representation.

Yet a more disturbing element is also present. *The Avengers* has a visionary strength related to a small body of men loyal to nothing but their machines, with which they have intuitive sympathy, who find

exhilaration in the notion of a fight to the death which is given justifica-
tion by biblical notions of retribution. This is a clutch of ideas which
becomes deeply disturbing when seen in the context of the coming years,
and when we recall that both d'Annunzio and Oswald Mosley saw the air
forces of their nations as the peak of manly perfection, in a manner
prophetically satirised by Rex Warner's novel *The Aerodrome*.[64]

The range of responses to the beauty of nature and the exhilaration of
flight is wide, and the psychological states it encompasses commensur-
ately complex. In some forms it is a powerful force for understanding and
survival, a way of making transitory sense of the mangled truths of war;
in others it is disturbing in its implications. Yet in all it provides a
striking insight into the mental responses of those most deeply involved,
and shows artistic response and re-creation at all levels as a powerful
force in helping the onlooker – and perhaps the participant – to under-
stand the inner realities of aerial combat and survival.

III

According to the official history, 51 Zeppelin raids took place during the
war years; in them just under 200 tons of bombs were dropped, killing
557 and injuring 1358, and inflicting £1 527 585 worth of damage.[65] In
the Metropolitan Police District, 183 were killed and 516 injured. Dur-
ing the Blitz of 1940–41, 18 000 tons of bombs fell on London alone; in
the months of September, October and November 1940 an average of
210 tons fell each night. Throughout the country 51 509 civilians were
killed in air raids from 1939 to 1945.[66]

Regarded in the light of the later devastation, the air raids of the Great
War were trifling, but to those involved, without the dubious comfort of
knowing the greater suffering to come, their horror was real enough.
Zeppelins were a terror-weapon from the unknown; and for the first time
in centuries England herself, the island fortress, came under direct
physical attack. The psychological impact of the marauding forms in the
night sky was great, and in the effort to come to terms with it artistic
responses are of central importance. Fully to understand such treatments
of the raids in 1916, it is necessary to see them in the context of similar
works throughout the war. These – and the raids to which they respond –
may be considered in four stages. First there was the uncertainty of the
early months of war and speculation, followed by the initial raids, and the
sense of outrage they generated. Then came the period of the heaviest

raids, in which press reports were limited to brief official statements, and then the final period in which many Zeppelins were destroyed and the threat overcome. Stances, responses and images evolve during each stage as means of ordering and understanding the new experience, some restricted to particular periods and others of wider currency. All reveal a collective psychology under threat, and the approaches used to mitigate and finally overcome this danger: in a very direct sense, they show the practical value of the arts in wartime as an aid to survival.

A fitting expression of the early attitude to the Zeppelin threat is a cartoon by David Wilson[67] showing a Zeppelin with a caricature face of the Kaiser flying above the German High Seas Fleet. The heading is clearly intended to be comic: 'The Threat of the Zeppelin: Gas-bag or Terror – Which?' (see illustration 13). This is strengthened by the ridicule of the weapon in the reference to the Kaiser in the drawing, which uses the traditional method of satiric attack through degrading humour: beneath this is a note of considerable defiance, since the act of holding up something to ridicule implies one's superiority over it. Yet the dark tones and enclosed composition hint at an unease and uncertainty which it is the artist's aim to dispel, and this is enhanced by the inclusion of a question mark outlined by the smoke from the German ships. In January 1915, when the cartoon appeared, there had been no raids: there was no suggestion of what their results would be, and Wilson's drawing neatly encapsulates the attitude of mingled defiance and unease beneath a veneer of comedy. In so doing it both gives expression to a prevalent feeling – in itself a cathartic function of no little value – and also suggests a means of overcoming fear. The dual role of both expressing public feeling and attempting to influence and reassure seen here is present in many other treatments of the Zeppelin menace, both in this early stage and throughout their predominance. Fully to realise the value of such responses in coming to terms with the reality of Zeppelin raids, however, it is necessary to consider the intense expressions of outrage that were generated by the raids themselves when they began a few months later.

Typical is a report of a raid on Southend in the *Daily Mirror* of 11 May 1915. Over a hundred incendiary bombs fell, causing the death of one woman, injuries to two others and serious damage to several houses, circumstances essential to a full awareness of the violent anger of the report. Under the headline 'more murder: woman killed by air pirates' bomb at Southend' appears a series of photographs of the damage caused by the raiders, with a text beginning 'The pirates have been committing

more murder, this time from the air'. The *Daily Express*[68] carried extensive eye-witness reports of the event, and *The War Budget*[69] included the following paragraph in a photographic report:

> The huns are so brave as to drop their incendiary bombs from a thousand feet in the air during the night, injuring men, women and children indiscriminately, and then fly away.

References to the raiders as 'baby-killers'[70] were profuse, and the raids were cited as further evidence of German 'frightfulness':[71] the extremity of the reaction shows the deep-seated psychological effect of the raid, which in turn demonstrates the importance of later, less direct treatments of air raids as a way of ordering and accepting their actuality.

A more immediate response was the direction of outrage into more productive channels. The desire to fight back – perhaps the inevitable first reaction – is given striking visual expression in a poster by Frank Brangwyn. A soldier shakes his fist at a departing Zeppelin, in the wake of which lies the body of a woman, whose distraught son is being comforted by another woman in mourning. The heading 'The Vow of Vengeance' aptly expresses the popular feeling of the moment, and the drawing's dark intensity captures the sense of outrage and turns it to a more constructive purpose in terms of the war effort in general. That the poster advertises insurance against air attack for readers of the *Daily Chronicle* does not lessen its impact: taken as a whole it is a fine example of how a psychological outlet and practical function may combine in a work of popular art in wartime. A less intense, but no less representative, interpretation which again harnesses the outrage is L. Raven Hill's cartoon 'Our Friend the Enemy'.[72] A distinguished figure dressed in a frock coat stands on a balcony overlooking a darkened London above which a Zeppelin rides in a searchlight beam. The caption reads: 'John Bull (very calmly) "Ah, here he comes again – my best recruiter"'. It is a fine example of how a cartoon may embody a complex of contemporary response and attitudes with simple directness, and shows the importance of popular art forms giving expression to widespread feeling.

On 1 June 1915 the Press Bureau directed that 'no statement whatever must be published dealing with the places in the neighbourhood of London reached by aircraft'[73] except the short communiqué issued by the Admiralty – then responsible for London's defence – which gave very brief details of locations and casualties. This effectively prohibited the extensive eye-witness accounts of the kind published by the *Daily Mirror* and the *Daily Express* of the Southend raid, with the ostensible purpose

of concealing from the enemy the effects of their work. It was not a success: rumour inflated the casualty figures, and extensive campaigns forced the government both to remove the ban and, more important in physical terms, to improve London's defences. But during the period of eight months when the ban stood, other means had to be found to convey public feeling and guide public response. The means found for these purposes in this key stage of the Zeppelin assault play an important part in the establishment of a popular iconography of depiction.

Cartoons are again of much importance, of them G. L. Stampa's 'Grit'[74] being the most celebrated. An elderly shopkeeper inscribes 'Business as usual during alterations' on the small area of his shop not devastated by raiders. It is comically ludicrous, but it asserts defiance at a time of danger and uncertainty: the cartoonist circumvents official restrictions to make clear that, despite raids and rumours, the daily round continues. An important group of cartoons ridicule Count Zeppelin. Representative is one showing the Count comforting a humanised airship which counters his accusation of failure to destroy London in the words 'Then you had no success?' with 'Oh, yes, father; I've got home again'.[75] Others disarm the raiders by making them comically familiar. A distraught landlady cries ''Ere's the Zeppelins, sir!' to be met by her drowsy lodger's comment 'Right-o! Put 'em down outside':[76] the effects of 'frightfulness' are depicted in a series of four drawings of that title, which show devastation resulting, not from air raids, but from complaints about high grocery prices and badly-cooked breakfast eggs.[77] A further comic target is the excessive fear of the nervous. An anxious wife awakened by a raid asks her husband if he has locked the front door,[78] and a portly gentleman practising 'easy descents' in a Zeppelin fire-escape-ladder finds himself inextricably entangled with it.[79]

Taken together, these cartoons, and the many more of which they are representative, perform an important function in influencing public opinion about Zeppelin raids, forming an essential adjunct to the official communiqués and a counter to alarmist rumours. Stampa's drawing shows the desire to keep going under all difficulties, and also illustrates the traditional national desire for understatement: the ridicule of the Count is a simple assertion of his invention's failure, and the others stress the essentially harmless nature of the raids and the foolishness of over-anxiousness in responding to them. In all, they emphasise the very limited effect of the raids on morale, the inadequacy of the threat, and the ample strength of the people in rising to meet it and continue their normal lives. Concealed within this, perhaps, is an inner uncertainty which prompts the need to prove such strength by open statement: yet

artistic responses such as these seem of great importance in giving order and perspective to the threat, also serving as a source of courage and means of reassurance by providing a pattern and example to be followed by the onlooker.

A similar psychological function is fulfilled by a second popular response, which was frequent during the stage of press control but also thrived throughout the war; a simple fascination with the mechanical features of the airships. Illustrated journals and contemporary histories produced large spreads of photographs and diagrams showing the Zeppelins' size, methods of buoyancy and control, and pre-war proving flights. The *Illustrated London News* of 18 September 1915 is typical in this, describing the construction in straightforward and apparently quite impartial terms:

> The hull within is divided into from seventeen to twenty-three isolated compartments, each holding an oval gas-bag, with safety-valves, etc., the idea being to enable the airship, as a whole, to keep up should a shot pierce any one part of the hull.

This approach continued throughout the craft's use: later reports discuss the addition of a stern propellor, chart the development of the weapon since the war began, and examine the construction of the later 'Super-Zeppelin'. Often the language assumes no little knowledge on the part of the reader. References to gondolas, auxiliary suspension cables, 'power eggs'[80] and 'strong aluminium alloy'[81] are frequent. The particular significance of treatments of this order is that they remove the element of the unknown from the Zeppelins which, in the early stages, and later on when new versions were introduced, was the most likely element to induce fear. Fear of the unknown is always stronger: as a contemporary account confessed, 'It is the uncertainty attaching to an air raid that is most to be feared'.[82] Daily experience was making the raids themselves familiar, and cartoons were extending the familiarity into contempt: a detailed awareness of the nature of the raiding machine was a further necessary stage in removing ignorance and consequently in mitigating fear. Once more the psychological importance of popular treatments of the raiders as a means of rendering them comprehensible, and thus endurable, is clear.

Overlapping with this stage of the air war, but continuing until the later months of 1916, was a convention of depiction in word and visual image which rests once more upon fascination. It contains some of the most striking treatments of the theme, and reveals if anything a more

significantly widespread complex of attitudes, since the convention extends to writing of all types, drawings in popular journals, and paintings of a more serious kind. A passage from Edgar Wallace's weekly history *The War of the Nations* establishes the language of fascination:

> It floated into this great concentration of fierce white light, a silver pencil, moving at an incredible height, and so far away that it seemed that the crash and roar of its dropping bombs had no association with that beautiful, almost ethereal, vision of the skies.[83]

It is shared by Michael MacDonagh's private experience:

> High in the sky was a Zeppelin picked out of the darkness by searchlights – a long, narrow object of a silvery hue! For a few minutes the airship . . . was plunged upon by two searchlights, and in their radiance she looked a thing of silvery beauty sailing serenely through the night.[84]

Other accounts from a wide range of sources share the fascination, describing the airships as 'like a heavenly messenger of glistening gold'[85] and 'a terrific but very splendid sight'.[86] The complexity here is considerable. To begin with there is the heightened appreciation of the beauty of the night sky which Londoners saw afresh because of the blackout regulations. Added to this was the novelty of the searchlights of progressively greater power and quantity which cut through the darkness. The attitude which sees the raiders as objects of beauty, quite apart from the literal truth of the strangely ethereal visions they presented, again shows the desire to familiarise and remove from a context of fear and danger something potentially of great disruptive power. Two further elements are discernible. First, the image is a combination of beauty and fear in a latter-day embodiment of Burke's principle that terror is implicit within the sublime and, more important, the same element of mesmerism which forces a child to revisit scenes of horror to steel itself against the fear.

This complex of attitudes is also expressed in many visual treatments, which are almost exact counterparts of the verbal accounts quoted above. The iconography is immediate: a Zeppelin is caught in the beams of searchlights, with buildings and sometimes spectators silhouetted beneath. An anonymous but heavily retouched photograph in Wilson and Hammerton's weekly *The Great War*[87] is one of the earliest to establish the pattern of extreme contrasts of light and dark, which is taken up in later versions. The *Illustrated London News* of 23 October 1915 has a

drawing showing an airship in searchlight beams above the rooftops, with an intriguing caption:

> The picturesque vision of the shadowy enemy sailing overhead and dealing death here and there on man, woman and child without discrimination, suggests a Whistlerian Nocturne.[88]

It is ironic that an artist whose work so soon before the war had been regarded as the apogee of anarchy and dissolution should now be seen as a yardstick of beauty: but it is also, perhaps, an intentional reference to the greater lawlessness of the Zeppelins themselves. However it is regarded, it is certainly a striking evidence of the interchange of idiom and style between popular and fine art under the exigencies of war for a most valid purpose: the description of a weapon as an object of beauty is a strong statement of defiance. Similar depictions are frequent: an anonymous drawing in *The Graphic* of 25 September 1915 [89] displays the iconography in simple form, Edwin Bale's treatment of the theme in the same journal some weeks later[90] reduces it almost to semi-abstract levels, and Charles Pears's large painting *The Attack on the Zeppelin*[91] (see illustration 14) is the finest of his many similar works, this one adding the elements of bursting shells and light reflected on water in a fearfully literal translation of Whistler nocturnes of fireworks over the Thames.

Fascination and defiance are clearly present in this convention of representation, perhaps evidencing once again the desire to conquer fear by constantly confronting its object. Perhaps the very existence of a convention of such visions demonstrates a mildly obsessive state of fear. Whether or not this be the case, it is certain that the depictions reflected popular attitudes to the airships, which were greeted on every appearance by crowds in streets and open places anxious to see them. The same editions of the popular papers which report the outrage at Southend discussed above go on to describe onlookers rushing out into the streets. Michael MacDonagh records the suspension of a Parliamentary session during 'a rush of Members and journalists out into New Palace Yard,'[92] to observe the raiders, and a *Punch* cartoon shows an illuminated Zeppelin above a coastal resort with the legend 'go to Northend-on-sea: Frequent Zeppelin displays'.[93] Clearly the convention is recording the mood of the moment: how far it was responsible for generating the mixture of defiance and fascination is impossible to ascertain. Without question, the artistic treatments are a means of ordering and defining the reality of the raids: the need to fix a strange and complex reality within an artistic

convention shows well that the popular and fine arts fulfilled a clear psychological need.

The final stage in the treatment of Zeppelin raids continues and develops the iconography just considered, and shows the role of the arts in moments of clear, if transient, victory to complement its function in time of doubt. September 1916 saw the beginning of the defeat of the airships with the introduction of incendiary bullets and improved night-flying techinques. From the depiction of Zeppelins in searchlight beams it was a logical development to paintings of Zeppelins crashing in flames, and many of these were executed to reveal the exuberance of the early victories. E. S. Hodgson's drawing[94] of the fall of the Schutte-Lanz airship at Cuffley is one of the earliest, to be followed by many other versions of the same incident. These vary from those which present it as a distant splash of crimson against a night sky – along the lines of earlier views of airships in searchlights – such as a drawing in *The Bystander* of 27 September 1916[95] and T. B. Meteyard's water-colour *Zeppelin coming down at Cuffley*,[96] to much more terrible depictions such as Charles Dixon's illustration for *The Graphic*.[97] Gordon Crosby's huge canvas *Lieutenant Warneford's Great Exploit*[98] depicts a similar but earlier en-counter in like fashion, and Dixon's *A Zeppelin's lurid end above the clouds*[99] shows a later incident in similarly brilliant tone and texture. There was no shortage of photographs of the falling airship, which were carried by all the illustrated weeklies: but the merely photographic was inadequate to the mood. As *The Graphic* said, the Cuffley victory was 'the greatest spectacle ever offered to London, and all London could see it'.[100] Only the imaginative power of the artist could fully express the exuberance of victory in depicting the falling Zeppelin: again popular art is seen to fulfil a real psychological need.

The interpretative exuberance of the artist is matched in many repre-sentations of Zeppelins aflame by the contextualising import of the literary quotation, which stresses the great significance of the event by reference to cosmic events from the Bible or *Paradise Lost. The War Budget*[101] captions an appropriate drawing of the Cuffley Zeppelin by Filmore with the line 'As Lucifer like lightning fell from heaven' which, as well as being literally true, adds the moral implication that the hubristic 'frightfulness' has been justly repaid. Michael MacDonagh's more extensive quotation[102] fulfils the same purpose:

> Him the almighty Power
> Hurl'd headlong flaming from th'ethereal sky

With hideous ruin and combustion down
To bottomless perdition.

Dixon's picture of the Cuffley victory is captioned 'A pillar of fire by Night', and the same words recur over a *Graphic* illustration[103] of the fall of a later Zeppelin. The moral significance is great: the pillar of fire in the book of Exodus serves as a symbol of God's presence in guiding the children of Israel towards the promised land. Its quotation here suggests both the moral rightness and the ultimate victory of a divine cause. Exuberance is matched by moral fervour, and the visual convention amplified by the contextualising machinery of literary allusion. The treatment of Zeppelins began with rather hesitant statements, concealing uncertainty beneath comedy: the growing complexity and confidence reflects clearly the changing approach to the threat they present and its eventual defeat, and shows the importance of artistic interpretation to both reveal and, we may infer, influence attitudes and responses. In this, popular and fine art can be seen to perform a major role in the psychological survival of those under threat.

IV

It is salutary to compare the different roles of artistic interpretation discussed in the foregoing pages. Whereas the chivalric myth of the flying services in France was created for a public unaware of the real dangers of aerial combat, and without the direct involvement of those who flew, the more various treatment of airship raids was undertaken for those who mostly knew well the realities, either by personal experience or first-hand report. The latter, consequently, are far more closely related to the psychological realities of the situation, whereas the former generates a myth of little permanent relevance or value. If the mythic treatment aided the young pilot to survive by giving him a paradigm against which to build his own reality, it did so more by accident than intent: conversely, the treatment of Zeppelins seems at almost every stage to reveal an insight into the mental state of those under attack, and to offer cathartic release, in so doing providing a major force of survival and endurance.

In many ways comparison is inappropriate, since the risks from airship raids were infinitely less than those of aerial combat: the latter was far more in need of a heroic myth as a redefinition of reality. Both are valuable in terms of allowing the beholders to comprehend and survive.

Yet the greater apparent honesty of the Zeppelin visions inevitably suggests that those at home were able to accept a greater realism and psychological acuteness than that habitually offered them. This suggests that the public at home are capable of bearing reversal and hardship with both dignity and forbearance. That it was so long before the authorities allowed them to do so, in releasing information that was up to date, accurate and not loaded with false optimisim, remains one of the larger instances of authoritarian misjudgment of the war years.

The value of the remaining kind of response – the ecstatic uniting with nature in the joy of flying and the imminent threat of death – is less certain. Doubtless it records the feelings of many of the fliers themselves, in both its aspects. It must also be acknowledged that, as a means of surviving the horrors of the air war which, as we have seen, were as real and various as those of the trenches, it had its usefulness. But at the same time it developed the idea of the flier-élite, caring only for its machines and its ideals, and as such it is a chilling premonition of the larger terror to come in the 1930s and 1940s.

7

The Snark of the Somme

By September it was clear that the breakthrough with which the Somme had begun had not been sustained. To give added force to the attack, it was decided to use the new weapon which had been developed in secrecy for some months – the tank. The tanks first went into battle on 15 September in the Ancre valley. They were not used in anything like the number that their creators saw as essential for them to have their full effect; but some remarkable gains were still achieved. For a brief period, before the enemy won back the ground they had lost, it seemed as if an advance of major proportions had taken place.

This element of victory was something which early reporters of the tanks were keen to convey to their audiences at home: yet they were faced with considerable difficulties in this task. It was two months after the first use of the weapons that photographs were released, and considerably longer until the press were invited to a public demonstration of the vehicles in action. Verbal accounts were placed under equally strict censorship so that, in all, the information allowed to reach the public was scant. In addition, there was the sensitive issue of the fairness of the tanks to be overcome: British outrage at German poison gas and Zeppelin raids rested squarely on the traditional sense of fair play, and anything which suggested taking an unfair advantage needed very careful treatment. Yet, although the long-term gains of the tanks' first assault were slight, there were some outstanding individual successes, and the over-all effect of their initial appearance was certainly that of a significant victory in terms of morale, which writers, correspondents and artists naturally wished to exploit. They found themselves in the frustrating position of having before them what appeared as a considerable breakthrough at minimal cost achieved by a wholly new device of war, but with a complete ban on factual reporting or description beyond the most basic outlines and suggestions. Haig's first mention of the tanks in an official communiqué is hardly informative:

In this attack we employed for the first time a new type of heavy

armoured car, which has proved of considerable utility. 12.50 p.m. Friday, 15 Sept. 1915, France.[1]

Under this ban, correspondents had to create a representation of the new weapon vague in outline yet compelling in atmosphere, at once stressing its fairness and revealing its invincible might.

These circumstances are worth emphasising, since the solutions found by those preparing the first accounts, both verbal and visual, in essence created the public perception of the tanks in a way that no simple photographic accounts could have done. Early accounts were not only informative, albeit in a skeletal way, of recent developments: they also generated a clear attitude towards the new machines and, in so doing, established a powerful iconography which became inseparable from the weapons themselves for as long as they remained in the public eye, persisting throughout the war in popular accounts and way beyond it in memoirs, fictional works and even official histories. Thus the early accounts are of crucial importance in assessing a literary and visual response to the tanks themselves and, in a larger context, are symptomatic of a series of attitudes to war in general in the popular arts.

In the quest for a paradigm of description linking the opposites of precision and vagueness, fairness and military worth, early writers found one kind of verbal imagery of paramount effectiveness which was to exercise profound influence on later responses. This was a group of related images relating the tanks to domestic, mythic and prehistoric animals. There were other techniques, many similarly intended to reveal familiarity and fairness, and some, like the naval imagery encountered in many accounts of the tanks' design and development, aimed largely at providing an honourable ancestry for them: but the animal imagery was by far the most frequent and influential. A close examination of one of the first press reports will show its effectiveness:

A slight hollow . . . was full of the monsters, like cows in a meadow – large shapeless bulks, resembling nothing else that was ever seen on earth, which wandered hither and thither like some vast antediluvian brutes which Nature had made and forgotten. Painted in venomous reptilian colours, which made them invisible against the dun background of dry autumn grass and bare soil, they were inexpressibly suggestive of living things – hybrids between Behemoth and the Chimaera, toad-salamanders, echidna-dragons – anything you please which is mythical and fantastic.[2]

The appearance of the tanks may give rise to some of the animal

comparisons, but much of the language here is derived from more complex sources than physical resemblance. The initial image is clear enough, the comparison to cows a simple device to render the tanks harmless by association: it is impossible to regard such a beast with horror. Those which follow are less straightforward. The impression of harmlessness is still strong, but it is clear that the terror is real enough in one form here. The suggestion of massive, evil shapes made by the words 'vast antediluvian brutes' is aided by the colouration, but it is noticeable that it is the colours and not the tanks themselves which are described as 'venomous' and 'reptilian': these would be too clearly repulsive terms with which to hail the newly-triumphant weapon. The comparison to prehistoric monsters is more complex. Such animals are indeed horrific: but the horror is strictly controlled, since we are aware of their herbivorous habits and also of their extinction. Conan Doyle's *The Lost World*, in which such beasts figure prominently, enjoyed great success when published in 1912, and they are extraordinarily popular among young children. The horror they inspire is genuine, but it is familiarised, as such monsters are regarded almost with a type of affection which lessens and controls their fearsomeness, and the reference here, while maintaining the idea of horror, really has little to do with the genuinely terrible aspect of the tanks because of the context within which it is placed.

Reference to Behemoth and the Chimaera is of further significance in re-defining the horror of the tanks. Behemoth appears at the end of the book of Job, first as an example of the placidly benevolent strength of God:

> Behold now Behemoth, which I made with thee; he eateth grass as an ox.[3]

Apart from echoing the herbivorous nature of 'antediluvian brutes', this reference stresses the essentially benevolent nature of the tanks, whether consciously or not. The word is used very frequently elsewhere in their description, and this is important when the idea of its creation by God is recalled, since it is a small step from there to the idea of an instrument of divine Nemesis, made explicit in a later verse:

> He is the chief of the works of God: he that made him can make his sword to approach unto him.[4]

This places the horror in the context of righteous wrath against evildoers, which is added to the earlier suggestion of placidity. Thus both invinc-

ible rightness and fairness are conveyed by the placing of the weapon within a biblical context, which also serves the function of distancing the reader from the real horror of the tanks.

This complex of contextualising is balanced in the reference to the Chimaera, a monster compounded of lion, serpent and goat slain by Bellerophon. The animal's very constitution repeats the combination of terror and placidity, and again the former is subsumed into an unreal context – in this case mythical – to provide further distancing from tangible fear. The final line of the passage repeats the stress on the mythical and fantastic, with the effect of reinforcing the earlier images.

Perhaps the most important single significance of the passage lies in the statement that 'they were inexpressibly suggestive of living things'. The images are genuinely terrifying, albeit within the context of myth which distances and redefines their frightfulness: yet this horror is always an animal, living thing, far less horrific than the mechanistic atrocity of the tanks as real engines of war. Final reference to 'toad-salamanders' and 'echidna-dragons' completes the unity of real and mythic beasts to make them both familiar and remote, harmless and artificially terrible, the toad's placidity complemented by the sala-mander's grandeur, the harmless echidna – an Australian burrowing hedgehog – matched with the heraldic force of the dragon.

The passage from *The Times* is important in drawing together the main strands of the animal imagery employed to describe the tanks, ranging from simple domestic beasts to prehistoric monsters, and mythic and fantastic creatures with complex dual significances such as Behemoth and the Chimaera. Similar references abound. The prehistoric theme is a cornerstone of Beach Thomas's early account in the *Daily Mail*, which describes tanks as 'blind creatures emerging from the primaeval slime'.[5] Philip Gibbs, too, likens the tanks to 'prehistoric monsters . . . the old Ichthyosaurus',[6] but later adds to this the reassuringly familiar in 'toads of vast size emerging from the primaeval slime'.[7] Beach Thomas takes the mythology a stage further by quoting from Lewis Carroll:

> To watch one crawling round a battered wood in the half light was to think of 'the Jabberwock with eyes of flame' who 'Came whiffling through the tulgey wood, And burbled as it came'.[8]

The horror is real enough: but by the literary association it is rendered akin to a shadow on the nursery wall, and again a distancing context is created which, paradoxically, makes the horror less real by making it more familiar.

Almost every initial account of the tanks uses the animal iconography in one form or another, establishing it not only as a means of representation, but also as a classification and definition of tanks as both horrifically effective and ludicrously familiar, at the same time laying stress on their great effectiveness in battle and precluding any ideas of their unfairness, the dual perceptual stance achieving near-ideal expression in the range of animal images employed. The profound effectiveness and success of the imagery is revealed by its very frequent use in later accounts of all kinds, in which it predominates over all other kinds of figurative description which aim to engender similarly positive responses, consciously or otherwise. Examples are legion. J. C. Macintosh's *Men and Tanks*,[9] a fictionalised reminiscence of active service in the Tank Corps, talks repeatedly of 'faithful beasts'[10] and 'antediluvian monstrosities'[11], and as late as 1918 captions to photographic illustrations in the *Illustrated London News* still refer to 'antediluvian monsters'[12] and 'primaeval mastodons'[13], and to 'herds' of the tanks which are 'Monsters not indigenous to the soil of Palestine'.[14] Captain D. G. Browne, in one of the better histories of the use of tanks, attacks the 'halfpenny strategists, Messrs Gibbs and Beach Thomas, tossing up a coin . . . to decide who should use the word Behemoth' and continues that 'this ignorant flapdoodle did an ill service to the new unit'.[15] Yet, only a few pages before, Browne himself describes a tank training ground as 'a zoo during the Pleistocene Age' and refers to tanks as 'gorgeous monsters' and 'some huge prehistoric animal'.[16] The language is even employed, albeit in ironic fashion, by the Tank Corps's commander, in designating a scheme for the concealment of tanks to fight in isolated rearguard actions in the German offensive of spring 1918 as the 'Savage Rabbits' operation,[17] nicely capturing the elements of familiarity and violence implicit within the earlier images and thoroughly demonstrating their pervasive influence.

Once the violence of the tanks has been subsumed into this semi-mythic animal context, it is freely and frequently stressed in the strongest terms, to emphasise the extraordinary military worth of the weapons. An early but representative example of this is found in the caption to an illustration of the destruction left behind by a tank – censorship still precluding depiction of the vehicle itself – appearing in December in *The Sphere*.[18] This makes reference to toads and lizards as well as Diplodocus and Behemoth, revealing a familiar complex of redefining responses. But the sheer power of the machine is also conveyed, making explicit the duality of the animal images as both placid and immensely threatening:

When one sees the unspeakable things moving, with their great blunt noses thrust in the air before them, limbless and wheelless, going with a movement as smooth as that of a snake, but majestic and deliberate as a giant tortoise, it is such a mixture of pantomime and pure horror as no nightmare ever equalled.

Violence is quite explicitly revealed, but it is still within the context of animals, which prevents the tanks from being seen as unfair or villainous. In this the caption is typical, as comparison with the examples quoted below will reveal. It is also typical in another way, namely its stress on the comic absurdity of the new monsters. The mixture of nightmare Gothic and absurd comedy is present in many of the accounts quoted above, as an extension of the duality of purpose implicit within the animal imagery. It is taken a step further by many artists and cartoonists immediately after the first appearance of the tanks when censorship precluded accurate visual representation. In many ways these have an important function in keeping alive public interest in an important news story, but they also have deeper significance. The elements of comedy and nightmare again reveal the strangely familiar, strangely distanced attitude of the animal images of early press reports, and this language is essential to both elements. Tanks are depicted as strange monsters of all kinds, familiar yet horrific, comic yet deadly, and placed within contexts mythic and literary to provide the same duality of response as that generated by their verbal equivalents. The mere use of such representational techniques shows the sheer pervasiveness of the animal imagery, not only in the literal way in which the cartoonists interpret it, but also in the way that its duality is represented: for, however comical the mythical beasts appear, the response of the German troops which they attack is always one of panic and terror. Such cartoons appeared in *Punch*[19] (see illustration 16), *The Bystander*[20] and other magazines, and *The Weekly Dispatch* commissioned 'the most famous humorous artists of the country' including Heath Robinson, H. M. Bateman and Alfred Leete to air their fantasies inspired by press reports in an article called 'My dream of Tanks'.[21] All show German troops recoiling in exaggerated horror before extraordinary animal shapes advancing on them, encapsulating the dual response of the verbal accounts in very direct fashion. Some capture the more complex redefinition of certain prose accounts. A drawing in *The Graphic*[22] by David Wilson shows a machine horrific in its size and violence, yet its caption places it within the context of comic parody of the animal iconography, and more important, the description

of the machine as 'The Snark of the Somme' echoes the reference to stylised, literary horror already encountered in Beach Thomas's Lewis Carroll quotation.

The pervasive animal imagery, with its successful linking of horror and comedy, familiarity and mythic distance, is thus a major force in generating a dual perception of the tanks in the early stages of their use, which effectively solves the many problems which faced the early reporters, but which also had great influence on later verbal treatments of the weapons. Some measure of its influence may also be seen in what are apparently more serious artistic responses to the weapons, as will later be shown; but it is the element of duality it contains which is perhaps the most pervasive feature in treatments of all kinds. In the animal imagery, this duality is encapsulated in a single unified response. In many paintings and illustrations, it is matched by, and often combined with, another form of duality which is well expressed in the following lines;

> The tank is terrifying, or inspiring and rather ludicrous, according to whether it is against you or for you.[23]

Whereas the duality of the animal iconography is implicit within each individual statement to employ it, that reflected in this statement depends clearly upon the viewpoint of the beholder and, as will become apparent, the literal truth of this gives rise to two powerful conventions of representation in both popular and serious visual responses to tanks. The differences of the opposing viewpoints, and their very precise iconographic conventions, are well shown in the caption to a drawing by Sir Muirhead Bone. Also apparent here is the degree to which these two threads are really a separation of the two approaches of the animal iconography:

> the 'Tank' is seen here not as the British soldier sees it – a friendly giant with lovable droll tricks of gait and gesture – but as it must look to a threatened enemy, the very embodiment of momentum, irresistibly grinding its way towards its prey . . . the spectator is as crushed worm and, in fact, finds there is more force in that phrase than he knew.[24]

The comic absurdity and nightmare horror of the tank is again shown in animal terms; but, whereas the verbal treatments in images such as that of the prehistoric beast contain both these elements within one iconography, the passage suggests that visual representations other than the imaginative cartoons already encountered require two parallel but in-

dependent conventions to do so, as is indeed the case.

The drawing captioned by the above passage reveals one of the two strands, in quite simply depicting the tank from the viewpoint of the enemy, seen from the front and the side with the eye-level considerably lowered, so that the tank becomes a threatening bulk towering over the onlooker. Another drawing of Bone's[25] makes this point more forcefully still, and many other depictions use closely similar techinques. A much reproduced official photograph[26] shows the effect of the view very clearly, with no exaggeration from the artist's imagination to stress the tank's threatening aspect, which is none the less considerable. A drawing by D. Macpherson in *The Sphere* makes full use of the viewpoint, and the sheer mass of the front horns of the tank looming above the trench parapet is once again emphasised by the lowered eye-level.[27] It is interesting to note that the first published photographs[28] and drawings[29] which show the tanks from the front have a slightly higher eye-level, so that the impression of mass and weight is lost. But there are very few of these, and the lowered viewpoint quickly becomes the standard perspective to stress the tanks' forcefulness. As before, the early versions tend to establish the pattern for later treatments. Subsequent official photographs make full use of the threatening aspect of the full front view of the tanks breasting enemy trenches, and this is often turned to fearful dramatic effect in drawings, for example in an illustration by Fred Leist, an official artist to the Canadian Forces, in *The Graphic* in September 1918.[30] This introduces the element of machine-gun fire emanating from the gun-port in the tank's central front plate, which is also present in a similar drawing which appears on the cover of Richard Haigh's *Life in the Tank*,[31] a post-war memoir. A popular engraving by G. De Witt[32] exaggerates the tank's size still further, so that it becomes almost an abstract shape, but still one of immense mass and violence. It is not only the more popular treatments which use such iconography: perhaps the most disturbing of all depictions of this kind come from the least likely source, the official war artist Sir Willian Orpen. In *A Tank*[33] (see illustration 19) the weapon is silhouetted against a lowering sky and desolately-coloured landscape on the brink of a trench, and in *Tanks*[34] two vehicles are shown in the same threatening position, if anything increasing the other's horror in the power and intensity of the two towering forms.

In all these illustrations, then, the same technique of foreshortening and a lowered eye-line to emphasise the threatening force of the tanks is employed, giving powerful expression to the violence of the weapons and the awesome effect they have upon the enemy. It is interesting to note that the characteristic viewpoint from below and slightly to one side of

the weapon is used also in several of the cartoons which depict tanks as mythical monsters, David Wilson's 'Snark of the Somme' in particular conveying the destructive force implicit within more naturalistic depictions, and further evidencing the widespread currency of this particular iconography, which reveals one aspect of the dual attitude towards the tanks.

It is balanced by an equally widespread iconographic tradition in the depiction of tanks as friendly and victorious weapons seen from the viewpoint of the troops advancing with them. Here the established viewpoint is from the side and rear of the tank, placing the onlooker in close proximity with the vehicle from its ally's standpoint rather than its enemy's. An early Canadian War Records photograph[35] – one of the very first to be reproduced – is probably the initial source of this iconography, with viewpoint from behind and beside the tank with the eye-level at its natural height, about a foot beneath the highest point of the tank's superstructure. A week after its publication, a drawing by Alfred Pearse[36] established a new context for this view of the tanks which became the convention for later depictions. The tank is shown from an identical viewpoint, but it is now surrounded by heroically-advancing Tommies. Later depictions of this kind abound. One of the more interesting is an illustration by D. Macpherson in *The Sphere*[37] showing tanks advancing in the company of highland troops from exactly the same angle and, as in the Pearse illustration, overcoming German opposition with ease. Again the iconography is not restricted to popular illustrations. Bernard Adeney's *A Mark V Tank going into Action*[38] (see illustration 17) shares this viewpoint and includes advancing figures, while his *The Advance*[39] combines elements of both iconographies.

One further aspect of the duality revealed in these two conventions of representation is of interest, namely the sheer size of the tanks. In all the representations of tanks from the advancing soldier's viewpoint, the dimensions of the tanks are often reduced so as to stress the companionship between infantry and mechanised artillery. Conversely, those which see the tanks from beneath a trench parapet often exaggerate their proportions. For example, Frédéric de Haenen's early depiction which is otherwise unusual in showing the tank in profile,[40] shows the tank at about one and a half times its actual size.

The two conventions of visual representation here catalogued show an alternative solution to the problem of showing the tanks as both fair and effective, and the duality they reveal when seen in combination echoes very clearly that implicit within the single verbal convention of animal imagery. There are other influential conventions which reveal similar

esponses: but in these closely related verbal and visual iconographies is contained the essence of the complex nature of responses to the tanks, solving the initial problems with vigour and imagination and also revealing important larger issues about perceptual stances in wartime to which we shall have cause to return in a later chapter.

II

The house is crammed: tier beyond tier they grin
And cackle at the show, while prancing ranks
Of harlots shrill the chorus, drunk with din;
'We're sure the Kaiser loves our dear old Tanks'

I'd like to see a Tank come down the stalls,
Lurching to rag-time tunes, or 'Home, sweet Home',
And there'd be no more jokes in Music-halls
To mock the riddled corpses round Bapaume.[41]

However effective the popular perceptions of tanks were, Siegfried Sassoon's lines point out their essential flaw: the lack of any genuine moral sense. Since the fairness of the weapons was one of the original difficulties so convincingly solved by the popular iconography, it is fruitless to look within it for statements of outrage. Yet the poem, as well as showing how completely treatments of the kind examined in the foregoing pages sidestep such issues, raises the question of whether any other artistic responses to the tanks adopted a stance of ethical rather than pragmatic validity. The number of 'serious' paintings of tanks is not large, but their range of style and attitude is considerable, approaching in some cases the intensity of Sassoon's poem – although responses of such force are very few in number.

One end of the range may be seen in some of the illustrations of Bernard Adeney, an official war artist who was a gunner in the Tank Corps and who consequently had intimate knowledge of the weapons and their reality, which bore little relation to the heroic myths and affectionate metaphors of the popular representations. Yet little of this is revealed in one particular group of his works, which seem essentially to be engineering drawings with a fascination for the mechanical aspects of the tank. *A Mark IV Male Tank*,[42] for example, is a pencil drawing of the tank's side elevation with the addition of a tree and some slight foreground detail, exactly of the kind found in architectural drawings. Other

pencil sketches show tanks from other viewpoints in similar idiom, which is as free from interpretative rearrangement as one might reasonably expect of a drawing, since there is no depiction of surrounding battlefield, and certainly no heroically-postured troops. All is reduced to crisp, precise outlines and stylised shadows: one almost expects a drawing office cartouche in the bottom right-hand corner. Only slightly less disinterested are some of the ink and water-colour sketches of Adrian Hill. *A Wounded tank, from the Hamel engagement,*[43] for example, retains the rigid side-elevation of Adeney's drawing and, although it is placed in a more explicit setting, it is one of wrecked military equipment impersonally presented and not a desolate battlefield shown with genuine compassion.

Little by way of interpretation, let alone moral stance, is evident here, and the two charcoal and wash drawings by Sir Muirhead Bone referred to above are far more effective in revealing the horrific aspect of the tanks, ironically enough when seen in the light of the frequent attacks made on his pedestrian approach. Adeney and Hill may also be considered together in a second type of visual response: those paintings which show tank depots and workshops in which vehicles are undergoing repair. Hill's *Repairing a Male Tank, In the Workshops, Blangy*[44] records engineering work with a precise documentary detail, like many paintings of the eighteenth and nineteenth centuries, of work in railway or industrial workshops such as, say, J. C. Bourne's series of sepia washes of railway works,[45] and fulfilling the mundane aim of Haig's 'permanent record of the duties which our soldiers have been called upon to perform'.[46] Apart from Haig's aim, there is no reason why representations of such scenes should not comment upon the reality they reveal: the condemnatory vigour of de Loutherbourg's *Coalbrookdale by night,*[47] in which vast flames dwarfing the figures of working men make a powerful statement about the fierceness and destructive effect of industrialisation on human and natural values, is part of a tradition of landscape painting in which the artist's condemnation is implicit. There are paintings from the war years which fall into this convention: George Clausen's *In The Gun Factory at Woolwich Arsenal, 1918*[48] and its series of associated lithographs make a single, clear point through stylistic reference to paintings such as de Loutherbourg's. They are clearly in a tradition of horrified fascination at the destructive power of mechanism which the earlier artist and his contemporaries began, whereas Hill's sketch falls into a convention of simple, unthinking photographic record. Some of Adeney's work comes into a similar category, but increases the detachment by the use of soft pastel colours; the tanks and their workshops become toy-like against a

background of gentle pinks and blues, and any impression of weight or mass which might reveal an interpretative stance is firmly negated by this incongruity of colour and texture. There is a fascination about them, but again it is that of the engineer who has little thought of the effect of the weapons he is designing.

A similar incongruity of medium appears from a most unexpected quarter, in John Singer Sargent's water-colour *Camouflaged Tanks, Berles-au-Bois*,[49] depicting two officers seated to the side of a camouflaged tank beneath a group of trees. As a water-colour it is exquisite, the use of the medium to display the brilliant dappled light beneath the trees being simply virtuosic; yet as a reponse to the weapons themselves it is far less satisfactory, largely because of its technical supremacy. As with Sargent's *Arras*[50] – a depiction of the ruined cathedral very much in terms of a romantic meditation on classical ruins – we feel that the interest in chiaroscuro and composition predominates over a relevant interpretative response, and the painting is more suggestive of spontaneously ebullient English summer landscapes than the destructive forces of the tanks in battle. Perhaps this shows the continuity of tradition in wartime, constituting a reaction of some strength to the incongruity and unreality of the scene; but as an approach to the nature and purpose of the tanks it is wholly lacking in relevance.

Sargent's water-colour is a heavily romanticised view of tanks within a landscape, both physically and with all the art-historical associations the term conveys. It is to other treatments of this conjunction that we must turn to find any more serious moral and intellectual response to the real nature of the tanks. There are, almost inevitably, paintings which show the tanks in a battle context, stressing their heroic force in a manner suggestive of the long traditions of battle landscapes which have adorned officers' messes since the eighteenth century. It is perhaps not surprising that those which fall most clearly into this category, such as Edward Handley-Read's *Advance of Tanks*,[51] which depicts tanks crossing a battlefield apparently impervious to bursting shells in very much the fashion of latter-day comic-book illustration, were shown in a very popular exhibition at the Leicester Galleries in 1917. But the same exhibition contained other paintings by the same artist which are much more sensitive in response, namely, *A Tank and a Crater*[52] and *Derelict Tanks in High Wood*.[53] Both show tanks within ravaged battlefields, surrounded by broken, limbless trees, in a manner which reveals not only the destruction caused by the hostilities of which the tanks are a part, but also the vulnerability of the weapons themselves. A painting by Sir William Orpen, *The End of a Tank and a Hero at Courcelette*[54] is very

rare in showing the body of a tank officer next to the ruined bulk of the machine itself, extending Handley-Read's theme with infinitely more strength and pathos. The composition is strangely fragmented. The tank is shown greatly foreshortened from the front and side, but with none of the mass and force usually associated with this perspective. It is a lifeless thing, amid an arid, tussocky landscape, and it is balanced by the body of the 'hero' and fragments of uniform and equipment scattered in the foreground. The arbitrary nature of the composition is complemented by its few touches of colour, which give the pencil drawing an air of drained tautness and nightmare clarity. The scene is given an impersonal remoteness which, unlike that of the documentary sketches of Adeney and Hill, adds to its horror. The apparently arbitrary fragmentation reflects the purely mechanical aspects of the tank's destructive power, and in this it is one of the most serious and condemnatory statements about the weapons and their consequences, made more effective by its complete lack of stylistic reference or iconographic allusion which seems to stress the strangely alien nature of the machine. Moral statement is thus clearly present in this account of seemingly fortuitous desolation, in which landscape and tank are united in a literal and metaphorical wilderness.

Tank and landscape are again united, in a different idiom, but for a related purpose, in other paintings such as David Baxter's *A Tank on the Menin Road, Ypres*[55] and, most significantly, Adrian Hill's *A Derelict Tank, Ypres.*[56] In the latter the ruined tank is silhouetted against a sky which reflects the dull brown of the foreground, a desolation of mud and waterlogged shell-holes. The dark, murky texture of the mud overwhelms the whole composition and is unrelieved by the tank itself, which squats uncertainly on the horizon. It is impossible to regard it in the terms of heroic myth or comic fantasy of popular iconography, for reasons much more serious than because it does not share the stylised viewpoints they employ. In many ways it resembles photographs of abandoned tanks in seas of mud, but its sombre tones, unrelievedly turbid textures and stolid forms make it infinitely more powerful in revealing the sheer waste of tank and landscape. Yet in one deeply ironic way the resemblance with verbal iconography is striking, although in a manner fearfully different from that of the buoyant early versions examined above: the likeness of form and texture shows the tank as subsumed into the landscape, and its outline in silhouette makes it inescapably resemble some loathsome beast. Here, though, there is no comic or mythic dimension: gone, too, is the aseptic cleanness of the visions in the illustrated journals. The tank is a vile thing: the animal imagery has been given forceful but unexpected validity in a painting

which reveals the destruction engendered by the machine and the desolation in which ultimately it is its own victim. Although it is recognisably representational, there is no clear stylistic reference, and as a statement of revulsion it stands alone, encapsulating all the most loathsome attributes of the animal imagery which earlier had the function of both familiarising and distancing. Regarded in these terms, it is a startling comment not only upon the nature of the tank, but also on the distortions of actuality, sophisticated in manner but simplistic in effect, perpetrated by the convention of verbal representation in animal terms.

Orpen and Hill thus reveal the sterility and dissolution of tanks within a landscape, showing a clear moral standpoint not often seen elsewhere, and providing a disturbingly different embodiment of the early writers' bestial images. But for a balanced view within the larger art-historical context, we must also look for another treatment that which rejoices in the mechanical force and power of the tanks in the manner violently celebrated by the Vorticists in an avant-garde, semi-abstract style. Superficially, the tanks would seem the ideal subject for a Vorticist canvas, with their wholly mechanical destructive energy. The lozenge shape seems, in its complete unrelatedness to natural forms, an appropriate part of Wyndham Lewis's early idiom in paintings such as the *Composition*[57] of 1913, and just as suggestive an inspiration as the camouflaging of merchant-ships in Edward Wadsworth's *Dazzle Ships*.[58] The tanks would seem to be the very embodiment of Lewis's 'New Living Abstraction' in both form and function: but there are no paintings of tanks by the Vorticists themselves, and only a tiny number which display anything like their avant-garde technique.

Two paintings in oils by Bernard Adeney move towards a modernist style through the development of the simple, clean forms and textures of his other drawings and water-colours into a style approaching Cubist abstraction. Their bright, transparent tonal values and near-abstract forms present their subjects with clinical detachment, but is this which contributes largely to their failure as depictions of the tanks' violence: the lines are insufficiently energetic, the forms too representational, and they are neither the impartial engineering drawing nor the steelly geometric statement of mechanical energy found in the canvases of Roberts or Nevinson. It is ironic, too, that both share the stylised viewpoint and composition of the advancing tanks so often depicted in the illustrated journals, as the two canvases are those already encountered, namely *A Mark V Tank going into Action* and *The Advance*. Ultimately, then, there is no genuinely avant-garde representation of the most avant-garde weapon of the war. Nevinson's own painting, *A Tank*,[59] dates from later

in the war. Exhibited at the Leicester Galleries in March 1918, it has neither the cynical realism of his *Paths of Glory*[60] nor the much more forceful, jagged incisiveness of the Cubist-influenced paintings such as *The Doctor*[61] (see illustration 21). It is a semi-realistic depiction which, like many of Nevinson's later war paintings, lacks force and appears bland in both style and attitude.

Perhaps the very abstractness of the tanks themselves precludes this: as kinetic sculpture they would be hard to improve upon. But more important, perhaps, is the Vorticists' increasing awareness of the difference between championing violence in a peaceful world and recording its devastating acutality in one at war. It would be inappropriate to suggest as a consequence of this lack of mechanist abstraction that paintings of tanks represent a triumph of humane values: but in the visions of waste of Hill, Baxter and Orpen there is a real awareness of the tragic nature of the tanks and an attempt to show this in clear, representational terms by their relation to the landscape. As an antithesis to the confident ambivalence of the animal images of verbal accounts and the equivalent duality of popular illustrations, they perhaps show a greater honesty, even though only in one case is the immediate human casualty represented, the landscape in others being symbolic of their destructive powers.

Yet it is not only popular representations which present tanks within iconographic conventions designed to modify our response: more serious paintings are similarly subject to the urge to redefine their reality, testifying to the general difficulty of separating the two strands of war art. It is ironic that the animal image seems present both in the most fervent expressions of joy in the tanks and in the most abject portrayals of their horror and dissolution: but given the pressures of the contemporary situation, it would be hard to say which response is the more valid. The generation of a perceptual viewpoint through iconographic conventions tells us much about the response of the arts – both popular and serious – to the actualities of the war and the needs of the civilian population, whereas the more desolate paintings show the continuity of compassion. In their own ways, both are aspects of the urge to extend tradition and redefine experience which is found in so many responses to war in art of all kinds, and both are valid statements in response to a fearfully successful new weapon.

III

In 1921, having completed several profoundly effective collages, the production of which involved extensive study of the illustrated journals discussed above, Max Ernst produced his first large-scale canvas, *L'Eléphant Célèbes.*[62] It is a nightmare vision, full of dissociated surreal image. A vast central figure, compounded of elephant and Sudanese corn-bin, stands threateningly above a headless nude torso whose raised forearm is covered in blood. Viewed through half-closed eyes, the image is familiar: the massive bulk of the object bearing down on the figure, the animal-mechanical nature of the trunk, legs and body, and the lowered eye-line are inescapably suggestive of many aspects of the popular verbal and visual iconography of tanks. Its comic absurdity is matched by its surreal menace, and it is perhaps the most complete embodiment of the complex, contrasting elements of the popular icons of the tanks.

The pervasiveness of the iconography is once more revealed: what began as an ebullient regeneration of an instrument of victory has become a feverish image of menace haunting a disturbed collective unconscious.

8

England, Whose England?

I

The preceding chapters have all considered how various forms of verbal and visual art treated certain key aspects of the war in 1916. But as well as these essentially responsive roles, the arts had another important function in the projection of war aims and objectives. These included the protection of the rights of Belgium, freedom for the occupied areas of France, and a range of abstract concepts such as honour, peace, civilisation and liberty.

The most significant and sustained of these topics was the idea of the kind of England for which war was being waged. This is apparent both in official material, such as recruiting posters, and in more individual responses such as poems and novels, so that once more a consensus is revealed of the kind so apparent in the work discussed in the foregoing pages. As a consequence of this consensus, such works reveal much about how England was seen by people in positions of influence, and for this reason they attract attention from a social and political viewpoint as well as because of the psychological functions they perform. Because depictions of this kind do not refer specifically to any single event, they are no more prominent in 1916 than in any other year, although that year is of particular importance within the pattern of their appearance throughout the war. Most prominent in the first years, after 1916 they become far less common among material produced by serving soldiers and those with personal experience of the war, while remaining forcefully evident in popular treatments of war by those at home throughout, and in many cases beyond, the fighting.

The conventional view of England is most clearly seen in popular art with a clear practical function, such as the encouragement of recruiting. An early poster produced by the Parliamentary Recruiting Committee[1] (see illustration 19) exemplifies works of this kind, and serves to define the essential elements of the convention. In the foreground a soldier stands with his hand outstretched, pointing to the village scene which forms the main element of the composition. The village is

surrounded by interlocking hills, the fields separated by neat hedges and occasional trees. In the middle distance is a group of three thatched cottages, the nearest with ivy trained along its walls. Above them, the sun shines past a group of clouds. The whole composition is an ideal view of an ideal English village, aesthetically pleasing and idyllic in mood. Above the scene appears the legend 'Your Country's Call', and beneath it 'Isn't this worth fighting for? Enlist now'. The poster is clearly designed to appeal simply and forcefully to the beholder's love of his native land, idealised as a nation of country lanes, rolling hills and peaceful thatched cottages.

A somewhat similar kind of England is presented in George Clausen's *A Wish*, one of four posters commissioned and produced by the Underground Railways of London in December 1916, for display in messes, YMCA huts and similar locations with the forces overseas. Clausen's poster is an idealised English pastoral, not only in its subject, but in the manner of life it presents. The ancient church and graveyard, thatched cottages and immemorial elms are not only features of the perfect English village, but emblems of social continuity, which is shown also in the villagers talking unhurried at the church gate, the mother and child beneath the tree and the lone figure simply musing. The execution is similarly traditional, continuing a convention of topographic engravings and water-colours of the English landscape. Like the recruiting poster, it presents an ideal vision of England, but it goes a stage further than that poster by using a style which in itself is part of an English tradition.

This, then, is the England for whose protection men are encouraged to enlist, and which is held up as something worth their sacrifice when they are actually fighting. It is an attractive ideal, but one which can have had little reality for the majority of men urged to enlist, or those fighting in the ranks on the various fronts. Its relation to reality, and the implications of the ideal it presents, will be explored shortly, but the iconography has other manifestations which demand consideration first.

In verbal form, the equivalent of such works is seen frequently. A popular example comes from John Buchan's novel *Mr. Standfast*, published in 1919 as the final volume of the trilogy including *The Thirty-Nine Steps*[2] and *Greenmantle*[3]. At the beginning of the novel the central character Richard Hannay rests for a moment on a hill overlooking an English village.

In that moment I had a kind of revelation. I had a vision of what I had been fighting for. It was peace, deep and holy and ancient . . . It was more; for in that hour England first took hold of me . . . I understood

what a precious thing this little England was, how old and kindly and comforting, how wholly worth striving for.[4]

Here not only is the ideal English village described, but we are also told of the response it evokes in the onlooker – a desire to protect the 'deep and holy and ancient' peace. Once again, idyllic pastoral is created, but a significant further layer of meaning is added to instil more strongly the desire to fight for this perfect England.

Later in the novel, another significance is added to this icon, when Hannay spends much time reading the English classics:

I discovered for the first time what pleasure was to be got from old books. They recalled and amplified that vision I had seen from the Cotswold ridge, the revelation of the priceless heritage which is England.[5]

The idea of English art, particularly literature, as a further aspect of this ideal nation, providing an enriching filter through which the village landscape is seen, is of much significance not only in Buchan's novel but in many other popular works of the war years and shortly after. In *Mr. Standfast*, a network of such allusions is established by the use of *The Pilgrim's Progress* as the source of the code used by the protagonists. This is far from an accidental choice: the book had almost universal acceptance in England when Buchan was writing, having become established as a cornerstone of faith second only to the Bible. Thus its use in the novel stresses the inevitable goodness and rightness of the British cause, to reinforce the vision of an ideal pastoral England by adding a moral and literary dimension. Hannay is pleased when he is past 'the hill difficulty';[6] the location of the enemy stronghold is conveyed by a series of telegrams quoting Bunyan; and Hannay's confederate Mary Lamington suggests that her main contribution will lie in the booths of Vanity Fair. The metaphor is strongly assertive of the continuity of English values, and in this it is typical of many popular works which make reference to earlier literature. An early number of *The Sphere*,[7] for example, prints John of Gaunt's speech from *Henry V* under the heading 'This Dear, Dear Land'. On the adjacent page an illustration shows a solitary soldier guarding the cliffs at Dover – another potent national symbol – with the heading 'This fortress, built by nature for herself'. Allusions to the Agincourt scenes of the same play are also common. The anonymous author of *Iron Times with the Guards*, for example, quotes Henry's speech

before the battle and draws a parallel between Agincourt and Ypres.[8] Clearly such references have much significance in asserting the continuity of a tradition powerfully English in the face of the war.

The quotation of earlier literary forms to show the continuity of England and English values is matched by the great outpouring of poetry[9] about the nature of the nation during the war. Much of it furthers the image of a perfect, village England and suggests that dying for such a country would be the culmination of service, and a rare privilege. The *locus classicus* of such an idea, of course, is Rupert Brooke's sonnet 'The Soldier' from the sequence *1914*, with its talk of 'some corner of a foreign field/ That is for ever England'.[10] Its sestet is a version of the England shown in the Clausen poster, seen as the object of service and sacrifice:

> And think, this heart, all evil shed away,
> A pulse in the eternal mind, no less
> Gives somewhere back the thoughts by England
> given;
> Her sights and sounds; dreams happy as her day;
> And laughter, learnt of friends; and gentleness,
> In hearts at peace, under an English heaven.

A less celebrated expression of the idea of dying for England is given in a verse by the popular poet R.E. Vernede:

> All that a man might ask thou hast given me, England
> Yet grant me one thing more;
> That now when envious foes would spoil the splendour,
> Unversed in arms, a dreamer such as I
> May in thy ranks be deemed not all unworthy,
> England, for thee to die.[11]

This is perhaps the most complete statement of the idea that dying for England is the highest privilege a man could hope for: the sentiment, along with the quality of the verse, makes it hard to accept for a present-day reader. Yet the idea was common among writers of the time, appearing in Ivor Gurney's early poem 'Strange Service',[12] and the vastly popular war anthems such as the words written by Sir Cecil Spring-Rice to 'Jupiter' from Holst's *The Planets*, 'I vow to thee my country'.[13]

This notion of service to an ideal England is part of a ganglion of related ideas which can be loosely grouped together under the title of a

public-school code, in which serving the country is seen as upholding the school's honour and repaying one's debt at the highest level. Some lines by J.M. Rose-Troup, which appeared in an anthology which was a great popular success, make this link clear:

> Mourn not for those whose names are writ in gold
> They fought for England, gladly gave their all.
> Kept Harrow's honour spotless as of old,
> Nor feared to answer to the last great call.[14]

A further aspect of this public-school code, integral with the idea of service and the idealised view of England as an island of country villages perceived in terms of popular literature, is the concept of playing the game, both in literal terms and as a chivalric code of conduct. Chapter 5 has mentioned the use of this at the Somme attack, and it was frequently referred to as a metaphor of fighting. Often, too, it was applied literally: an article in one of the London weeklies compares the arts of spin-bowling and grenade-throwing,[15] and cricketers were often recruited as bombing instructors and specialists in the field. The apotheosis of this code as a metaphor, though, comes in the immensely popular novel *Tell England*,[16] which appeared in 1922, and went through 19 cheap editions in the next 20 years. It also achieved great popular success in the film version by Anthony Asquith released in 1930. These details are important because they suggest that the ideas the novel contained were shared by a large proportion of the reading public, even several years after the end of the war: the psychological significance of this is considerable, as will later emerge.

The stress on the school code and the school's honour is established by the first two-thirds of the novel which take place at 'Kensingtowe School' and recount the experiences of the narrator, Rupert Ray, and his friend Edgar Doe, before their departure to Gallipoli. Doe's experiences as Brigade Bombing Officer are recounted almost entirely in terms of the public-school cricket-field, the tradition and importance of which has been pressed home earlier in the novel during the Staff v. School match of July 1914. Faced with an important attack, Ray is certain that his friend will not fail in his task:

> from all I knew of Doe and his passion for the heroic, I felt assured that he would never stay in the crater like a diffident batsman in his block. He would reach the opposite crater, or be run out.[17]

When he is wounded, the comparison continues:

> His cap fell off, and the wind blew his hair about, as it used to do on the cricket field at school.

In its own way, this cricketing comparison asserts the continuity of English life and values just as strongly as does Clausen's lithograph. Additionally, it might seem to offer a means of imposing order upon confusing experience, in perceiving war as an elaborate cricket game, which offers a means of survival similar in kind if not degree to the adoption of a reckless 'knight-errant-of-the-air' approach by young pilots as discussed in chapter 6. In the actual circumstance of battle, though, this was a practical possibility only for a small, élite group of public-school subalterns, and the larger function of such metaphors is in the effect they had on readers at home. Hardly anyone who read *Tell England* could have been untouched by the loss and suffering of the war: if they could believe that their loved ones regarded battle as a glorified cricket match in the service of the country and its values, and death as something as painless as a fall on the cricket pitch – while still significant as the ultimate sacrifice – this would provide consolation, albeit of a spurious and limited kind. The popularity of the novel so long after the war supports the view that these stances met with widespread acceptance in a period when many must have still been trying to make sense of the suffering and loss of the war.

That such attitudes were prevalent during the war, as well as after it, is shown in a poem which appeared first in *The Times* and then, with an accompanying full-page illustration, in the *Sphere*:[19] 'Three Hills' by Everard Owen. This combines the ideas of a perfect pastoral England with the idea of service to school and hence country, through the familiar sporting analogy. The three hills of the title are in England (the school), in Flanders (a hill of battle) and 'in Jewry' (Calvary), thus adding the new element of a parallel with the crucifixion to the notions of service and sacrifice. The first stanza establishes the perfect England, compounded of village, public-school and cricket pitch, for which the sacrifice is made:

> There is a hill in England,
> Green fields and a school I know,
> Where the balls fly fast in summer,
> And the whisp'ring elm trees grow.
> A little hill, a dear hill,
> And the playing-field below.

The subsequent stanzas establish the literal and symbolic circumstances of the 'sacrifice', so that the whole poem stresses once more the idea that giving one's life for one's country is the highest form of service.

All these visions of England see the country as a demi-paradise of quiet lanes and thatched cottages, through the filter of popular classics which extol a moral code of devotion exemplified in the idea of playing the game and other aspects of public school life. Service for such a land is a sacred duty: death for it is the ultimate privilege. Seeing the war in such terms must have offered much consolation for many, most particularly those at home trying to make sense of a war of confusion and uncertainty, but also for soldiers of a small élite in the earlier years of the fighting. For those at home, it offered consolation and purpose amidst the loss, and as a scaffolding of fiction it doubtless fulfilled a psychological role of no little importance.

That said, there is much that is disturbing about this view of England. Most of those who enlisted, we assume, did so as much to protect their own families as to further the ideas of honour and the values perpetuated by the mythology of village England: as noted earlier, the view of England this represents is that of those in positions of influence, not that of the great mass of the people, even accepting the great access of romantic enthusiasm for the English cause at the outbreak of war. In the works produced later in the war, the view rests on a serious misconception of the reality of things: there is, after all, very little similarity between Suvla Bay and a Staff v. School match, and the idea of noble sacrifice for English values has little relevance to the scything machine-guns of the Somme. Whether the perpetrators of the myth set out deliberately to falsify or conceal, or whether they wished to make the best of things – in itself an important element of the English code – it is impossible to say: intentions must have varied according to the nature and purpose of the individual work, too. Many people believed in ideals of this kind, but were also aware of the reality of the suffering: but many more, especially at home, must have been seriously misled by such mythic contextualising, so that this emerges as one strand of response to the war in the face of which it is hard to retain the necessary historical detachment.

The nature of the distortion offered by this view of England, which is presented as the object of sacrifice in the code of the playing field, is made clear when we consider to what extent England actually was a rural nation at the outbreak of war. The census of 1911 shows that 21.9 per cent of the population of England and Wales lived in 'rural areas'.[20] This

is the culmination of a movement that had been taking place for many years, of course, so that the idea of village England was a myth long before the outbreak of war. Even in 1851, the 'rural' population was only 49.8 per cent of the whole, and in actual numbers of people there was little change during the 60 years, 8.9 million living in the country in 1851 and 7.9 million in 1911, whereas the urban population more than trebled from 8.9 to 28.1 million over the same period.[21] This shows clearly that the rural England presented in the popular art forms so prevalent during the war was a personal reality for only a small proportion of the population. Further, the kind of rural England shown is a false view of the reality, a village idyll which reveals nothing of the hardships of actual village life. The falsity is thus two-edged, presenting an England which is both unrepresentative and unrealistic. To the average factory-worker, 'England' meant a narrow street and a back-to-back rented house with no sanitation: to the average farm-worker, it meant back-breaking labour for a few shillings a week and the promise of patronising largesse at harvest.

This makes stronger still the link between the ideal village England and the outlook of the public-school, as the pastoral vision is as much the creation of the middle classes as is the code of service and playing the game. This is the village community the middle classes were busy creating before the war in Garden Suburbs and the semis of Metroland. It is perhaps no coincidence that Clausen's poster was produced by the Underground Railways, who did much to foster the idea of idyllic village life in Pinner, Harrow and Golders Green immediately before the war. Related to it is the perception of the nation in terms of popular classics and the moral elements of the school code of the playing field. All are shared by a small proportion of the population, but one which was most influential in guiding opinions. For the members of this class, it performed a valuable function in asserting the continuity of values: but it is far more limited in scope and significance than all of the other kinds of artistic conventions examined in these pages.

If such views were held by such a small proportion of people, it is pertinent to ask why they seem so pervasive and so deeply held. The reasons are twofold. First, there is the desire already mentioned, to see the war in terms of simple and glorious sacrifice for English values, which redefines and makes tolerable the suffering in terms of the playing field, or an abstract code of values, or in the clear-cut elements of the paintings of the death of John Cornwell.

The second reason is less straightforward. Put simply, it is the desire to

re-create a series of social and moral values held dear by the upper middle classes which had been seriously under threat from many sources in the years before the war. For anyone raised according to High Tory principles, Britain in the early years of the century was full of disturbance and disquiet, in which the old values were apparently threatened from every side. Politically, the Conservatives had been in opposition since 1906, and had in that year seen the foundation of the Labour Party, with nine MPs and nearly a million members throughout the country. The Trades Disputes Act of the same year reversed the notorious Taff Vale Judgement of 1900, so that union officials were no longer responsible for financial losses caused by strikes. A Royal Commission recommended that union strike and benefit funds should be regarded as separate in law, and that peaceful picketing be made lawful. Although the Osborne Judgement of 1909 outlawed the so-called political levy, allowing unions to deduct contributions only from those workers who had explicitly requested that this be done, the Trade Union Act of 1913 reversed the position, so that those who did not wish to make contributions had to 'contract out'. 1913 saw the membership of the TUC-affiliated unions approach three million, nearly twice the number of two years before.

All this occurred within a climate of much industrial disquiet. Only Lloyd George's intervention had averted a national rail strike in 1907. The next year engineers on the north-east coast struck for seven months. In 1910, the Northumberland and Durham miners struck in favour of an eight-hour day, and the South Wales miners were out for ten months. Dockers, seamen and transport workers struck in 1911: amidst rioting and looting, two people were killed in the Liverpool Docks. In August 1911, not even Lloyd George's intervention could prevent a rail strike. The following February the miners struck and remained out until April: a strike by workers in the London Docks lasted from May until August. Like most of the strikes of this period, the demands which sparked it off now seem eminently reasonable: the request for a small increase in wages and the reform of the casual system which gave no security to any of the dock workers. With hindsight, the demands of most of the strikers seem inevitable steps towards a fairer distribution of the national wealth, but at the time they represented a shift of power towards the urban working classes which was regarded with extreme mistrust, even trepidation, by the middle and upper classes.

Further unrest came from other quarters. The militant Women's Social and Political Union had been formed in 1903, and its disruptions of public life included an invasion of Parliament in 1910 and the creation of the first martyr of the suffrage movement, Emily Wilding Davison,

who threw herself under the King's horse in the 1913 Derby. The same year saw the passage of the 'Cat and Mouse Act', which allowed the authorities to release Suffragettes on hunger strike from prison, to re-arrest them when their health had improved. It put a stop to the appalling practice of forcible feeding but did nothing to tackle the practice at root cause. In another area, pressure for Irish Home Rule was strong, with Asquith's administration introducing bills to secure it, and gun-running developing to such an extent that a popular fear in 1914 was that war would break out in, and over, Ireland rather than in Europe.

If all this were not enough, a sweeping programme of social reforms had been introduced by successive Liberal administrations. Elementary education throughout England and Wales had been introduced by Balfour in 1902: Old Age Pensions, National Insurance giving benefits for medical aid and unemployment, Labour Exchanges and half-day closing were all introduced between then and 1911. The Tory establishment fought its rearguard: in 1909 the Lords rejected Lloyd George's Finance Bill, precipitating a constitutional crisis of an unprecedented nature which was only solved by the severe limitations on the powers of the Lords imposed by the Parliament Act of 1911. Alongside all of these changes, in which the whole social structure of the nation was being refashioned, came technological advances of an alarmingly rapid and pervasive kind: the car, the telephone, the typewriter and powered flight were all agents which threatened the established order and gave further independence and power to the new industrial classes, in their implications if not directly.

In the face of all this, it is hardly surprising that the war was seen, albeit subconsciously, by many in positions of influence and authority as a means of re-stating the values which had been so seriously undermined in the pre-war years. This is not to suggest that a deliberate reactionary campaign was mounted: the government itself was, after all, the very administration that had implemented many social changes which had undermined the old order. Rather, it is to propose that a closing of ranks behind an ideal vision of England, which was purely mythic long before the war, was an instinctive response among privileged middle and upper class people who felt themselves threatened. For them, this was the England that was being fought for. Here was a chance to reassert the proper English values and the right way of life, and defeat those who had called these things into doubt at home as well as those who threatened national honour abroad. Perhaps the most appalling manifestation of this impulse appears in the treatment of conscientious objectors, who were treated with infinitely greater brutality than any external enemy:[22] the

parallel between the sufferings of these people and those of the Suffrag-
ettes is strong, and it is tempting to attribute the way both were treated to
a fear amongst those in authority of the threat to established order from
outside their ranks. The rebuttals of trade union power, such as that of
Sir Edward Carson (see p.47), demonstrate this tendency in a less vicious
form, but it is most apparent in the milder-seeming visions of village
England and the assertions of national identity in the code of the playing
field. These arise not from the 'Capitalist' backlash as an inevitable
part of the Marxist dialectic: things are rarely so simple. Rather, they
represent an instinctual recourse to the familiar and comforting – in
practical as well as moral terms – in a time of stress, uncertainty and fear.
All the works of popular art discussed here fulfil precisely this function –
the assertion of continuity of ideas of English life and values which are
potently retrospective in nature. This England is an ideal. If it had ever
existed, it had done so for only a tiny fraction of the population and had
vanished long since: the moral values, while laudable and proper in some
contexts, did little except give those at home a false view of the war,
causing tragic misunderstandings and aspirations, which were shortly to
turn to bitter anger and recrimination.

 This, then, is the psychological significance of the war art which
presents this group of related views of Englishness. Re-creations of a
mythic ideal England have been popular at many stages of English
history: Polydore Virgil's court histories, the Elizabethan romance at
Woodstock, William Morris's Golden typeface and craft guilds are all
similar, reaching towards an ideal. But all these are essentially harmless
and idealistic. The presentation of England as a rural paradise, and the
moral code with which it is linked, is disturbing both in its social
divisiveness and in the false vision of war it purveys. Ironically, those
who were to suffer most directly as a result were those who would, under
different circumstances, perpetuate this vision – the generation of
impressionable public-schoolboys waiting to graduate from the OTC to
the BEF. That such an effect was indeed the result is shown in works like
R.C. Sherriff's *Journey's End*,[23] where the young subaltern who has
longed to go to the front to be with his public-school hero finds, instead of
the worshipped captain of the house eleven, a man isolated by responsi-
bility and tormented with anxiety in the face of the appalling conditions
of the trenches. The confrontation is real and desperate: that the play was
produced in 1929 shows that, even then, the false ideal of the public-
school code and the public-school war was still something that needed
forceful demolition. 'Blast England',[24] Wyndham Lewis had written in
1914: it is both tragic and ironic that his wish was in large measure

fulfilled, but that the very characteristics against which his wrath was directed should survive for so long as a deeply misguided image of the ideal nation and value-system for which war was being fought.

II

It would be wrong to suggest that the village England myth was the only ideal offered to the nation as that which was being fought for: but it is hard to find complementary, and more realistic, examples of works which uphold Britain's urban and industrial heritage in this manner. Perhaps this evidences the inevitable recourse of the Englishman to his agrarian roots in time of stress, or perhaps it is the re-statement of a series of values for which the more reactionary elements among opinion-formers still longed. But, as the census figures show, Britain had been a predominantly industrial country since 1851, and it seems unlikely that loyalty to the city was lacking in the minds of those who fought. Certainly loyalty of this kind was exploited in recruiting campaigns, where 'Pals' Battalions' of men were formed from one city, in an extension of nineteenth-century civic pride. Appeals to such loyalties, though, are almost wholly lacking in art forms of all kinds and intended audiences.

Visually, there are few works which reveal even an awareness of industrial Britain, let alone the idea that its heritage is worth protection. Frank Dobson's *The Balloon Apron*[25] (see illustration 20) is rare in including, in the scene which forms the background to the balloon defence barrage which is the painting's main subject, factory chimneys and industrial buildings along with the rolling countryside familiar from earlier posters. This is a work which achieved limited display: amongst the more widely-exhibited works there is nothing which makes reference even in this incidental manner to the industrial nature of the nation. There are, certainly, works which record Britain's industrial production during the war, but these are essentially different. For example, Frank Pennell's lithographs of work in the ordnance factories[26] depict heavy industrial processes, but only within the war context: these are representations of Britain's war effort, not depictions of a tradition to protect which the war was being fought. There is no advancement of the concept of Britain's industrial traditions: this is perhaps strange in a country which prided itself on its immaculate craftsmanship before the war, and which invented the concept, as well as the practice, of an industrial revolution.

The same is true of a series of lithographs produced by the Department of Information in 1917, called 'Britain's Efforts and Ideals'.[27] To illustrate the 'Efforts', nine artists were commissioned to produce six litho-

graphs each on one particular aspect of the war. Of them, only three cover industrial work – the series depicting shipbuilding by Muirhead Bone; Nevinson's group on aircraft production; and George Clausen's collection of illustrations of gun manufacture at Woolwich Arsenal. Other groups depict agriculture, naval trade and the treatment of the wounded: there is no emphasis on industrial production of other kinds. The most celebrated painting of the war on an industrial theme, *In the Gun Factory at Woolwich Arsenal, 1918,*[28] again by Clausen, is similarly concerned with industry directed solely at the production of war *matériel*: it is a product of the war, not something which the war is being fought to defend. Perhaps this emphasis is understandable in the circumstances under which the lithographs and Clausen's larger oil painting were commissioned, but it is none the less striking that peacetime engineering achievement is not held up as another facet of Englishness which is worthy of sacrifice. Compared with the awareness of Britain's industries and cities as entities of great national significance during the Second World War, and the stress by implication and open statement on their protection, the lack of such material in the earlier war is even more apparent. In the later conflict the *Your City* series of posters showed the importance of the urban landscape as something to be fought for, and the films of Humphrey Jennings[29] and the Crown Film Unit[30] stressed industrial production of many kinds in the same way, as a further facet of British character which must be kept safe from enemy aggression. True, the circumstances were very different in that Britain's cities were involved in the fighting at the most immediate level from 1940, and the documentary film movement had in the 1930s given industry a rather romantic appearance: but the comparison shows that appeals to a loyalty to an urban and industrial heritage could be made, as well as showing their complete absence in the earlier war.

If the concept of England as an idealised pastoral nation predominates over the idea of the country's urban and industrial heritage as something worthy of sacrifice, it is also true to say that, in the popular arts, the nostalgic return to earlier systems of values is far more prevalent than a concern for the issues of post-war reconstruction and development. This should not, however, be taken to indicate a lack of interest in such matters, as concern for the nation's development after the war was apparent in many circles from the outset of hostilities. 1916 saw many advances in this area. The introduction of conscription, the cost and likely duration of the Somme attack and the widespread and increasing intrusions into the nation's private life by the ever-growing machinery of the state made clear that the effects of the war were to be far greater than

had at first been supposed by most, and that in consequence post-war problems would be greater, and the state would have to take a larger hand in their solution. Asquith's administration was significant in beginning the work. In 1916 a Cabinet Reconstruction Committee was formed, to become the Ministry of Reconstruction in the following year, with the aim of 'moulding a better world' from the experience gained during the war. Its committees investigated the likely post-war problems of demobilisation, housing, labour and unemployment benefit. In this they were aided by the National War Aims Committee (NWAC), set up in 1917 to encourage public discussion of issues of this kind to combat the growing war-weariness of the population at home. It functioned in a manner similar to the old Parliamentary Recruiting Committee, issuing pamphlets and statements to be read at theatres and generally fostering popular interest and discussion by whatever means became available.

The first practical result of the concern for reconstruction and reform came in the Pensions Acts of 1915 and 1916, and the creation of the Ministry of Pensions the year after, although these could be seen as the conclusion of work begun before the war, and made necessary by the great expansion of the working population in response to the war's material demands rather than a concern for the improvement of conditions at the coming of peace. The later years of the war saw a great deal of preparatory work for subsequent change: the creation of the Ministry of Health in 1919 was possible only because of the work done to lay its foundations in 1917 and 1918. The Board of Education report for 1917–18 stressed the importance of extending state educational provision as a result of war experience, and in 1918 Fisher's Education Act introduced a minimum leaving age of 14 and the concept of further education and training beyond it. Adult education and education in the forces also attracted interest, local adult institutes reporting a growth in groups wishing to discuss post-war problems, and a similar interest developing within the forces leading to the formation of the Army Education Corps.

Complementary to these parliamentary moves, and perhaps more effective in that they put into practice many key concepts of change, were the advances made possible by the greater powers of the various ministries. The Ministry of Munitions was important, towards the end of the war, in providing facilities such as canteens, crêches for working mothers, and model housing estates such as that built for factory workers at Gretna: it also carried out pioneering work in industrial psychology within the factories themselves. Very gradually, a greater understanding

of the needs of the industrial worker began to develop. This occurred largely in the cause of achieving increased production, of course, but not all pressure for reform had the same spur at its root. It is indicative, for instance, that one of the earliest initiatives came from outside establishment circles, in the Reconstruction Conference held in October 1915 by the National Union of Women Workers.[31]

Given this general climate, it might be expected that both popular and fine art would be involved in the discussion of post-war aims in a variety of ways. Certainly, there is much material of a kind which raises issues of reconstruction for discussion at a serious level. Sir Oliver Lodge's *The War and After*[32] was one of the first books to tackle post-war problems. Inspired by a desire to provide material in manageable form for adult students of 'The Workers' Educational Association and other organisations',[33] it includes discussion of industry, social reform and problems of readjustment to peace. Publishers' lists for 1917 included *Democracy After the War*[34] and *After War Problems*, a volume of essays by the Earl of Cromer, Lord Haldane and others. In March *The Athenaeum* published 'An Employer's View of Reconstruction', to be followed the next month by 'A Working-Man's View of Reconstruction'. Yet these would all have appealed only to a small group of the population actively concerned with reconstruction, to the extent, for example, of attending WEA or other extension classes to discuss the topic. A circulation of a rather broader range, though not necessarily larger extent, was aimed at later in the war by *Reveille*, a periodical published by HMSO and concerned with a rather different, but no less real, problem of reconstruction: the provision of work, rehabilitation and some kind of fulfilment for those maimed by the war in mind or body. Edited by John Galsworthy, it contained poems by Hardy and Kipling, articles and stories by John Masefield, Enid Bagnold, Jerome K. Jerome and others, and illustrations by Max Beerbohm, Raven Hill, Edmund J. Sullivan and Frank Brangwyn. These were interspersed by articles from the Minister of Pensions and pieces discussing the problems of coming to terms with an artificial limb, 'The Romance of Surgery' and 'Curative Workshops'.[35] This was an imaginative and pioneering effort to mix the discussion of serious problems with attractive and popular articles and illustrations, and showed the direct involvement of the arts in the idea of dealing with the most tragic of the war's consequences. It is true, as Galsworthy admits in his editorial in the first number, that some of the 'items of mere Art or Literature'[36] have little to do with the problems of the disabled soldier: but many of them do tackle the issue directly, and the journal is

far more than a simple assembly of unconnected pieces by well-known artists and writers found in many of the charity gift-books produced earlier in the war.

A discussion of problems of a wider nature is, however, less easy to find amongst works directed at a very large popular audience during the war years, and it is true that the more immediate problems of the war itself – which in a sense include the issues discussed in *Reveille* – take precedence over questions concerning the larger difficulties of a nation adjusting to peace in economy and social structure. There are, though, some writings which do this in a forceful and deeply-felt way. A feeling which must, we may infer, have been common among the fighting men appears in a volume of recollections by J.C.W. Durrell, Chief Commissioner of the Church Army in France:

> One thing at least is certain, that the men who have fought in France will not tolerate the old abuses in our social and industrial life. They will refuse to return to the cramping conditions under which so many of them were living when their country called them to come out and fight her battles.[36]

Here the disparity between the country which 'called' the fighting men – presumably presented to them as the ideal village England – and the squalid reality of industrial tenements is made explicit, in terms which show the social divisiveness of the years before the war and the exploitation of the working man that seems a strong undercurrent in many popular treatments of the war but which rarely achieves open expression.

A similar response is apparent in a passage from a volume of war experiences published anonymously in 1917. Here the depth of anger is far greater, being directed against the living conditions of working people before and during the war, and the determination that they shall be improved at the coming of peace. The young narrator visits the widow of his servant, recently killed in France, and is appalled at the conditions in which she lives with her young family. He asks:

> And is this one of the things for which we have fought? Has all the suffering and sacrifice been endured for the sake of things as they are? It is not enough that we have fought for the present, for a condition of things in which slums can exist. We cannot be satisfied but in the hope that our fight has been for a future which will amend the errors of the past, and atone the wrongs and evils of the present.[38]

A little further on the writer makes this impassioned appeal:

> Oh! England, awake, rise up in the greatness of your coming victory, and say 'there shall be no more slums'.[39]

The book continues to discuss Ireland, social justice, the role of women after the war and other aspects of reconstruction, in one of the most sustained treatments of the subject in popular form to be produced during the war years.

Works such as these apart, treatments of problems of reconstruction in the popular arts are rare. Even in work of official origin, there seems to be limited awareness that these are issues which need to be aired. This is clearest in the lack of visual treatments of the theme, as evidenced in the 'Ideals' illustrated in the 'Britain's Efforts and Ideals' series. Of the twelve coloured lithographs, five are concerned with the rebirth of countries such as Poland, Serbia and Belgium. The subjects chosen for the others include Democracy, Justice, the freedom of the seas, and – simplest of all – 'The End of the War'.[40] All are heavily allegorical, using traditional compositions and elements such as female nudes standing before ruined landscapes, all of which seem to owe more to Delacroix and Alma-Tadema than to more recent artists. The use of such traditional and retrospective forms reflects the lack of concern with reconstruction in detailed terms, and suggests once more the subconscious desire to restore pre-war values rather than a wish to banish the injustices of the old systems. This is shown in the subjects of the lithographs: none is concerned with a subject of major significance in terms of post-war reform, such as housing or working conditions, for example. Taken in conjunction with the views of England presented in the 'Efforts' lithographs, which show only a concern for the immediate aim of winning the war, they show clearly that reconstruction and change were not regarded as primary war objectives by the Department of Information. The lack of concern for popular feeling which this reveals is also shown by the way in which the lithographs were displayed. They were prepared in an edition of 200 copies and exhibited at the Fine Art Society in July 1917, being seen only by a tiny minority of the population compared with, say, the recruiting poster discussed at the start of this chapter, or any of the commerical illustrations of the popular papers or weekly histories of the war. That the exhibition was also mounted in Paris, New York and Los Angeles suggests that the Department of Information was more concerned with opinion abroad than at home. Such a purpose, though quite comprehensible in itself, is strangely out of accord with the aims of the

NWAC, and shows a division of aim among the propaganda organisations at a time when those at home desperately needed an infusion of fresh hope and purpose. This is significant in both the subjects and in the mode of display of these lithographs since, as well as showing how little importance was attached to the feelings of the working people at home during the war, it reveals a lost opportunity on a purely practical level. Stress on the creation of a better country at the coming of peace in the lithographs' subjects, and a greater range and scope of display and distribution, would surely have been effective in encouraging a renewed commitment to the war effort among the industrial workers upon whose labours so much depended.

The lack of treatments of issues of reconstruction is the more striking when seen in comparison with the great mass of material discussing the theme which was produced almost from the very start of the Second World War. The comparison is not, of course, historically valid, since the lack of material in the first war – and the lack of concern at which it hints – must be seen to have contributed to the lack of reform in social areas between the wars which made such measures essential in the 1940s: but the juxtaposition is none the less revealing because it shows what might have been achieved, and in showing the difference travelled in social attitudes and their reflection in art forms of all kinds during the intervening years. Images of the English pastoral do occur, but far more rarely than in 1914. The very early *If War Should Come*,[41] a public information film containing advice about what to do in wartime, concludes with a sequence in which the camera pans round an idyllic country landscape, to the accompaniment of 'Nimrod' from Elgar's *Enigma Variations,* icons familiar from the earlier war, but strangely incongruous with the film's earlier scenes, which are almost exclusively concerned with precautions against air raids in cities. A matter of months later, *The Dawn Guard* presents a supposed discussion between two members of the Home Guard about the aims of the war. The older wants a return to pre-war conditions, but the younger looks forward to a society more just in its distribution of wealth and opportunity.

Other films reflect similar aims: *Tyneside Story* discusses the aspirations of shipyard-workers, many of whom regarded the war as a means of eradicating the slumps of the pre-war economy, and marks an important advance in technique in the use of the People's Theatre Company instead of professional actors, in a limited but significant awareness of the opinions and preferences of working people of a kind undreamt of in the First World War. Most significant of all is the feature film *Went the Day Well*, made by Cavalcanti from a story by Graham Greene in 1942, in

which an ideal English village is taken over by Germans disguised as British troops. It is the local squire who is the arch-collaborator, and the poacher and a Cockney evacuee who finally escape to give the alarm, and this reversal of customary social structures is a powerful index of how far popular feeling had moved away from the village idylls of Clausen and Buchan in the earlier conflict.

Film was not the only popular medium to display this greater concern for regeneration after the war. *Picture Post* argued passionately for a Britain in which unemployment would be banished. In 1941, a special number included articles by Thomas Balogh on 'The First Necessity in the New Britain: Work for All',[42] by A.D.K. Owen on 'Social Security',[43] and by B.L. Coombes, a Welsh miner, on the mismanagement of the mining industry in the 1930s and its future reorganisation.[44] In the light of the recurrent sporting metaphors of the earlier war it is interesting to consider this passage from Coombes's article:

> We claim to be a nation that plays the game, and 'that's not playing cricket' is a national reproach. But have you ever seen a cricket team win when its batsmen crouched over the wicket and refused to use the bat no matter what was sent along? That is the sort of game we've seen our leaders playing in the past.[45]

This is concerned with the management of the state in peace rather than in war, but is none the less significant in offering a different perspective of the concepts of fair play so prevalent in the earlier war. It implies that, seen from the standpoint of the working man, the notion of playing the game is very different in nature, and more selective than the declarations of honesty and equity would have us believe.

Articles of this kind in *Picture Post* served to keep alive the public interest in reconstruction, which was also being developed at a different level by more serious writers such as George Orwell, whose *The Lion and the Unicorn*[46] examined the social issues raised by the war, and by organisations such as the Army Bureau of Current Affairs. The strong presence of Labour members in the coalition government was also very important and, taken together, all these forces produced considerable movement towards social reform of a far-reaching nature even during the war, with the passage of the Butler Education Act in 1944 and the preparatory work for the creation of the National Health Service. There were, of course, many other reasons for the social changes and differences between the two wars: but the popular arts of the second war, especially the photo-journalism of *Picture Post* and the work of both

official and commercial film-makers, show that serious issues could be discussed within a format which would appeal to large, non-specialist audiences, revealing again the deficiency of such material during the war of 1914-18.

Yet although the idea of social regeneration and change is not a primary concern of the arts in 1916, there is a powerful movement, beginning in that year but reaching its peak nearer the end of the war, towards a rejection of the simplistic views of village England and its complacent values which have been examined here. It lay in the deep personal compassion and sense of outrage of the artists whom we now regard as the authentic voice of the suffering people of the war. In them, the elaborate scaffolding of codes of duty and allegiance is dismantled, leaving instead a compassion which is shown most clearly in statements about the complex incidents of war. It is striking that the finest poems of Owen, Rosenberg, Gurney and Sassoon discuss individual moments of experience, instead of making general, loose assertions of duty, sacrifice or safety in fighting as do Grenfell, Brooke and their many imitators. 'Dead Man's Dump',[47], 'Futility',[48] 'A Working Party',[49] 'To His Love'[50] and the many other poems for which these stand as representatives, all relate personal episodes, and show individual sensibilities trying to make sense of them in moral and emotional terms, rather than glorying in them as icons of sacrifice for a tradition or system of values. The same is true of the finest paintings of the war. Nash uses the abstract forms of his broken landscapes to symbolise the broken minds and bodies of the combatants, and offers us no solution, and little hope save in the larger forces of nature in, for example, *Spring in the Trenches*.[51] No sense is made of the suffering in any such treatments of the war, but there is an intellectual honesty in them which cannot admit the kind of heroic posturising and myth-making which the older poems and canvases adopt, and this marks a change of direction of great significance in social and artistic, as well as in moral, terms.

Paradoxically, this compassion is often accompanied by intense cynicism. Nash refers to a desolate landscape in the ironic title *We Are Making a New World*:[52] Nevinson titles a canvas showing a soldier sprawled ungainly in death *Paths of Glory*[53] – a phrase used hitherto in all seriousness by writers apparently unaware of the complete line: 'The paths of glory lead but to the grave'. William Roberts's dreadfully angular figures in *The Gas Chamber*[54] reveal the appalling dehumanisation of war in a manner that is compassionate in equal degree to its cynicism, and the same is true of Mark Gertler's *The Merry-Go-Round*,[55] which presents the awful continuity of the war in symbolic terms. All of

these paintings move a long way away from the traditional forms used by the earlier painters of the war. Nevinson espouses a Cubist style for many of his paintings, Gertler develops a personal symbolism, while Nash takes the symbolic landscape style of Samuel Palmer and other English visionaries and elevates it into a kind of semi-abstraction which is a clear stage in the movement towards his involvement with the Surrealists in the 1930s. The traditional forms no longer have relevance, it seems: yet in the extreme attenuation and modification of more familiar patterns is further evidenced the compassion of such artists, in the desperate effort to hold on to some element of continuity in the appalling circumstance of war. The same is true of Wilfred Owen, whose Keatsian mannerisms become, in a mature poem such as 'Strange Meeting',[56] a style founded on personal compassion in which sensuality of sound is countered by the sense of unfulfilled expectation in the use of para-rhyme, so that the tragedy of loss is quite inseparable from the poem's essential structure.

Along with this compassion and cynicism is a stream of anger. It is apparent not only in the clear outbursts, such as Sassoon's open satires of the military mind and Owen's outrage in poems such as 'The Dead-Beat',[57] but also in the forms and structures of many of the finest paintings, the jagged lines of which have a terrible energy which in itself is a vigorous rejection of war and all the values for which, according to the earlier generation of writers, it is being fought. It is directed, as is made explicit in Ezra Pound's elegant and controlled fragment of war poetry, against the 'Liars in public places'[58] – those responsible for the perpetuation of the war, and those for whom the myth of village England and its associated code of values was the highest ideal, for which to die was the highest form of service and privilege. It is also worthy of note that almost all of these later artists view the war from standpoints outside the circle of the traditional English ruling class, and thus do not share the notions of duty extolled within it. Owen was brought up in a middle-class home, but completed his education in France; Rosenberg had an orthodox Jewish upbringing in the East End of London; Nevinson railed against his public-school background in terms at once forceful and pathetic. A similar distance from establishment views is seen in the records of war from the viewpoint of the private soldier, the best of which include Frank Richards's *Old Soldiers Never Die*[59] and Frederic Manning's *Her Privates We*,[60] the latter originally published in 1930 with the author acknowledged only as 'Private 19022', an acuity which is symbolic of the sustained observation of the loss of personal identity in war which permeates the volume.

These are the works of art of the war years which convey most deeply the loss and pity, and they do not properly concern us here. Yet the works of popular and fine art which have been discussed in the preceding pages, and perhaps most especially those which portray a national identity of the idealistic and misleading kind seen in this chapter, are as essential to an understanding of the great works of the war as they are to a grasp of how those at home made sense of events and strove to carry on with their lives. If the effect of the earlier visions of England is deeply distortive and misleading in its grave impact on the generation of those about to join the fighting, despite the value of such visions in helping those at home to survive the complex events of the war, the final effect of the greatest art of the war is ultimately hopeful in evidencing the triumph of compassion over suffering. Owen's finest poems deal not with nations but with individuals: it is difficult to name a single painting of the major war artists which depicts physical suffering amongst enemy soldiers. Such works do not offer a solution; but they do offer a personal compassion from which, we may hope, a kind of understanding may eventually emerge. Nowhere is this movement towards personal feeling, away from false concepts of national unity and honour, more clearly shown than at the close of Owen's 'Strange Meeting':

> Foreheads of men have bled where no wounds were.
> I am the enemy you killed, my friend.
> I knew you in this dark; for so you frowned
> Yesterday through me as you jabbed and killed.
> I parried; but my hands were loath and cold.
> Let us sleep now . . .[61]

9
Influences and Reactions

I

Throughout 1916 art had fulfilled diverse roles in the assimilation and ordering of war. It had informed, and offered guidance and a pattern of response to events; it had contextualised, placing recent happenings within a historical frame; it had erected and perpetuated myths, some valid, some misleading, to make reality bearable; sometimes it had fulminated, and sometimes goaded and encouraged to renewed effort; and occasionally it voiced compassion and offered comfort in loss. Whether conscious or unwitting, individual or collective, these currents are clearly present: but fully to assess the effect of art in war it is necessary to discover the extent to which it was absorbed by the population, and the kind of reactions it inspired among them. Like any subjective response, this is impossible to quantify; but some idea of the currency of attitudes and ideas in the various art forms may be gained by looking at statistics of publication and circulation.

Circulation of newspapers grew steadily throughout the war. In 1914, for example, the *Daily Mirror* had a circulation of 850 000, but in 1916 it was anything up to 1 580 000.[1] The *Daily Mail* sold a million copies on average in 1915, but 1 200 000 in the following year. Announcing its increase in price to 1½d. in November 1916, *The Times* claimed sales of 200 000: those of *The Daily Telegraph* were slightly higher. From earlier chapters it is clear that there is little difference in attitude to the war between the popular and the serious papers, so that they may be considered as a single group, and when this is done a total figure of something between 6 and 6½ million copies sold emerges. Readership of the Sundays rose even more rapidly. *The Sunday Pictorial* was founded in 1915, but had already achieved sales of 1 900 000 by January 1916, and approached the 2½ million mark in July. The *News of the World* rose from 1½ to 2½ million copies sold, between 1910 and 1916, and *The People* sold something around 2 million copies. As with dailies, the figures for the serious Sundays are far lower, *The Sunday Times* and *The*

Observer probably selling half a million copies in total. This gives a total of between 7 and 7½ million copies sold for the Sunday papers.

These are figures for copies sold: it is much harder to arrive at accurate figures for the number of readers. Even with many heads of households in the army, we may assume that each copy was read by two or more people, and this would give conservative estimates of 12 million for dailies and 14 million for Sundays. Presumably many purchased both kinds, and so the total figure is impossible to define accurately. Taking the highest figure for the Sundays, though, and assuming that two people read each copy, gives a figure of 15 million – though this may well be a serious underestimate for the crucial periods of the war. Looked at in terms of the size of the population, this figure is more revealing about the degree of penetration of newspaper coverage of the war. The Census of 1911[2] gives 36 million for England, with another 4 million for Scotland. In 1914 two-thirds of the population were aged between 15 and 64: in 1916 about 2 million were overseas in the forces.[3] This gives a domestic working population of something like 24½ million. If we apply to this the earlier estimate of 15 million people reading a daily or Sunday paper, it is clear that well over half the domestic working population read a national newspaper of some kind during 1916 on a fairly regular basis. This is, of course, a very rough estimate, but it rests upon valid figures for the circulation of individual papers, and probably gives a fair idea of the breadth of influence of the press at the time. To it must be added figures for local weekly and daily papers and the major evening papers, though the extent to which these had an independent readership rather than being subsumed within the figure already computed it is not possible to say.

The extent of these figures suggests that, in general terms, the press was telling the people what they wanted to hear, and we may support this by more specific instances. On 3 June – the day the news of the Battle of Jutland broke – the *Daily Mirror* sold 1 375 000 copies. The edition which carried the news of the death of Kitchener, on 8 June, sold 1 580 000. From this it seems reasonable to infer that readers had found reassurance, as well as factual information, from the paper when it recounted the battle, and turned to it again for support in the later moment of shock and loss. A similar confidence is shown in *The Sunday Pictorial*'s figures at the start of the Somme attack: 2 042 427 copies were sold on 2 July, and 2 484 502 on 9 July. From these figures it seems clear that the papers were fulfilling functions which their readers found acceptable: how far they were aware of the complex psychological signi-

ficances examined in the foregoing chapters it is hard to say, especially since they functioned largely at a subconscious level, and this is a subject to which a later section of this chapter will return.

Few other printed sources enjoyed such a large readership. Circulation figures for the popular contemporary histories of the war such as *The War Illustrated* and *The War Budget* are not available, but they most likely measure in hundreds of thousands, the whole group perhaps totalling sales of a million: here again, the numbers of readers are likely to be far higher, but impossible to compute. The mere existence of the publications right until the end of the war, though, shows that their treatments and general attitudes at the very least did not go against popular feeling and, bearing in mind the frequent similarities in tone and content between them and the popular press, it is likely that they were an accurate barometer of popular feeling, as well as exerting an influence upon public opinion in the ways discussed earlier.

The print runs of published books vary greatly, then as now, according to the nature of the work and the popularity of the writer. Some were produced in very large editions. The second series of *A Student in Arms* by Donald Hankey[4] was issued in an edition of no less than 100 000, but this was in response to the very great sales of the first volume, and is not typical. The fascicles in which *Sir Douglas Haig's Great Push* appeared from October 1916 also had a run of 100 000 copies, thanks, we may assume, to its semi-official status and perhaps also to funding from one or more of the propaganda agencies. Such figures were very high, though, in contrast to the usual editions of two or three thousand. John Masefield's *The Old Front Line* was first published by Macmillan in New York, in an edition of 3982 copies, in November 1917. Heinemann issued the book in England during December in an edition of 20 000,[5] a high figure for a volume of this kind, dwarfing the more usual runs of 1500 or 2000 which many of his own books had been given before the war, and perhaps this reflects the involvement of the propaganda department. But although the run was large in terms of serious book production, it was very small in comparison with the circulation of the newspapers, and this puts into perspective the ideas it expresses in terms of the effect they had in influencing responses to the battle, while in no way negating their sensitivity or value. It is perhaps inevitable that the hectoring editorials should attract more attention than the still small voice of compassion and understanding: yet this should warn us against assuming a parity of influence between treatments of the war which differ so greatly in production and availability.

The same warning is valid about visual treatments of the war. While

the official photographs would be seen by many millions, and artists' impressions in the London weeklies would reach an audience of hundreds of thousands when the full readership of all the journals in which they appeared is taken into account, the numbers who saw the work of the major war artists were far fewer. This was largely because their work was exhibited at the private Bond Street Galleries, and only much later in the war, with the appointment of Beaverbrook as Minister of Information, were more extensive arrangements made for the display of official war art. Much of the collection of the Imperial War Museum was not exhibited during the war, and has rarely been made available to the public since: paintings and drawings of tanks, which formed the main subject of part of chapter 7, for example, fall into this category, with the exception of the drawings by Bone which appeared in *The Western Front* and some canvases exhibited at shows featuring the work of Handley-Read and Nevinson.

Some works were exhibited to a wider audience. Eric Kennington's *The Kensingtons at Laventie*,[6] for example, was exhibited at the Goupil Gallery to collect money for the Star and Garter fund. Three of Nevinson's early paintings were shown in an exhibition of work by The London Group at the Goupil Gallery in 1915: in October 1916 a larger show of his work was held at the Leicester Galleries, and near the end of the war a collection of his paintings depicting 'The Fourth Year of the War' was exhibited in the same setting. As a result of the large number of exhibitions of his work, it was also reproduced in the London weekly magazines,[7] so that it received a currency far wider than that of most of the other war artists.

Works exhibited at the Summer Exhibitions of the Royal Academy were also much reproduced. These tended towards the more conservative treatments of war themes of the idealised kinds seen in the work of the popular illustrators, though, and even these tended to be in the minority, the more familiar flower studies and rural watercolours dominating, with the occasional exception, throughout the war. One such exception was Frank Salisbury's Cornwell portrait, which was shown in 1917. This, and the other portraits of the boy-hero, achieved far wider currency because of their fund-raising intention, and this they shared with popular prints issued as supplements with the main magazines throughout the war years. It was through images of this kind, rather than the paintings of the war artists which are today far more familiar, that the impressions of most people were formed about the reality and nature of the war.

One form of visual treatment of a more recent development also had a

wide currency – the film. The number of bookings taken for the Somme
film given in chapter four – 2000 in the first two months – suggests that it
was seen by large numbers in this period. A contemporary report esti-
mated that two cinemas in the same district showed the film to
between 12 000 and 15 000 people in seven screenings.[8] Geoffrey Malins
was similarly enthusiastic about the public response to the film:

> People crowded the theatres to see the pictures; thousands were
> turned away; and it has been estimated that the number of those who
> have seen these Official War Films must run into many millions.[9]

Malins is here referring specifically to the Somme film, using the plural as
he does throughout his account. Even when allowance is made for his
own interests and exaggeration, it seems clear that the film was seen by
very large numbers. This reveals something of the significance of the
views it expressed in terms of the extent of their possible influence, and
also shows that the cinema was rapidly becoming a major source of
information for a large portion of the population, moving towards its
peak in the 1930s when nearly 20 million tickets were sold every week.

These, then, are some of the ways in which art of various kinds was
made available to its audiences during the war, and the comparative sizes
of those audiences. Exact details of circulation are hard to come by, so
that recourse to conjecture of the kind used here is frequently necessary.
But even from such general estimates, it is clear that the primary
influence was the popular daily press, and that we need to view with some
caution the idea that more serious art forms exerted a powerful influence
on a large sector of the population. This does not, of course, lessen the
value of the attitudes revealed, or functions performed by work with
more limited circulation. The degree to which such work, whatever its
breadth of circulation, actually exerted an influence of a kind which it
implied, whether intentionally or not, is another matter, which is briefly
explored in the next section.

II

Assessing influences of this kind is an uncertain venture, especially
when, given the complex psychology of their nature and operation, the
effect may well be achieved without the full knowledge of the beholder.
Even in cases where influence is seen and recognised, it is unlikely to
have been recorded. Such narratives of the wartime experiences of
people at home during the war as exist in archival sources concentrate on

events experienced directly, not learnt through art or reportage, and they are in any case beyond the scope of this study. Instead, we must resort to diaries and recollections of the articulate few, carrying with us an awareness that the act of recording for an external reader in itself modifies the experience recorded. In some cases, however, we may learn much about instant reactions or the longer-term effects of works of art of various kinds, and three individual reactions to the treatment of the opening of the Somme offensive are of value as an example in this respect.

Vera Brittain records how she learnt of the opening of the battle in *Testament of Youth*. Except for the addition of the text of the newspaper report, the account is very similar to that given in her diary,[10] so it may be assumed that this was a genuine response which was felt at the time, and not something revised in hindsight. On the afternoon of 1 July she had been to a performance of the Brahms *Ein Deutsches Requiem* – ironic enough in itself – and learnt of the attack as she left:

> we came out from the dim, melodious peace to hear the shouting of raucous voices, and to see the newspaper boys with huge posters running excitedly up and down the pavement. Involuntarily I clutched Betty's arm, for the posters ran:

> 'GREAT BRITISH OFFENSIVE BEGINS'

> A boy thrust a *Star* into my hand, and, shivering with cold in the hot sunshine, I made myself read it.[11]

The immediate impact of this is to show an essential element of response: cold fear and anxiety for the safety of those involved in the fighting. Very few could separate the safety of relatives or loved ones from the larger issues of strategy, and this puts the larger issues of asserting national unity or laying undue stress on the bombardment to distort the reporting of the battle into a different context, inevitably making them less significant to their readers. The results of this shift of significance in terms of the functions of immediate press reports are twofold. First, they make clear very forcefully the great importance of the reassuring tone of the first reports of the Battle of Jutland as a means of aiding the survival of those involved with the fighting, not only through having relatives in the fleet, but through being close to men who would be called upon to fight to resist an invasion should such a thing come about as a result of the naval reversal. In reassuring at this level, the press editorials' function is revealed as one of even greater importance than hitherto asserted. Secondly, the justification of the larger strategy and the longer view becomes

even more necessary, to explain the planning and progress of the battle and thus show that the sacrifice of the fighting men was at best achieving some tangible result, or at worst to show personal loss as something necessary to national victory, and thus encourage continued support of the war effort in those at home – an aim the press accepted as inevitable, since it believed in the rightness of the war, and needed little official goading to proclaim. Vera Brittain's reaction thus shows clearly the need for the kind of justification and contextualising so often encountered in first treatments of aspects of the fighting.

An idea of the response to the stress on maintaining the high output of munitions can be gained by looking at two passages which show contrasting attitudes. Some weeks after the release of the Somme film, a letter containing this paragraph appeared in *Pictures and Picturegoer*:

> As I saw the great piles of munitions I at once realised how much Tommy depends on us for help. *How* many hundreds of precious lives you and I might save by working our very best all the time! Tommy doesn't grumble and worry about Bank Holidays or Sundays off – no, he works and 'rests' – works and 'rests' – week in, week out – and always with a smile and a song![12]

This seems to be a perfect response to the treatment of munitions in the film and other contemporary reports detailed in chapter 4. First, it stresses the number of lives that might be saved by hard work in the munitions factories, placing the emphasis on helping the soldiers – the relatives of those reading the letter – rather than on killing Germans or larger strategical purposes which are respectively more brutal and less easily understood. Secondly, it appeals as an equal to comrades – 'you and I' – and stresses by implication how wrong it is to grumble about giving up Bank Holidays, in a more effective use of the spur to renewed effort which is a recurrent *motif* of popular treatments. Finally, the picture of the 'Tommy' it presents is the icon of long suffering endurance – smiling, singing and never complaining – which is presented in treatments of all kinds, as shown in chapter 5.

If this is a genuine reaction, it certainly shows that the reports, most particularly the Somme film, have had the effect intended. But we should be wary of accepting it as what it claims to be. The letter is written by Adelaide Archer, who describes herself as 'a "filler" in a munition factory', yet the very perfection of the reaction seems a little too contrived to be convincing. It may well be a genuine reaction, in which case it shows well how the psychological strategies adopted in the film to

ensure the continued co-operation of the munition-workers succeeded in practice, but it may well have been produced specially to further the appeal, either by one of the propaganda organisations in an unofficial way or by the journal itself, in the manner often adopted by newspapers and journals wishing to stimulate discussion of a particular topic.[13] Either way, it is of much interest: if genuine, it shows the success of the techniques of implied persuasion, and if manufactured, it shows the kind of response the writers and film-makers desired, revealing that the techniques discussed in chapter 4 were used quite consciously to encourage renewed efforts in the production of munitions.

Another reaction serves as a corrective to the buoyancy of the letter. Whether it is more typical it is impossible to say, yet its tone and circumstances seem unlikely to have been uncommon. The passage occurs from an officially-sponsored volume called *Women War Workers* edited by Sir George Stone and published in 1917, and clearly intended to congratulate the war workers and spur them on to even greater efforts. An account of the night shift contains this paragraph:

The ordinary factory hands have little to help them keep awake. They lack interest in their work because of the undeveloped state of their imaginations. They handle cartridges and shells, and though their eyes may be swollen with weeping for sweethearts and brothers whose names are among the killed and wounded, yet they do not definitely connect the work they are doing with the trenches. One girl, with a face growing sadder and paler as the days went by because no news came from France of her 'boy' who went missing, when gently urged to work harder and not to go to sleep so often, answered, with angry indignation: 'Why should I work any harder? My mother is satisfied with what I takes home of a Saturday'.[14]

This is not a passage which a modern reader can read without a sense of outrage, both at the conditions which are taken for granted – the tacit acceptance that a worker will fall asleep during a twelve-hour night-shift while working with explosives – and at the patronising and complacent attitude to the 'undeveloped' minds of the workers. We may feel that the passage was included in the book to show to the middle-class readers at whom it is clearly directed the irresponsible and limited attitude of the workers, as an ironic parallel to Sir Edward Carson's injunction to the workers discussed at the close of chapter 3. Yet it seems to convey a more accurate account of the genuine feeling of many such people, for whom the blanching exhaustion of night work and the shock of loss was a far

more immediate reality than the need to produce more shells to support 'Tommy' in the trenches. In the face of such feeling, the appeals to work harder would presumably merge with other images of authority and 'duty'. But in 1916 the sense of duty was strong, and the effect of the exhortations of the press and the 'gentle urging' of the supervisors cannot be denied, even in the circumstances described in this passage. Once again, the pressures of personal loss are overwhelming, and must be the first consideration in any study of the effects of treatments of the larger issues of the war; but once again they reveal the importance of the reassurance and contextualising of the more popular and most immediate responses to the fighting.

These examples, few as they are, show the dangers of making simple or large-scale assumptions about how people reacted to the strategies and stances of the more popular art forms. In general terms, the influence of the press reports must have been strong, whereas that of the more complex treatments in minority art forms was clearly strictly limited. In the last analysis we cannot gauge the effect of any of these treatments: perhaps all that may be said is that their intentions were clear, that they did not go against the views of most of the population save in exceptional circumstances, and that they provide a record of the fears and aspirations of the people, whether in broad agreement with establishment and official views, as is the case with the press, or by offering the more personal and sometimes more compassionate view of an individual artist.

III

What, finally, may be said of this mass of material and the stances and strategies it presents? It is too easy to assume the presumptuous precision of hindsight and see it as superficial and callous, or regard it as the striking-board against which the artists of the later years of the war rebelled. True, there is much, especially in the more popular treatments of events, most particularly the Somme, which is misleading and distortive, perhaps most understandably so in the clumsy, tangled appeals for increased production, and most callously so in the easy acceptance of high casualties. The village England myth is deeply distortive: it is not easy to forgive the perpetuation of a fiction of clean-cut heroism for so long after the darker reality was clear.

Yet there are more positive, more human functions. Consolation and reassurance are offered, even though they may falsify the larger patterns of the war's progress. Patterns of survival are put forward, so that those

at home can simply keep going: campaigns are waged which might achieve some lessening of the suffering, by the adoption of measures of greater efficiency. And it was, after all, the first mass-circulation war: making sense of it for others, when the daily occurrences, let alone the longer ground swell, were far from clear, could not have been easy. In order to make sense of it, though, the more damaging, longer-term myths developed, so that the quotidian consolation turned to a broader falsification, on the Somme and elsewhere. Much of the consolation offered by the arts was constructive and genuine: it is the larger perpetuations and contextualisings which are more disturbing. In the tension between these two – the nurturing and the deceiving – is the enduring paradox of the art of 1916.

Notes

Sizes of paintings are given in inches, with height preceding width.

1 Functions and Circumstances

1. Jeffrey Farnol, *Some War Impressions*, 1918, p. 82.
2. 'An O.E.', *Iron Times with the Guards*, 1918, p. 168.
3. Donald Boyd, *Salute of Guns*, 1930, p. 127.
4. Keith Henderson, *Letters to Helen*, 1917, pp. 49–50.
5. *The Times History of the War*, vol. VII, 1916, p. 21.
6. Michael MacDonagh, *In London during the Great War*, 1935, p. 169.
7. Mrs Eustace Miles, *Untold Tales of Wartime London*; *A Personal Diary*, 1930, p. 132.
8. Enid Bagnold, *A Diary without dates*, 1917, p. 72.
9. Bagnold, p. 91.
10. 'An amateur Officer', *After Victory*, 1917, p. 16.
11. Charles Dovie, *The Weary Road*; *Recollections of a Subaltern of Infantry*, 1929, p. 12.
12. Collected in E.D. Swinton, *Eye-Witness's Narrative of the War*, 1915; and E.D. Swinton and the Earl Percy, *A Year Ago*, 1916.
13. *Collected Poems*, 1947, p. 75.
14. *The Collected Poems of Wilfred Owen*, C. Day Lewis (ed.) 1963, p. 31.
15. *The Western Front: drawings by Muirhead Bone*, 2 vols, each in 5 parts, 1917. Quotation from unnumbered prefatory pages.
16. *Introduction to History* (Open University Arts Foundation Course), 1978, *passim*.
17. Hervey Allen, *Toward the Flame*; *A War Diary*, 1934, pp. 9–10.
18. Leonard Thompson, in Ronald Blythe, *Akenfield*, 1969, repr. 1972, pp. 42–3.
19. *The Collected Works of Isaac Rosenberg*, Ian Parsons (ed.), 1979, p. 103.
20. Day Lewis (ed.) p. 67.
21. Oil on canvas, 28 x 36, Imperial War Museum, London, hereafter IWM.
22. See, for example, Sir William Orpen, *Sir Douglas Haig*, Oil on canvas, 29½ x 25, IWM.
23. See, for example, Sargent's *Arras*, 21½ x 27½, collection of Sir Philip Sassoon.
24. See, for example, George Davis, *Closing Up*, Oil on canvas, 38 x 60, IWM.

2 The Range of Response

1. *With the Allies*, 1915, p. 227.
2. *The Soul of the War*, 1915.
3. *On the Path of Adventure*, 1919, p. 12.
4. Basil Clarke, 'How the Progress of the War was Chronicled by Pen and Camera', *The Great War*, vol. 10, 1917, pp. 413–28. Quotation from p. 418.
5. The early organisation of the Press Bureau is dealt with in M. L. Sanders and Philip M. Taylor, *British Propaganda during the First World War, 1914–18*, pp. 18–32.
6. Clarke, p. 423.
7. See ch. 1, n. 12.
8. See *The History of The Times*, vol. 4, part 1, *The 150th Anniversary and beyond*, 1952, pp. 222–8.
9. Cook's *The Press in Wartime*, 1920, is a valuable account of the subject.
10. Philip Gibbs, *The Pageant of the Years*, 1946, p. 143.
11. Gibbs, p. 168.
12. According to Gibbs, *Realities of War*, 1919, rev. and enl. 1929 and 1936, p. 21. Lyn Macdonald, in *Somme*, 1983, gives 'writer chappies', p. 79.
13. Gibbs, 1946, p. 168.
14. For an account of the working conditions of the photographers, see Clarke, p. 418 ff.
15. Mortimer's studies are among the few to be reproduced in the illustrated journals with the name of the photographer. They were also given dramatic titles, such as *The Vigil* (*The Graphic*, 7 April 1917) and *An eye for an eye, and a tooth for a tooth* (*Illustrated London News*, 21 September 1918, pp. 336–7).
16. Sanders and Taylor gives a thorough account of the various successive organisations. Also of value are J.D. Squires, *British Propaganda at Home and in the United States*, Cambridge, Mass., 1935; and M.L. Sanders, 'Wellington House and British Propaganda during the First World War', *Historical Journal*, XVIII,1, 1975, pp. 119–46.
17. An account of the informal operation of Wellington House is given in Lucy Masterman, *C.F.G. Masterman: A Biography*, 1939.
18. First Report on the work of Wellington House, INF 4/5.
19. Second Report, IWM.
20. *England's Effort: Letters to an American Friend*, 1916; 3rd edn, 1916, with an additional letter.
21. For example, *Roof over Britain*, 1945 and *Front Line*, 1942.
22. Nicholson himself describes the work of the department in 'An aspect of British Official Wartime Propaganda', *Cornhill Magazine*, 71, 1931, pp. 593–606.
23. Discussed in detail in Sanders and Taylor p. 43ff.
24. The fullest account of the origin and development of the war artists' scheme is given in W.P. Mayes, *The Origins of an Art Collection*, unpublished ms in the IWM.
25. See the correspondence regarding Bone's employment in the IWM Department of Art, First World War G4010/27, Artists at the Front; Muirhead Bone, 1916–17.

26. See Merion and Susie Harries, *The War Artists*, 1983, pp. 73–81.

27. Introductory accounts of the involvement of these and other artists are given in Harries.

28. For an account of the first screening of this film and its effects, see Masterman, pp. 282–6. An early chronicle of film in the war is given in Marie Seton, 'War', *Sight and Sound*, Winter 1937–8, pp. 182–5. Other treatments occur in Rachel Low and Roger Manvell, *The History of the British Film, vol 3, 1914–1918*, 1956, pp. 154–60; Sanders and Taylor, pp. 123–30; and Nicholas Reeves, *Film Propaganda in the First World War*, unpublished Ph.D. thesis, University of London, 1981.

29. The exact degree of involvement of MacDowell is hard to determine, but it is certainly greater than is implied by Malins in his *How I filmed the War*, 1920, which gives an egocentric yet still valuable account of the life of an 'official cinematographer'.

30. Malins, p. 177.

31. Message read to the audience at the first London screening; quoted widely in the press, and beneath stills from the film in *The Illustrated London News*, 26 August 1916, p. 241.

32. Reported by the *Evening Standard*, August 1916.

33. Kevin Brownlow, *The War, the West and the Wilderness*, 1979, p. 61.

34. In *With the Royal Flying Corps*, 1917 and *Tails Up France; The life of a RAF Officer in France*, 1918.

35. *The Woman's Portion*, 1917; *Mrs John Bull Prepared*, 1918; *A Day in the life of a Munitions Worker*, 1917.

36. *Stand by the Men who have Stood by You*, 1918; *Old Father William*, 1918.

37. Produced by prominent members of the University, some 87 of these were printed and enjoyed wide popularity early in the war.

38. The operation of the PRC is dealt with by Sanders and Taylor, pp. 15–18.

39. Posters are discussed in depth in Martin Hardie and Arthur K. Sabin, *War Posters issued by belligerent and Neutral Nations 1914–1919*, 1920.

40. Recent bibliographies include Harro Grabolle, Hilda Spear and Ian Wallace, 'British and German Prose Works of the First World War', *Notes and Queries*, August 1982, pp. 329–35 and August 1983, pp. 326–9; and Stuart Sillars, 'British Prose of the First World War: Some neglected works', *Notes and Queries*, December 1984, pp. 507–8.

41. *Undertones of War*, 1929.

42. *Goodbye to all that*, 1929.

43. *Memoirs of an Infantry Officer*, 1931.

44. Evelyn Waugh, 1945.

45. Catherine W. Reilly, *English Poetry of the First World War*, 1978, lists over 2200 poems on the theme of the war, but this figure is misleading as it includes poems written up to 1973 but excludes those appearing in periodicals and newspapers.

46. E.B. Osborn (ed.) 1917.

47. *Poems*, 1920.

48. *The Collected Poems of Edward Thomas*, R. George Thomas (ed.), Oxford, 1978.

49. *The Collected Works of Isaac Rosenberg*, Parsons (ed.), 1979.
50. *Counter-attack and other poems*, 1918.
51. *Poems 1914–1930*, 1930.
52. 1915.
53. An entertaining survey of some of the more popular novels is contained in Mary Cadogan and Patricia Craig, *Women and Children First: the Fiction of two World Wars*, 1978; M.S. Greicus, *Prose Writers of World War 1*, 1973 is a brief introductory outline; and Holger Klein (ed.), *The First World War in Fiction*, 1976, is a serious study of some of the more important works. There is no detailed study of the role and nature of both serious and popular fiction during the war.

3 Jutland

1. Detailed accounts are given in A.J. Marder, *From the Dreadnought to Scapa Flow*, 3, 1966; S.W. Roskill, *The Strategy of Sea Power*, 1962 and *Admiral of the Fleet Earl Beatty*, 1980; Richard Hough, *The Great War at Sea, 1914–18*, 1983.
2. Discussed in Patrick Beasly, *Room 40; British Naval Intelligence 1914–18*, 1982.
3. The German communiqué is quoted in full in Langhorne Gibson and J.E.T. Harper, *The Riddle of Jutland: an Authentic History*, 1934, pp. 254–5.
4. *Daily Mirror*, 3 June 1916. The text of the communiqué is quoted from this source: it appeared in identical form in all the London papers on that date.
5. *Daily Mirror*, 3 June 1916.
6. See Gibson and Harper, p. 257.
7. Quoted, for example, in the *Daily Mirror* and the *Daily Express*, 3 June 1916.
8. All quotations from the statement are from *The Sunday Times*, 4 June 1916. The other Sundays carried it in identical form.
9. *Daily Mirror*, 5 June 1916: identical forms appeared in the other London dailies.
10. Reported in *The Times*, 8 June 1916.
11. *The Sphere*, 10 June 1916, pp. 226–7.
12. *The Sphere* 4 November 1916, p. 93.
13. *The Graphic*, 10 June 1916, Supplement p. 1.
14. John Leyland (ed.), *Souvenir of the Great Naval Battle*, 1916, p. 28.
15. See Henry Newbolt, *History of the Great War based on Official documents, Naval Operations*, Vol. VI, 1928; and HMSO, *Narrative of the Battle of Jutland*, 1924. The list of books discussing the relative merits of the two commanders is long, and includes J.E.T. Harper, *The Truth about Jutland*, 1927; Reginald Bacon, *The Jutland Scandal*, 1925; J.L. Pastfield, *New Light on Jutland*, 1933: the views are usefully summarised in J. Irving, *The Smoke Screen of Jutland*, 1966.
16. 7 July 1916.

17. *Daily Mirror*, 10 July 1916.
18. *The Poetical Works of Mrs Felicia Hemans*, 1879, pp. 373–4.
19. 3 September 1916.
20. Pages unnumbered: the drawing appears in a chapter headed 'Jack Cornwell, V.C., of the "Chester".
21. n.d. (?1920), illustration facing p. 224.
22. 1919, illustration facing p. 145.
23. Herbert Strang (ed.), n.d. (?1917). Pages unnumbered: the drawing appears in a chapter headed 'The Battle of Jutland'.
24. p. 138.
25. 8 July 1916.
26. *The Times*, 26 July 1916.
27. *The Times*, 22 September 1916.
28. A photograph in the *Daily Mirror* of 22 September 1916 shows pupils at a school in Ilford performing this ritual.
29. *The Times*, 22 September 1916.
30. For example, Sir Edward Parrott, *The Path of Glory*, facing p. 32.
31. *The Times*, 10 February 1917.
32. Oil on canvas, 49 x 39, Welholme Galleries, Grimsby (on loan from Humberside Area Health Authority).
33. *The Times*, 23 November 1916.
34. Oil on canvas, 156 x 72, HMS Raleigh, Torpoint, East Cornwall. The painting was commissioned by the Admiralty as a record of the event: its fund-raising use was a later development.
35. *The Times*, 24 March 1917.

4 The Somme (1)

1. *The Star*, 1 July 1916.
2. The main alternative views of the battle are summed up in John Terraine, *The Smoke and the Fire*, 1980, p. 100 ff.
3. *Daily Telegraph*, 3 July 1916.
4. *Daily Mail*, 3 July 1916.
5. See ch 2, note 28.
6. See ch 2, p. 27.
7. 1916.
8. *The Bookseller*, October 1916, p. 480.
9. For this reason, and for reasons of space, it is not discussed in this chapter.
10. For a more complete account of the figures, see Terraine, p. 45.
11. For a discussion of the relative sizes of later bombardments, see Terraine, p. 118.
12. 28 June 1916, pp. 20–1.
13. *Daily Express*, 1 July 1916.
14. *Daily Mirror*, 3 July 1916.
15. *Daily Mail*, 3 July 1916.

16. *Daily Express*, 3 July 1916.
17. *The Times*, 1 July 1916.
18. 2 July 1916.
19. 3 July 1916.
20. *Daily Express*, 3 July 1916.
21. *The Times*, 3 July 1916.
22. *Illustrated War News*, 19 July 1916, p. 22.
23. *Illustrated War News*, p. 22.
24. *Illustrated War News*, 12 July 1916, p. 38.
25. *The War Illustrated*, 15 July 1916, p. 509.
26. *Daily Express*, 3 July 1916.
27. *The Times*, 1 July 1916.
28. *Daily Telegraph* 3 July 1916.
29. *Daily Telegraph*, 1 July 1916.
30. All on 1 July 1916.
31. *Daily Mail*, 3 July 1916.
32. *The Times*, 3 July 1916.
33. *With a Machine Gun to Cambrai*, 1969, p. 83.
34. See, for example, Lyn Macdonald, *Somme*, 1983, pp. 47–8.
35. *Illustrated London News*, 15 July 1916, pp. 72–3.
36. For an absorbing survey of the variety of results produced by the barrage,
 see Martin Middlemass, *The First Day on the Somme*, 1971.
37. *Daily Mail*, 3 July 1916.
38. *Daily Express*, 3 July 1916.
39. *Illustrated London News*, 26 August 1916, p. 240.
40. *The Bioscope*, August 1916, p. 476.
42. *Daily Mirror*, 3 July 1916.
42. *Punch*, 2 August 1916, p. 87.
43. *Punch*, 10 March 1916.
44. *England's Effort: Letters to an American Friend*, 3rd edn, 1916, with an
 additional letter, p. 233.
45. pp. 16–17.

5 The Somme (2)

1. *The Times*, 3 July 1916.
2. *Daily Mail*, 3 July 1916. The communiqué also appeared in identical form
 in the other daily papers on that day.
3. 3 July 1916.
4. 3 July 1916.
5. 5 July 1916, p. 3
6. *Daily Express*, 3 July 1916.
7. *The Times*, 3 July 1916.
8. *Daily Telegraph*, 3 July 1916.
9. *Daily Mirror*, 4 July 1916.

10. *Daily Mirror*, 5 July 1916.
11. *Daily Mail*, 3 July 1916.
12. *Daily Telegraph*, 3 July 1916.
13. 15 July 1916, p. 516.
14. 15 July 1916, p. 516.
15. 3 July 1916.
16. *The Times*, 3 July 1916.
17. *Daily Mail*, 3 July 1916.
18. *Daily Express*, 3 July 1916.
19. 27 July 1916.
20. *Daily Mail*, 3 July 1916.
21. *Daily Mail*, 3 July 1916.
22. 15 July 1916, p. 519.
23. 3 July 1916.
24. From the sonnet 'Peace', *Collected Poems of Rupert Brooke*, 1918, p. 5.
25. 3 July 1916.
26. *Daily Mail*, 3 July 1916.
27. Quoted in Kevin Brownlow, *The War, the West and the Wilderness*, 1979, p. 65.
28. 3 July 1916.
29. *Daily Mail*, 3 July 1916.
30. *Illustrated London News*, 29 July 1916, pp. 134–5.
31. *Illustrated London News*, 29 July 1916, pp. 134-5.
32. See, for example, a drawing by R. Caton Woodville reproduced in Elizabeth O'Neill, *The War 1916*, 1917, facing p. 58.
33. See *The War Illustrated*, 15 July 1916, p. 523.
34. This and the following group of quotations from newspapers comes from the editions of 3 July 1916.
35. p. 526.
36. *The Collected Poems of Wilfred Owen*, C. Day Lewis (ed.), 1963, p. 52.
37. 'Dulce et Decorum Est', *Collected Poems*, p. 55.
38. *Collected Poems*, p. 77.
39. *Collected Poems*, p. 77.
40. Day Lewis (ed.), p. 82.
41. Letter of [?16] May 1917, in Harold Owen and John Bell (eds), Wilfred Owen: *Collected Letters*, 1967, p. 461.
42. Day Lewis (ed.) p. 36.
43. Letter dated 19 July 1917. IWM, Department of Art, First World War 267 A–6, Paul Nash, 1917.
44. Oil on canvas, 24 x 36, IWM.
45. Oil on canvas, 28 x 36, IWM.
46. Pencil, pen and water-colour, 15½ x 19½, IWM.
47. Water-colour, 11 x 15¼, IWM.
48. Pastel on brown paper, 9¾ x 13¾, IWM.
49. p. 44.
50. p. 55.
51. pp. 26–7.
52. p. 55

53. p. 58.
54. p. 31.
55. p. 45.
56. p. 40.
57. p. 31.
58. pp. 76–7.

6 The War in the Air

1. David Lloyd George, House of Commons, 29 October 1917. *The Parliamentary Debates (Official Report)*, Fifth Series vol XCVIII, House of Commons, 16 October–8 November 1917, col. 1247.
2. 'Flight Commander', *Cavalry of the Air*, n.d. (?1918), p. iii.
3. *The War Budget*, 29 June 1916, p. 201.
4. *The War Budget*, 29 June 1916, p. 201.
5. *The Work and Training of the Royal Flying Corps*, n.d. (?1918). Introduction by Lord Hugh Cecil, p. 5
6. H.W. Wilson and J.A. Hammerton (eds), *The Great War*, vol. V, 1916, p. 364.
7. Edward Parrott, *The Path of Glory: Heroic Stories of the Great War*, n.d., pp 112–30.
8. *The Sphere*, 11 December 1915, p. 276a.
9. 'Flight Commander'.
10. H. Bordeaux, L.M. Sill (trans), 1918.
11. Eric Wood, *Thrilling Deeds of British Airmen*, 1917, p. 114.
12. *The Work and Training of the Royal Flying Corps*, p. 4.
13. See, for example, W.L. Wade, *The Aeroplane in the Great War: A record of its Achievements*, n.d. (?1920), *passim*.
14. *The War Budget*, 5 August 1915, p. 367.
15. *The War Budget*, 2 December 1915, p. 85; and 25 May 1915, p. 41.
16. *The Great War*, vol. 5, 1916, p. 364.
17. *Tales of the Flying Services: The adventures and humours of aerial warfare*, 1915, p. 109.
18. *The War Budget*, 27 July 1916, p. 334.
19. 'A cool hand', *The Tatler*, 28 November 1917, pp. 262–4. Quotation from p. 264.
20. Ira Jones, *An air-fighter's scrap-book*, 1938, repr. Harmondsworth 1942, p. 43.
21. Bernard Pares, *With the Russian Army*, 1915. Quoted in *The Sphere*, 11 December 1915, p. 276.
22. Cecil Lewis, *Sagittarius Rising*, 1936, p. 60.
23. Lewis, p. 60.
24. Yeates, V.M., *Winged Victory*, 1934, repr. 1972, p. 31.
25. Lewis, p. 61.
26. For example, 24 April 1915, p. 290; and 2 December 1915, p. 85.
27. *Closing Up*, oil on canvas, 38 x 60, IWM; illustrations for many books, including Eric Wood; and illustrations in the London weeklies.

28. For example, *The end of a German Aeroplane: at a Great Height over Arras*, Water-colour, 18¼ x 13, IWM; and *An attack on a German Troop Train*, Water-colour, 18¼ x 13, IWM.
29. Yeates, p. 180.
30. *The Great War*, vol. XI, 1918, pp. 393–4.
31. Yeates, p. 340.
32. *The War Budget*, 29 June 1916, p. 201.
33. *Death in the Air: The War Diary and Photographs of a Flying Corps Pilot*, 1933.
34. Yeates, p. 37.
35. Yeates, p. 352.
36. Oil on canvas, 42 x 28, RAF Staff College, Bracknell.
37. Oil on canvas, 42½ x 54¼, IWM.
38. *R.F.C. H.Q. 1914–1918*, 1920, p. 121.
39. *Over the Front in an Aeroplane*, 1915, p. 6.
40. 'Flight Commander', pp 59–60.
41. Oil on canvas, 36 x 48, IWM.
42. 'Contact' (Alan Bott), *An Airman's Outings*, 1917, p. 149.
43. 27 x 20¾, IWM.
44. p. 209.
45. Lewis, p. 205.
46. Oil on canvas, 50 x 30, IWM.
47. Yeates, p. 190.
48. Yeates, p. 310.
49. Yeates, p. 402.
50. Yeates, p. 307.
51. Written by Yeates on the flyleaf of Henry Williamson's copy of the novel and quoted by Williamson in his preface for the 1961 reissue, p. 6.
52. Yeates, pp. 66–7.
53. Yeates, pp. 402–3.
54. Yeates, p. 307.
55. Keith Henderson, *Letters to Helen*, 1917, pp 229–30.
56. Yeates, p. 67.
57. Yeats W.B., *Collected poems*, 1933, p. 152.
58. Joseph Hone, *W.B. Yeats 1865–1939*, 1943 (2nd edn 1962), p. 457.
59. 'Flight Commander', p. 118.
60. Water-colour, 24 x 36, IWM.
61. Reverse painting on glass, 24¾ x 19, IWM.
62. Including, among others, October 5 1918, pp. 378–9; March 24 1917, pp. 348-9; June 2 1917, p. 647; January 9 1915, p. 38.
63. *The Graphic*, January 29 1916, p. 166.
64. 1941.
65. Jones. H.A., *The War in the Air*, 1931, vol. III, Appendix III; vol. V, Appendix I.
66. Tom Harrison, *Living through the Blitz*, 1976, repr. Harmondsworth, 1978, pp. 21, 127, 356.
67. *The Graphic*, 16 January 1915, p. 65.
68. 11 May 1915.

69. 22 May 1915, p. 10.
70. *The Sphere*, 12 June 1915, p. 256, etc.
71. *The War Budget*, 9 March 1916, p. 121: *The Graphic*, 30 September 1916, pp. 386–7, etc.
72. *Punch*, 27 October 1915, p. 343.
73. *The Times History of the War*, vol VII, 1916, p. 4.
74. *Punch*, 22 September 1915, p. 250.
75. *Punch*, F.H. Townsend, 25 August 1915, p. 163.
76. *Punch*, A. Wallis Mills, 13 October 1915, p. 310.
77. *Punch*, George Morrow, 7 July 1915, pp. 28–9.
78. *Punch*, G.L. Stampa, 21 July 1915, p. 74.
79. *Punch*, Ernest H. Shephard, 1 September 1915, p. 193.
80. *Illustrated London News*, 3 November 1917, p. 532.
81. *The War Budget*, 9 March 1916, p. 121.
82. Herbert Strang (ed.), *The Blue Book of the War*, 1917: quotation from chapter 'Air Raids' in part I (pages unnumbered).
83. 28 October 1916, p. 215.
84. Michael MacDonagh, *In London during the Great War*, p. 82: diary entry for 13 October 1915.
85. *The Times History of the War*, vol. VII, 1916, p. 20.
86. Account of the raid of 7–8 September 1916 by an eye-witness, *The Times History of the War*, vol. VII, 1916, p. 27.
87. Vol. V, 1916, p. 367.
88. p. 238.
89. p. 398.
90. 13 November 1915, p. 638.
91. Present whereabouts unknown: reproduced in the *Illustrated London News*, 12 June 1915, p. v.
92. MacDonagh, p. 82: diary entry for 13 October 1915.
93. *Punch*, Lewis Baumer, 7 July 1915, p. 23.
94. *The Graphic*, 16 September 1916, p. 332.
95. p. 548.
96. 15 x 10⅞ IWM.
97. 9 September 1916, pp. 310–11.
98. Oil on canvas, 72 x 48, IWM.
99. *The Graphic*, 26 October 1918, p. 461.
100. 9 September 1916, p. 310.
101. 14 September 1916, p.135.
102. MacDonagh, p. 139: diary entry for 13 October 1915.
103. Charles Dixon, *The Graphic*, 2 December 1916, p. 679.

7 The Snark of the Somme

1. *Daily Mail*, 16 September 1916, p. 5. The communiqué also appeared in all the other daily papers.
2. *The Times*, 19 September 1916, p. 10.
3. Job XL, 15.
4. Job XL, 19.

5. *Illustrated London News*, 2 December 1916, CXLXIX, p. 866.
6. Philip Gibbs, *The War Despatches*, Catherine Prigg (ed.), 1964, p. 174.
7. Gibbs, p. 175.
8. *Illustrated London News*, 2 December 1916, CXLXIX, p. 866.
9. n.d.
10. Macintosh, pp. 26, 58, etc.
11. Macintosh, p. 53.
12. *Illustrated London News*, 9 February 1918, CLII, p. 160.
13. *Illustrated London News*, 9 February 1918, CLII, p. 160.
14. *Illustrated London News*, 2 March 1918, CLII, p. 265.
15. *The Tank in Action*, 1920.
16. Browne, p. 35.
17. For further details, see A. and C. Williams-Ellis, *The Tank Corps*; The *Country Life* Series of Military Histories, 1919, p. 154.
18. 'Footprints – an impression of a trench after a Tank had passed' by G. Bron, 2 December 1916, LXVII, p. 156.
19. Percy T. Reynolds, 'A few conceptions, picked up from press accounts here and there, of what the 'Tanks' are really like', *Punch*, 27 September 1916, p. 238.
20. Artist unknown, 'The prehistoric touch', *The Bystander*, vol. LI, no. 669, p. 549.
21. *The Weekly Dispatch*, 24 September 1916, p. 7.
22. 'The Snark of the Somme; or, the terrible tank', *The Graphic*, 23 September 1916, XCIV, p. 359.
23. Browne, p. 34.
24. *The Western Front: Drawings by Muirhead Bone*, 1917, I, plate XLII.
25. 1917, I, plate VII.
26. Seen, among numerous other places, on the front cover of Albert Stern, *Tanks 1914–1918*, 1919.
27. 2 December 1916, LXVII, pp. 158–9.
28. *Illustrated London News*, 2 December 1916, CXLXIX, pp. 886–7.
29. Including M. Ugo's 'The "Tanks" in action on the Western Front', *The Sphere*, 2 December 1916, LXVII, p. 157.
30. 'In pursuit of the Germans – the Tanks', *The Graphic*, 7 September 1918, XCVIII, p. 266.
31. n.d.
32. Reproduced on the cover of A. and C. Williams-Ellis, *The Tank Corps*.
33. Charcoal, chalk and water-colour, 23½ x 17¾, IWM.
34. Charcoal and water-colour, 24 x 29, IWM.
35. *Illustrated London News*, 25 November 1916, CXLXIX, p. 628.
36. *Illustrated London News*, 2 December 1916, CXLXIX, pp. 668–9.
37. 'Tanks in action on the Western Front', 23 February 1918, LXXII, p. 184.
38. Oil on canvas, 20 x 24, IWM.
39. Oil on canvas, 22 x 16, IWM.
40. *Illustrated London News*, 2 December 1916, CXLXIX, p. 699. Significantly, this view was also reproduced in F. Mitchell, *Tank Warfare*, n.d., p. 25.
41. Siegfried Sassoon, 'Blighters', *Collected Poems*, 1947, p. 21.
42. Pencil, 12½ x 17, IWM.

43. Ink and water-colour, 12 ¾ x 18, IWM.
44. Ink and water-colour, 12 x 18, IWM.
45. Collected in *The London and Birmingham Railway*, 1839.
46. *The Western Front: Drawings by Muirhead Bone*, I. Preface by Sir Douglas Haig (unnumbered pages).
47. Oil on canvas, 26¾ x 42, Science Museum, London.
48. Oil on canvas, 72 x 125, IWM.
49. Water-colour, 13½ x 21, IWM.
50. *Arras*, water-colour, 21½ x 27½, Sir Philip Sassoon.
51. Also known as *Tanks in Action*; Charcoal and water-colour, 21¾ x 30½, IWM.
52. Present whereabouts unknown: illustrated in *The Graphic*, 14 April 1917, XCV, p. 429.
53. As above.
54. Pencil, with a touch of colour, 16½ x 20¼, IWM.
55. Water-colour, 12½ x 20¾, IWM.
56. Ink and water-colour, 12 x 16⅜, IWM.
57. Water-colour, pen and pencil, 13½ x 10½, Tate Gallery, London.
58. *Dazzle-ships in Drydock at Liverpool*, Oil on canvas, 119½ x 96, National Gallery of Canada, Ottawa.
59. Oil on canvas, 18 x 24, IWM.
60. Oil on canvas, 18 x 24, IWM.
61. Oil on canvas, 22½ x 16¼, IWM.
62. Oil on canvas, 49⅜ x 42½, Tate Gallery, London.

8 England, Whose England?

1. *Your Country's Call*, produced by the Printers Jowett and Sowry for the Parliamentary Recruiting Committee (as poster no. 87), 30 x 20, 1915.
2. 1915.
3. 1916.
4. *Mr Standfast*, pp. 23–4.
5. *Mr Standfast*, p. 43.
6. *Mr Standfast*, p. 155.
7. 7 December 1914, p. 22.
8. 'An O.E.', *Iron Times with the Guards*, 1918, p. 183.
9. Shown, for example, in anon. (ed.), *Poems of the Great War*, 1914; E.B. Osborn (ed.), *The Muse in Arms*, 1917; and similar anthologies.
10. *Collected Poems of Rupert Brooke*, p. 9.
11. Quoted in Charles Dovie, *The Weary Road: Recollections of a Subaltern of Infantry*, p. 10.
12. *Poems of Ivor Gurney*, 1973, p. 36.
13. Most conveniently available in *Hymns Ancient and Modern Revised*, p. 785.
14. Osborn (ed.), p. 176.
15. E.H.D. Sewell, 'Bowling and Bombing: Cricket as a Training for Campaigning', *The Graphic*, 16 September 1916, pp. 341, 350.
16. By Ernest Raymond.

17. *Tell England*, p. 287.
18. *Tell England*, p. 290.
19. 27 November 1916, p. 3.
20. HMSO *Census of England and Wales, 1911*, Cd 6258, 1912–13, Vol. 1, p. 8.
21. HMSO, 1912–13.
22. See, for example, E. Sylvia Pankhurst, *The Home Front: A Mirror to life in England during the World War*, 1932, pp. 314–20.
23. 1929.
24. 'BLAST First (from politeness) ENGLAND': *Blast; Review of the Great English Vortex*, no. 1, 20 June 1914, p. 11.
25. Oil on canvas, 30 x 40, IWM.
26. For example, *The Gun Forge*, 15¾ x 21, IWM; and 'The Gun Dip', *Illustrated London News*, 21 October 1916, CLXXIX, p. 483.
27. A brief account of the series is given in Harries, *The War Artists*, pp. 78–81. Both the 'Efforts' and 'Ideals' are listed in detail under the artists concerned in *A Concise Catalogue of Paintings, Drawings and Sculpture of the First World War: Imperial War Museum*, 2nd edn, 1963.
28. Oil on canvas, 72 x 125, IWM.
29. Most particularly *Listen to Britain*, 1942, *A Diary for Timothy*, 1945, and the post-war *Dim Little Island*, 1949.
30. For example, *Wales, Green Mountain, Black Mountain*, 1942, *Night Shift*, 1942, and Jennings's *The Cumberland Story*, 1947.
31. See the *Report of Reconstruction Conference, October 1915*, 1915.
32. 1915.
33. *The War and after*, p. v.
34. By J.A. Hobson.
35. *Reveille*, no. 1, August 1918.
36. *Reveille*, no. 1, p. 4.
37. *Whizz-bangs and Woodbines: Tales of Work and Play on the Western Front*, 1918, p. 175.
38. 'An Amateur Officer', *After Victory*, 1917, p. 142.
39. 'An Amateur Officer', p. 171.
40. See Harries, p. 78, and entries under individual artists in the IWM *Concise Catalogue*.
41. The film was made in 1938 during the Munich crisis, but not released until August 1939, when it was re-titled *Do it Now*.
42. 4 January 1941, pp. 10–13.
43. 4 January 1941, pp. 14–15.
44. 'This is the Problem', *Picture Post*, 4 January, 1941, pp. 7–9.
45. Coombes, pp. 8–9.
46. 1941: repr. in *The Collected Essays*, 2, 1968.
47. *The Collected Works of Isaac Rosenberg*, p. 109.
48. Wilfred Owen, *Collected Poems*, p. 58.
49. Siegfried Sassoon, *Collected Poems*, 1947, p. 19.
50. *Poems of Ivor Gurney*, 1973, p. 42.
51. Oil on canvas, 24 x 20, IWM.
52. Oil on canvas, 28 x 36, IWM.

53. Oil on canvas, 18 x 24, IWM.
54. Pen, ink, pencil and water-colour, 12½ x 20, IWM.
55. Oil on canvas, 76 x 56, Ben Uri Gallery.
56. *Collected Poems*, p. 35.
57. *Collected Poems*, p. 72.
58. 'E P Ode pour l'election de son sepulchre', *Hugh Selwyn Mauberly (Life and Contacts)*, in T.S. Eliot (ed.) *Ezra Pound: Selected Poems*, 1928, p. 175.
59. 1933: new edn, 1965.
60. 1930: new edns, 1943 and 1964.
61. *Collected Poems*, p. 36.

9 Influences and Reactions

1. Newspaper circulation figures throughout this chapter are taken from *The Newspaper Press Directory*, 1917.
2. Census of England and Wales, 1911, p. 1.
3. Figures for 1 August 1916 from *Statistics of the Military Effort of the British Empire during the Great War, 1914– 1920*, 1922, totalling just under two million.
4. April 1917.
5. Geoffrey Handley-Taylor, *John Masefield, O.M.: The Queen's Poet Laureate. A Bibliography and eighty-first birthday Tribute*, 1960, p. 41.
6. Reverse painting on glass, 55 x 60, IWM.
7. For example, *The Graphic*, 30 September 1916, p. 392 and *Illustrated London News*, 2 March 1918, CLII, pp. 272–3.
8. Cited in Marie Seton, 'War', *Sight and Sound*, Winter 1937–38, p. 184.
9. Geoffrey Malins, *How I filmed the War*, 1920, p. 176.
10. *War Diary 1913 – 1917: Chronicle of Youth*, Alan Bishop and Terry Smart (eds), 1981.
11. *Testament of Youth: An Autobiographical study of the Years 1900–1925*, 1933, rev. 1978, pp. 275–6.
12. *Pictures and Picturegoer*, 28 October 1916.
13. This was certainly done in *Picture Post* in the 1930s, on the personal assurance of a member of the editorial staff.
14. *Women War Workers*, p. 33.

Select Bibliography

Anon., *Death in the Air; The War Diary and Photographs of a Flying Corps Pilot*, 1933.

Anon. ed., *Poems of the Great War*, 1914.

The Athenaeum

Bacon, Reginald, *The Jutland Scandal*, 1925.

Bagnold, Enid, *A Diary without Dates*, 1917.

Baring, Maurice, *R.F.C. H.Q. 1914–1918*, 1920.

Beesly, Patrick, *Room 40; British Naval Intelligence 1914–1918*, 1982.

The Bioscope.

Blunden, Edmund, *Undertones of War*, 1929.

Blunden, Edmund, *Poems 1914–1930*, 1930.

Blythe, Ronald, *Akenfield*, 1972.

Bone, Muirhead, *The Western Front; Drawings by Muirhead Bone*, 2 vols, each of 5 parts, 1917.

Muirhead Bone 1916–17; Artists at the Front, First World War G4010/27, Department of Art, Imperial War Museum, London (unpublished correspondence).

The Bookseller.

Bordeaux, H., (Sill, L.M. trans.), *A Paladin of the Air*, 1918.

Boyd, Donald, *Salute of Guns*, 1930.

The Boys' Friend.

British Artists at the Front, 4 parts, 1918. I, *C.R.W. Nevinson*; II, *Sir John Levery* A.R.A.; III, *Paul Nash*; IV, *Eric Kennington*.

Brittain, Vera, *Testament of Youth; an Autobiographical Study of the Years 1900–1925*, 1933, rev. 1978.

Brittain, Vera, Bishop, Alan and Smart, Terry (eds), *War Diary 1913–1917; Chronicle of Youth*, 1981.

Brooke, Rupert, *The Collected Poems of Rupert Brooke*, 1918.

Browne, D.G., *The Tank in Action*, 1920.

Brownlow, Kevin, *The War, the West and the Wilderness*, 1979.

Buchan, John, *The Battle of the Somme; First Phase*, 1916.

Buchan, John, *Mr Standfast*, 1919.

The Bystander.

'Cable, Boyd' (Ewart, A.E.), *Doing Their Bit*, 1916.

Cadogan, Mary and Craig, Patricia, *Women and Children First; the Fiction of Two World Wars*, 1978.

Cecil, Lord Hugh (intro.), *The Work and Training of the Royal Flying Corps*, n.d.

Clarke, Basil, 'How the Progress of the War was Chronicled by Pen and Camera', *The Great War* (Wilson, H.W. and Hammerton, John eds), vol. 10, 1917, pp. 413–28.

Cohen, J., *Journey to the Trenches*, 1975.

Connolly, Cyril, *The Condemned Playground; Essays 1927–1944*, 1945.

'Contact' (Bott, Alan), *An Airman's Outings*, 1917.

Cook, Edward, *The Press in Wartime*, 1920.

Cooper, Bryan, *Tank Battles of World War 1*, 1974.

Coppard, George, *With a Machine Gun to Cambrai*, 1969.

Corbett, Julian and Newbolt, Henry, *Naval Operations (1914–1918), History of the Great War based on Official Sources*, 5 vols, 1920–31.

Cosens, M., *Lloyd George's Munitions Girls*, 1916.

Cromer, the Earl of, *After War Problems*, 1917.

Crozier, F.P., *A Brass Hat in No Man's Land*, 1930.

Curtis, Barry, 'Posters as Visual Propaganda in the Great War', *Block* (2), Spring 1980.

Daily Chronicle.

Daily Express.

Daily Mail.

Daily Mirror.

Daily News.

Daily Telegraph.

Davis, Richard, *With the Allies*, 1915.

Dawson, A.J., *Somme Battle Stories*, 1916.

Dovie, Charles, *The Weary Road; Recollections of a Subaltern of Infantry*, 1929.

Durrell, J.C.W., *Whizz-bangs and Woodbines; Tales of Work and Play on the Western Front*, 1918.

Elles, Hugh, *Fighting Tanks; an account of the Royal Tank Corps in Action 1916–1919*, 1929.

Evening News.

Ewart, Wilfrid, *Way of Revelation*, 1921.

Farnol, Jeffrey, *Some War Impressions*, 1918.

Farr, Dennis, *English Art 1870–1940*, 1978.

Fisher, H.A.L., *Educational Reform*, 1917.

'Flight Commander', *Cavalry of the Air*, n.d. (?1918).

Fuller, J.F.C., *Tanks in the Great War 1914–1918*, 1920.

Gibbs, Philip, *The Pageant of the Years*, 1946.

Gibbs, Philip, *Realities of War*, 1919.

Gibbs, Philip, *The Soul of the War*, 1915.

Gibbs, Philip, *The War Dispatches*, ed. Prigg, Catherine, 1964.

Gibson, Langhorne and Harper, J.E.T., *The Riddle of Jutland; an Authentic History*, 1934.

Grabolle, Harro; Spear, Hilda and Wallace, Ian, 'British and German Prose Works of the First World War', *Notes and Queries*, August 1982 and August 1983.

The Graphic.

Graves, Robert, *Collected Poems, 1965*, 1965.

Graves, Robert, *Goodbye to All That*, 1929, rev. 1957.

Gray, Cecil, *Tales of the Flying Services; the Adventures and Humours of Aerial Warfare*, 1915.

The Great War.

Greicus, M.S., *Prose Writers of World War 1*, 1973.

Gurney, Ivor, *Poems of Ivor Gurney 1890–1937*, 1973.

Gurney, Ivor, *War's Embers*, 1919.

Gurney, Ivor, *Severn and Somme*, 1917.

Sir Douglas Haig's Great Push; the Battle of the Somme, 1916.

Haigh, Richard, *Life in a Tank*, n.d

Handley-Taylor, Geoffrey, *John Masefield, OM; the Queen's Poet Laureate, A Bibliography and eighty-first birthday tribute*, 1960.

Hankey, Donald, *A Student in Arms (second series)*, 1917.

Harper, J.E.T., *The Truth about Jutland*, 1927.

Harries, Meirion and Harries, Susie, *The War Artists*, 1983.

Harrison, Tom, *Living through the Blitz*, 1976.

Haste, Cate, *Keep the Home Fires Burning*, 1977.

Henderson, Keith, *Letters to Helen*, 1917.

HMSO, *Narrative of the Battle of Jutland*, 1924.

The History of The Times, vol 4, part 1; The 150th Anniversary and Beyond, 1952.

Hobson, J.A., *Democracy After the War*, 1917.

Hough, Richard, *The Great War at Sea, 1914–1918*, 1983.

Hueffer, Ford Madox, *On Heaven, and Poems Written on Active Service*, 1918.

Illustrated London News.

Illustrated War News.

Imperial War Musuem, *A Concise Catalogue of Paintings, Drawings and Sculpture of the First World War*, 2nd edn, 1963.

Irving, J., *The Smoke Screen of Jutland*, 1966.

Jones, David, *In Parenthesis*, 1937.

Jones, H.A., *The War in the Air, History of the War Based on Official Sources*, 5 vols, 1931.

Jones, Ira, *An Air-fighter's Scrap-book*, 1938.

Lea, John, *Brave Boys and Girls in Wartime*, 1919.

Leask, G.A., *Golden Deeds of Heroism*, 1919.

Leicester Galleries, *Catalogue of Exhibitions 1917–1918*, 1918.

Lewis, Cecil, *Sagittarius Rising*, 1936.

Lewis, Wyndham (ed.), *Blast; Review of the Great English Vortex*, 1914.

Leyland, John (ed.), *Souvenir of the Great Naval Battle*, 1916.

The London Gazette.

Lodge, Oliver, *The War and After*, 1915.

Low, Rachel and Manvell, Roger, *The History of the British Film, 3: 1914–1918*, 1956.

MacDonagh, Michael, *In London during the Great War; the Diary of a Journalist*, 1935.

MacDonald, Lyn, *Somme*, 1983.

Malins, Geoffrey, *How I filmed the War*, 1920.

Manchester Guardian.

Manning, Frederic, *Her Privates We*, 1930, repr. 1964.

Marder, A.J., *From the Dreadnought to Scapa Flow, 3*, 1966.

Marwick, Arthur, *The Deluge; British Society and the First World War*, 1965.

Marsh, E.H. (ed.), *Georgian Poetry 1918–1919*, 1919.

Marsh, E.H. (ed.), *Georgian Poetry 1916–1917*, 1918.

Marsh, E.H. (ed.), *Georgian Poetry 1913–1915*, 1915.

Masefield, John, *The Old Front Line*, 1917.

Masterman, C.F.G., *Second Interim Report on the Work Conducted for the Government at Wellington House*. 1916, Imperial War Museum.

Masterman, C.F.G., *Report of the Work of the Bureau established for the purpose of laying before Neutral Nations and the Dominions the case of Great Britain and her Allies*, 1915, PRO INF 4/5.

Masterman, Lucy, *C.F.G. Masterman; A Biography*, 1939.

Mayes, W.P., *The Origins of an Art Collection*, unpublished ms in the Department of Art, Imperial War Museum.

Middlemass, Martin, *The First Day on the Somme*, 1971.

Mitchell, F., *Tank Warfare; the Story of the Tanks in the Great War*, n.d.

Morning Post.

Paul Nash, 1917, First World War 267 A–6, Department of Art, Imperial War Museum (unpublished correspondence).

Nevinson, C.R.W., *Paint and Prejudice*, 1937.

Nevinson, C.R.W., *The Great War – Fourth Year*, 1918.

Nevinson, C.R.W., *The Roads of War*, 1918.

Nevinson, C.R.W., *Modern War*, 1917.

News of the World.

Nicholson, Ivor, 'An Aspect of British Wartime Propaganda', *Cornhill Magazine*, 71, 1931.

The *Observer.*

'An OE', *Iron Times with the Guards*, 1918.

Oliver, F.S., *Ordeal by Battle*, 1915.

O'Neill, Elizabeth, *The War 1916; A History and an Explanation for Boys and Girls*, 1917.

Orpen, William, *An Onlooker in France*, 1924.

Osborn, E.B. (ed.), *The Muse in Arms*, 1917.

Owen, Wilfred, *Poems*, 1920.

Owen, Wilfred, Day Lewis, C. (ed.), *The Collected Poems of Wilfred Owen*, 1963.

Owen, Wilfred, Owen, Harold and Bell, John (eds), *Collected Letters*, 1915.

The Oxford Pamphlets, 1914–15.

Pankhurst, Sylvia, *The Home Front; A Mirror to Life in England during the World War*, 1932.

The Parliamentary Debates (Official Report), Fifth series, House of Commons, 1913–21.

Parrott, Edward, *The Path of Glory*, n.d.

Picture Post.

Pictures and Picturegoer.

Price, Julius, *On the Path of Adventure*, 1919.

Pulitzer, Ralph, *Over the Front in an Aeroplane*, 1915.

Punch.

Raymond, Ernest, *Tell England*, 1922.

Read, Herbert, *A Coat of Many Colours; Occasional Essays*, 1945.

Reeves, Nicholas, *Film Propaganda in the First World War*, unpublished Ph.D. thesis, University of London, 1981.

Reilly, Catherine W., *English Poetry of the First World War; A Bibliography*, 1978.

Reveille; devoted to the Disabled Sailor and Soldier.

Richards, Frank, *Old Soldiers Never Die*, 1933.

Rosenberg, Isaac, Parsons, Ian (ed.), *The Collected Works of Isaac Rosenberg*, 1979.

Roskill, S.W., *The Strategy of Sea Power*, 1962.

Sabin, A.K. *War Posters issued by Belligerent and Neutral Nations 1914–1919*, 1920.

Sanders, M.L., 'Wellington House and British Propaganda during the First World War', *Historical Journal*, XVIII, 1, 1975.

Sanders, M.L. and Taylor, Philip M., *British Propaganda during the First World War, 1914–1918*, 1983.

Sassoon, Siegfried, *Collected Poems*, 1947.

Sassoon, Siegfried, *Memoirs of an Infantry Officer*, 1931.

Sassoon, Siegfried, *Counter-attack and Other Poems*, 1918.

Second Report on the Work of Wellington House, INF 4/5.

Seton, Marie, 'War', *Sight and Sound*, Winter 1937–8.

Sherriff, R.C., *Journey's End*, 1929.

Sherriff, R.C., and Bartlett, Vernon, *Journey's End; A Novel*, 1930.

Sillars, Stuart, 'British Prose of the First World War: Some Neglected Works', *Notes and Queries*, December 1984.

Sillars, Stuart, 'Icons of Englishness; Tradition and Development in the Arts of the Great War', *Critical Quarterly*, vol 23, no. 2, Summer 1981.

Sillars, Stuart, *Strange Meeting; The Arts of the First World War*. Introductory essay to exhibition, Aberystwyth Arts Centre, 1979.

The Sphere.

Squires, J.D., *British Propaganda at Home and in the United States*, 1935.

The Star.

Stone, George, *Women War Workers*, 1917.

'Strang, Herbert', Ely G.H. and L'Estrange C.J. (eds), *The Blue Book of the War*, n.d.

Sunday Pictorial.

The *Sunday Times*.

Swinton, E.D., *A Year Ago*, 1916.

Swinton, E.D., *Eye-Witness's Narrative of the War*, 1915.

'John Talland', 'Tank Action at Cambrai, 1918', *Great War Adventures*, 16th series, n.d.

The Tatler.

The Teacher's Friend.

Terraine, John, *The Smoke and the Fire*, 1980.

Thomas, Edward, George R. Thomas (ed.), *The Collected Poems of Edward Thomas*, 1978.

The Times History of the War.

TP's Journal of the Great War.

Wade, W.L, *The Aeroplane in the Great War; A Record of its Achievement*, n.d. (?1920).

The War Budget.

The War Illustrated.

The War of the Nations.

War Office, *Statistics of the Military Effort of the British Empire during the Great War, 1914–20*, 1922.

War Office, *Women's War Work*, 1916.

War Pictorial.

Ward, Mrs Humphrey, *England's Effort; Letters to an American Friend*, 3rd edn. with an additional letter, 1916.

The Weekly Dispatch.

Williams-Ellis, Clough, *The Tank Corps*, 1919.

Wood, Eric, *Thrilling Deeds of British Airmen*, 1917.

Yeates, V.M., *Winged Victory*, 1934, repr. 1961 and 1972.

Index